The Story
of
Waterloo Village

From Colonial Forge
to Canal Town

JOHN R. GILES

Charleston · London

THE
History
PRESS

Published by The History Press
Charleston, SC 29403
www.historypress.net

Copyright © 2014 by John R. Giles
All rights reserved

Front cover, clockwise: Courtesy of the Canal Society of New Jersey; from the author's
collection; from the author's collection; courtesy of the Canal Society of New Jersey; from
the author's collection.
Back cover, inset: From the author's collection; *bottom*: Courtesy of the Canal Society of
New Jersey.
Maps rendered by Christopher Groll.

First published 2014

Manufactured in the United States

ISBN 978.1.62619.678.0

Library of Congress CIP data applied for.

Contents

CONTENTS

Foreword

Waterloo has a long and complicated history. It was the site of a finery forge in the 1760s, a canal town and transportation hub in the 1860s and home to three generations of the Smith family. In the 1960s, it was rediscovered and became a popular tourist destination and preforming arts venue owned by the State of New Jersey as part of Allamuchy Mountain State Park and operated by a foundation. However, by 2007, the foundation's fortunes had faded. The New Jersey State Park Service has now taken over the management role and, supported by the Canal Society of New Jersey and other nonprofit stakeholders, is working to bring Waterloo to life once again.

Today, Waterloo survives as a unique example of a nineteenth-century working community and a truly one-of-a-kind visitor experience. Its original streetscape is still intact, and despite years of neglect, the historic buildings are, one at a time, being reopened to the public. However, until now, Waterloo has had no in-depth written history. The farmers, millers, canalers, teamsters and storekeepers who once made Waterloo an inland port never dreamed that future generation would be interested in them. No founding father or famous general walked these streets. Even its former foundation operators, favoring their own ambitions, spent little time searching out what really happened here. To fill this void and promote public interest, this volume is a first attempt to create a comprehensive well-researched telling of the Waterloo story together with a detailed description of the village that can be used as guide. It has been no small task to bring together the pieces of

a story that extends back over 250 years. Although there are still questions unanswered, I think you will find the account compelling and see that life in the past was no less complicated than life is today. Even if canal boats no longer stop at Waterloo, the village is still hard at work offering us insights into the world from which we have come and maybe into ourselves as well.

JOE MACASEK
June 2014

Mr. Macasek has had a lifelong interest in local New Jersey history and industrial archaeology and has pursued this interest on both a personal and leadership level. He is president of the Canal Society of New Jersey, president of the Roebling Chapter of the Society for Industrial Archeology and director of communication for the Friends of Historic Speedwell, and he serves on the Morris County Heritage Commission. He is the author of the Guide to the Morris Canal in Morris County. *He holds a bachelor of fine arts in design from the Pratt Institute and is self-employed as a graphic designer with a special interest in historic interpretation.*

Acknowledgements

First, I must give my appreciation to Margaret for her patience through this long process. The many days I have spent at the library, the deed office or at Waterloo and the many, many early mornings and late nights reading, writing, deleting, rewriting, formatting, deleting and rewriting again are probably not what she expected when we retired. I promise you this will be my one and only book. (Although, I do have an idea about another.)

Over a year ago, I started pulling together some information about Waterloo Village with the thought of updating the out-of-date self-guide brochures that the Canal Society was handing out to visitors. After some conversations with Joe Macasek, the president of the Canal Society, he suggested that I might want to expand my research into a book. So Joe gets the blame for this last year of torture. He also gets my thanks for his thoughtful guidance, expert knowledge and all-around support and for the historical photographs that appear in the book.

A special thanks to my son-in-law, Christopher Groll, who, at the very last minute, was asked to professionally render all six maps used in the book. I know he believes that I should have paid him for this work, but getting him out of cleaning his garage and basement should be thanks enough, don't you think? And to my daughter, Kathryn, a published author, my thanks for her advice, support and encouragement.

My thanks, also, to Andrea Proctor, the interpretive resource specialist at Waterloo Village and full-time employee of the New Jersey Parks Department. We have had many discussions and e-mails back and forth

trying to separate fact from fiction. Her tremendous knowledge and resources of all things Waterloo have been invaluable to me.

I also must acknowledge two groups, separated by over one hundred years, who have had a significant impact on how I view Waterloo Village's history. First are the former employees who worked at the village when it was a living history museum. Over the past twelve months, I have had discussions with several of these former employees, and all have impressed me with their fond remembrances of the time they spent working at Waterloo. They speak of the camaraderie, the ability to be creative and their satisfaction with preserving and sharing history. It is quite apparent that they all hold Waterloo dear in their hearts and fervently hope that someday the village will be fully restored and open to the public. I hope and pray that this work meets with their approval and that, in some small way, it will move the village one step closer to the glory that it once knew.

Secondly, as I researched various census reports, family histories and other publications, I have been constantly reminded of the difficult life that the people who appear in this book have had. Even the Smith family members have not been without difficult times. There are many instances that I could mention, but let me just give one example. I cannot fathom the anguish that Peter Smith and his wife, Maria, must have felt in 1838 at the loss of three of their young children within a span of three months, two of those children only two days apart. Then, in 1845, their eldest son died at age thirteen, followed ten years later by the death of an infant at birth. Though this book may portray the Smith family as wealthy, successful, astute businesspeople and community leaders, we must not forget that they were human and not immune to human feelings.

Lastly, a note to my two young grandchildren, Cooper and Charlotte: It seems that interest in history, architecture and crafts have skipped the several generations that followed mine. I hope that as the two of you grow, you will find interest in preserving history and pleasure in following some of the old ways. You might as well start preparing yourself now, for it will only be a few short years until I will ask you to put down those things that start with an *i* and, in their place, will hand you a canning jar. To both of you, and your future, I dedicate this book.

JOHN R. GILES (GRANDPA)
May 2014

Preface

All villages, towns and cities are affected by changing times and economic conditions. Small villages and towns often wither away when a new highway bypasses them, an industry closes or an aging population is not replaced by younger generations. Even larger cities, such as those in the Pennsylvania coal belt or the Midwest Rust Belt, face these same challenges, though, of course, on a larger scale. For various reasons, some are more susceptible than others, and some—the lucky ones—are able to reinvent themselves as tourist centers, technology centers or art colonies. The unlucky ones begin to board up their windows so that they don't have to watch their own sad, slow and painful decline. This document will explore one such village's life cycles.

Waterloo Village is certainly no exception to the above patterns, having enjoyed several periods of economic growth and also having suffered through similar periods of decline. It has reinvented itself several times over its long history, succeeding for a time until the next crisis hit. Over its 250-year history, it has been an important colonial-era industrial village, a participant in the American Revolution, a farming community, a barren wasteland, an important transportation link that helped foster both a new nation and the Industrial Revolution, a historic and scenic backwater village, a home to vagrants, "the only first-class ghost town in the northern United States,"[1] a beautifully restored living history museum, a popular venue for concerts (artistic, cultural and rock) and, finally, a largely forgotten village of old buildings and old memories. It has boarded up its windows several times,

and just as often, someone with a unique vision has come along and ripped off those boards.

Waterloo Village in northern New Jersey today contains buildings of several different architectural styles with varying dates of construction and located in a beautifully scenic river valley setting. Though most of the old residential and industrial buildings are individually pleasing to the eye (overlooking the sorry condition of several of them), altogether they form a confusing jumble of colonial-era buildings mixed in with pre–Civil War buildings mixed in with Victorian-era mansions and carriage houses, with a healthy number of late twentieth-century buildings thrown in as well. Because of this jumble, it is difficult to visualize the evolution of the village over time.

Similarly, when you look at the beautiful stretch of the canal that still exists in the village today, the peacefulness of it belies the complex engineering that was required to integrate it into the village's footprint. So much of the early village has been changed or obliterated by the construction of this canal that it is quite difficult to understand how its construction affected the character and continuity of the early village.

For anyone interested in history, walking through any old town or village stirs a wonder of how the village changed over time and what factors caused those changes, either positively or negatively. Waterloo, because of its small size and isolated location, is an excellent candidate for such investigation.

INTENT

The intention of this book is twofold.

First, I will try to show, in broad terms, changes that occurred in the village over time in response to outside political or economic factors, such as changes in the industrial, commercial or transportation environment. My assumption is that a positive (or negative) change in the economic environment will be reflected by a direct correlation in the number and type of buildings being constructed, renovated, repurposed or abandoned. Therefore, if the assumption is correct, a study of the changes in the village's footprint and architecture over time should point to periods when either positive or negative outside economic influences were present. In a process akin to reverse engineering, we can then examine the nature and lifespan of

each of those influences. While the intent of this book is not focused on the impact that Waterloo Village had on the New Jersey economy or the growth of this nation, I will certainly touch on those as well.

Second, I hope to provide a readable, entertaining and informative story of Waterloo Village, written with the average visitor in mind. To that end, the flow of the story is more important than listing all the detailed facts and figures behind it. Therefore I will take a bird's-eye view of Waterloo over time, providing a generalized summary of the village's history. However, where I think that a low-level view will be interesting to the reader or necessary to his or her understanding of events, I will certainly get right down into the weeds. Keep in mind that I deliberately titled this volume *The Story of Waterloo*, not *The History of Waterloo*. The avid historian may be disappointed that I have chosen to leave out so many details, but then, a three-volume set of facts and figures would not only be boring for the average visitor but also difficult for him or her to carry around while walking through the village.

APPROACH

There are four stages of development (and decline) that can roughly be categorized as: the forge era, from about 1760 to 1830; the canal era, from about 1830 to 1870; the Victorian and early twentieth-century eras, from about 1870 to 1950; and the modern era, from about 1950 to present day.

Though a specific range of dates is shown for each era listed, this is for convenience only, as there was significant overlap between these phases.

In the following pages I will try to "peel back the onion" and show the impact on the village, in chronological order, of each stage of economic development and decline. This will be done separately for each stage with an overview of what was happening that led to the positive changes in the village. I will include a brief listing of buildings that were constructed in this phase or previously existing buildings that were modified during the period. I will also provide a map showing my best guess as to what the village footprint looked like during that time period. This will be followed by a discussion of the ensuing decline in the village's fortune. In the last chapter, I will provide a detailed history of each building, along with a photo of those that still exist.

CAVEAT

While this document is a story of the village, I have also felt it necessary to provide detailed discussions of some related topics. I feel that this background information will add to the reader's understanding of how and why the village developed as it did. In some cases, where these asides are short, they have been set as sidebars to highlight their importance. Where the information is lengthy and would seriously interrupt the flow of the story, I have added them as appendixes.

To prepare this study, I relied quite heavily on existing documents—some published, others not; some recent, some rather old; some quite scholarly, others less so. When something in a document made sense to me and was supported by other similar articles that appeared to be richly researched and referenced, I did not necessarily refer back to the original source documents and accepted what was written.

Sometimes, when something in an article did not pass the common-sense test and further research was not able to support or dispute what was in question, I felt it necessary to make an assumption without conclusive documentary support. I have tried to clearly identify the passages that were based on assumptions. I am acutely aware that revisionist history is always suspect, especially when it is not well documented. It is not my intent to rewrite history, but in cases where there are competing versions of events, I tried to judge which was the better supported. While I certainly do not wish to challenge the good work done by previous authors, I do reserve the right to question certain things and perhaps offer alternative opinions respectfully.

In researching for this book, I have run across descriptions of events that have been reported many times over, often verbatim, but not attributed to an original source. It is inevitable that, in this work, I have mistakenly attributed something to a secondary rather than a primary source. It is also inevitable that I have failed to attribute something that I considered to be general information that is widely known when, in fact, that something was published in an original document and should have been credited. For any such errors, I offer my apologies.

Finally, the building of the Morris Canal and, later, the railroads both had a tremendous impact on the village. Those two developments each deserve much more attention, discussion and detail than I have room for here.

For the canal buffs, the Morris Canal, whose construction made a direct physical impact on the architecture at the industrial heart of the village, will be discussed at some length, though only as it applies to the section of the

canal that passes through Waterloo itself. My discussions regarding the rest of the canal will be limited to general information only. I know that you will be disappointed that the book has such limitations. But I also know that you are a kind, reasonable, understanding, forgiving and supportive group. For anyone who would like more information about the Morris Canal, there are many excellent books that cover the entire length of the canal and include great photos.

For the track heads, since the railroads did not pass directly through the village proper and did not cause any major architectural changes to the footprint of the village, my discussions will center mostly on the effects that the railroads had on the development (or decline) of the village and not on the design of the railroad structures themselves. Also, regarding the same, I have a confession to make. In preparing to write this book, I have had several discussions with rail enthusiasts and found them, unlike the canal buffs, to be a rather rabid group of people who would expect and accept nothing less than a two-volume set of encyclopedic information for every mile of track that passed anywhere near Waterloo and that included angles of incline, radius of curves, descriptions and history of locomotives and rolling stock, configuration of track and engineering blueprints of bridges, roundhouses, switches, etc. Talking to them is like accidently letting an insurance salesman into your house! I have nowhere near the level of expertise required to properly address this matter to their satisfaction. Neither do I have the space to treat the subject as they would demand. Therefore, rather than printing something that may not be to their liking, resulting in my being tarred and feathered, I will keep my comments about the railroads as brief as possible. (OK, track heads, lighten up—I'm just trying to inject a little humor here. But you do need to get a life!)

1

Overview

U ltimately, the story of Waterloo Village is a story of water and earth and the human vision that tied them together. The water part of the story is provided by the largest natural body of water in New Jersey, now called Lake Hopatcong, and its outlet, the Musconetcong River. The earth part of the story is the vast quantity of high-grade iron ore lying beneath, but close to, the surface, as well as the abundance of old-growth timber. The vision is provided by the various entrepreneurs who risked their fortunes and futures throughout the long history of the village. Some were successful; some were not. But all were visionaries. When you combine the three elements of water, earth and vision, Waterloo Village emerges from the past.

THE WATER

Much of the history and archaeology of Waterloo revolves around the Musconetcong River and its role as a source of water power and, later, as a transportation conduit.

The topography of the northern New Jersey area resulted from glacial movements of the last ice age. The movement of glaciers stripped off mountaintops and dug deep valleys. After the glaciers receded, the area about seven miles north of Waterloo, now called Lake Hopatcong, consisted of two shallow, spring-fed ponds originally known as "Little Pond" and, to

its south, "Great Pond." Human habitation in the area can be traced back to about twelve thousand years ago, and the water of these two ponds had both religious and life-sustaining importance to the Lenape Indians, who fished, hunted and farmed this area.

The outflow of the pond system is the Musconetcong River, which flows generally west for a few miles and then southwest for another forty miles until joining with the Delaware River. The terrain that the Musconetcong River passes through for its first few miles is rugged, and the valleys are numerous, steep and heavily forested. The river in this stretch drops at a fast fifty-five feet per mile. The lay of the land along this portion of the river provides only a few flat and open areas, and the steep hillsides are not accommodating to a robust road network. Consequently, development in this area was limited to small villages and hamlets; the upper river does not flow through any large population centers. As the river approaches the valley at Waterloo, the land flattens out a bit, and over the next several miles, the river falls at a moderate sixteen feet per mile.[2]

Since the two ponds that formed Lake Hopatcong were mainly fed by springs, the volume of water flowing into the Musconetcong River was greatly affected by seasonality. Only a person of singular vision could have looked at this relatively short, narrow, wild and scenic stretch of river and imagined the future that it would have over the next 250 years.

Around 1750, a businessman from New York City, Garret Rapalje, built a dam at the outflow of the Great Pond. This initial reshaping of the water's course raised the water level behind the dam by about six feet. This increased water depth resulted in the Great Pond and the Little Pond being merged into one, areas of former shoreline being submerged and several islands being created in this early version of Lake Hopatcong. The volume of water stored behind the dam allowed for a more consistent year-round flow of water into the Musconetcong River. Mr. Rapalje then built an iron forge, called the Brookland Forge, just below the new dam. This forge operated for over thirty years.

About seven miles west of this new dam, the Musconetcong River flows through an area of fairly wide, marshy flatlands and then enters a narrow stretch of valley. This narrow valley forms a natural constriction of the river and was an advantageous spot for the development of water power. A survey team in 1743 noted the possibilities of this area, entrepreneurs acted on them and Waterloo was the result.

THE EARTH

The mountains that cross the northwestern part of New Jersey, now part of the Appalachian Mountain chain, are the oldest in the United States. Once they were as high as the Alps, but wind, rain and glaciers have all had a hand in wearing them down. Their twisted and worn ridges of granite are all that remain. They begin in southeastern Canada, running north–south along what is now the eastern border of New York State and then swing west where the Hudson River slices through them, near West Point. They continue west, where they become the highlands of northern New Jersey, and then turn south again, extending as far south as northern Georgia.

When nature was laying down this ancient landscape, it thoughtfully tucked pockets of iron ore into the portions of rock that formed northern New Jersey. While most iron ores are red or brown, in a few places, a significantly higher quality of coal-black ore, called "magnetite," can be found. Northern New Jersey was blessed with an abundance of this high-quality ore. The earliest Europeans to visit the New Jersey highlands, possibly as early as 1685, quickly became aware of the outcroppings of black rock and began small-scale mining. Samples of this ore were sent back to England for processing and evaluation to see if the ore had any real value. Reports back to the colonies were glowing—the English forge men stated that this was the best ore that they had ever worked and that it produced iron of extremely high quality, quite suitable for making steel.

By the early 1700s, many forges were operating throughout New Jersey, but the industry began concentrating in the north-central part of the state to take advantage of the plentiful and high-quality iron ore there. One of the major challenges to the growth of this industry was the highlands' poor road network, which had to traverse the high ridges and deep valleys of the mountain chain. The few roads were hilly, rough and subject to weather conditions. Transporting heavy and bulky ore from the mines to the furnaces and forges was inefficient, as was the onward transportation of the resulting pig iron and bar iron to the East Coast ports for export to England.

THE VISION

The vision, the third side of the triangle, was held by a succession of risk takers, willing to bet their personal and financial safety that they would

overcome daunting challenges. Over the village's 250 years of existence, these risk takers included the early frontier settlers, as well as later entrepreneurs. While some had a direct and long-lasting impact on the village's development, others may have had only a cursory or peripheral impact.

The first risk takers were the individual settlers of the early 1700s, when there were a few small subsistence farms dotting the meadows and valleys that, at this time, were considered the western wilderness. Carving out a farm, even a small one, from the heavily timbered, rock-studded, old-growth forests using only hand tools and perhaps a horse-pulled plow in the face of possible Indian conflicts would have been unimaginably difficult. The thick forest, the steep terrain and the lack of roads were not favorable to commercial agriculture during these early years of colonial expansion, so the motivation of these early settlers was likely not to have been financial but more of a reflection of the "go west young man" mentality or perhaps a desire to move up from common laborer to landowner. As stubborn as the land was, the vision of these early settlers was even more stubborn.

In 1743, a survey team led by John Lawrence passed through the area. He noted that the hills surrounding the Musconetcong River were heavily forested with oak and chestnut and that peaceful Native Americans were living in the nearby Allamuchy Mountains. He also noted that the terrain at the site that would later become Waterloo Village constricted the river, giving it the potential for water power. His survey team drove a metal stake into the ground at that site, declaring it to be the dividing line between east and west Jersey.

This survey work provided information needed by the next set of risk takers, the colonial entrepreneurs who recognized the potential of the area and risked their fortunes to overcome hardships and develop the early ironworking industry, not realizing that they were building a new nation in the process. Any investment in this area at this time was undertaken in the midst of the French and Indian War (1754–63), an unlikely time to be expanding westward. Even though most of the fighting occurred north and west of this frontier area and the local tribes here were friendly and peaceful, there was still a danger of raids by Native American tribes allied with the French.

The first of these entrepreneurial visionaries who invested in Waterloo were the shareholders of the Philadelphia firm of Allen & Turner. This company purchased land and established several industrial enterprises in the region. Among them were an iron mine and smelting furnace complex in Andover, New Jersey, and seven miles away, an ironworking forge in the valley that would become our village. Though these shareholders were

sympathetic to the challenges of the colonial settlers, ultimately their loyalty was to the British Crown. The success of the American Revolution resulted in the waning of their fortunes and led to the village's decline during the post-Revolution period.

The next visionary who had a major impact on the village, though a peripheral one, was a Morristown businessman named George P. McCulloch. I characterize his effect on the village as peripheral because his intent had nothing to do with Waterloo. However, through the luck of terrain, Waterloo was to greatly benefit from his idea. In the mid-1820s, he saw the need for, and the potential of, a canal system that would allow for the transportation of large quantities of both raw materials and finished goods, overcoming the rough terrain and bad roads of the northern highlands of New Jersey that had formed a "road block" between New York and Pennsylvania. Such a canal, linking the expanding western territories of the young United States with the large East Coast cities of Newark, Jersey City and New York City and with access to the East Coast shipping lanes would make New Jersey a central hub of transportation, commerce and industry. Mr. Ephraim Beach, an experienced canal engineer, became the implementer of this vision and, in the process, built a canal system like no other, overcoming monumental obstacles. The vision of the first entrepreneur and the skill of the second were significant factors in the spread of the Industrial Revolution and created a commercial environment that benefitted the entire region, not just Waterloo Village.

Around 1790, Ezekiel Smith, followed by his son John Smith and John's sons and grandsons over the next one hundred years, saw opportunity and acted on it when success was a less-than-assured outcome. The Smith family was the main driving force in the development of Waterloo Village throughout almost all of the nineteenth century. The family fortunes were based on agriculture, but the Smiths also branched out into transportation-related commerce. This shift was triggered by the opening of the Morris Canal, whose western branch conveniently (for the Smith family) passed directly through Waterloo Village. Their initiatives led to a long and prosperous period for the Smith family.

The development of the railroads, envisioned by many unnamed people, from the 1850s onward was the last and most effective of the nineteenth-century nation-building enterprises that opened up the country. These new technologies were employed fairly early in the Waterloo area to support the various industrial activities. But as you will later see, they also led to the eventual decline of the village.

Finally, in the modern era, Percy Leach and his partner, Louis D. Gualandi, began buying up property in the village. Their vision was to turn this northern New Jersey ghost town into a historically important village accessible to all. Their background in interior design certainly suited this vision, and eventually the village became a very popular living history museum. After a long period of creative success and financial failure, Waterloo has now passed into the hands of the State of New Jersey. Only time will tell what the state's vision will be.

THE LAY OF THE LAND

Since geography was directly responsible for Waterloo's long history, it's necessary to understand Waterloo in that context. (Refer to Map 1.)

Waterloo Village is a rather small, compact group of buildings, occupying a piece of ground about five hundred yards wide by three hundred yards deep. It sits mostly along the north bank of the Musconetcong River where it flows through a narrow valley formed by Schooley's Mountain on the south and Allamuchy Mountain on the north. Schooley's Mountain is quite steep almost all the way to the river with very little flat space along the riverbank suitable for either development or agriculture. Allamuchy Mountain, on the other hand, has a relatively flat shelf of gravelly soil that extends about a mile south to the riverbank.[3] On this shelf is where the village of Waterloo took root.

When talking about Waterloo, we can't just focus on the village itself. We need to have a more expansive mindset and consider the surrounding areas as part of the Waterloo picture. The early landowners invested heavily in large tracts of land that included much more than just the narrow valley where Waterloo developed. Within this expanded view is a small settlement located just over a mile upstream from Waterloo called New Andover. Although geographically a separate and distinct area from Waterloo Village, its history and that of our village are permanently intertwined, making it difficult to talk about one without including the other.

Just upriver of Waterloo, the steepness of the two ridges moderates, becoming rolling hills for a few miles, and providing a gap (Lockwood Gap) through the mountains that today allows several roads to pass through, including Route 206 north to the county seat at Newton and Routes 80 and 46 west to the Delaware River. Lake Hopatcong, the headwaters of

the Musconetcong River, and several other lakes sit in this area of rolling hills. As the Musconetcong flows out of Lake Hopatcong, it trends generally westward until it passes through the valley and then continues southwest until it enters the Delaware River. The Musconetcong River has several tributaries, two of which are of importance to the village and join the river just above it.

Farthest east is Lubber's Run, which joins the Musconetcong River about 1.1 miles east of Waterloo Village, draining a large, open and fairly flat area to the northeast. The settlement of New Andover developed near the confluence of these two watercourses and was once the location of a forge and a few houses, sheds and barns. No buildings remain at this site. A little closer to Waterloo is Dragon's Brook, which runs from north to south, draining a rather narrow valley. It enters the Musconetcong River slightly closer to Waterloo than Lubber's Run, just less than a mile upstream of the village.

THE ROAD NETWORK: THEN AND NOW

The unpaved road that passes through today's Waterloo Village, named Waterloo Village Road, was at one time the main road that ran between Hackettstown and Newton, with Waterloo being roughly halfway between the two. The original course of the road was dictated by terrain and, therefore, had many twists and turns, passing through both Waterloo and New Andover. In the mid-1800s, the old road was rerouted, and it was rerouted again in 1945. The paved main road today, Waterloo Road, bypasses both Waterloo and New Andover on their northern sides.

Just east of the village, Waterloo Road intersects with Continental Drive, whose route is overlaid on an abandoned rail line. North of this intersection, the rail bed, dating to the mid-1850s, is an unpaved popular walking path. It follows close by Dragon's Brook and connected Waterloo with the iron mine in Andover. South of the intersection, Continental Drive is paved and follows the path of a 1902 railroad bypass. This paved section passes between Waterloo and New Andover.

Our expanded view of Waterloo Village includes the valleys north and east of the village that are drained by Dragon's Brook and Lubber's Run, as well as the land on both sides of the Musconetcong River between Schooley's Mountain and Allamuchy Mountain, as far west as Saxton Falls.

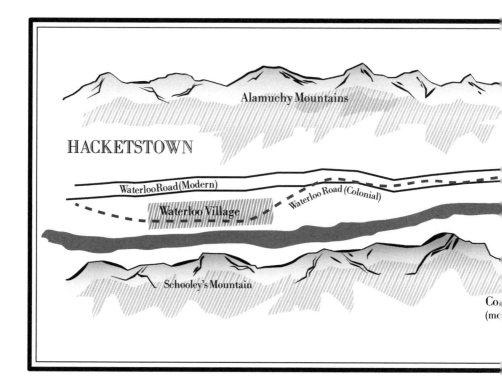

WHAT DO WE CALL THIS VILLAGE?

The village of Waterloo has had several names over its history. Originally it was called Andover Forge, named for an ironworking forge that was located here in colonial times. In the late 1820s, the name changed to Old Andover, and it changed again in the early 1840s to Waterloo Village. For convenience, I will refer to the village as Waterloo regardless of what period of time I am discussing, with a few exceptions.

Similarly, the small settlement upstream, near the confluence of Lubber's Run with the Musconetcong, was originally called Lubber's Run until the late 1820s, when it began to be called New Andover. I will use the latter name in this book. (Appendix A has a detailed discussion of the source of the various names that these villages were known by.)

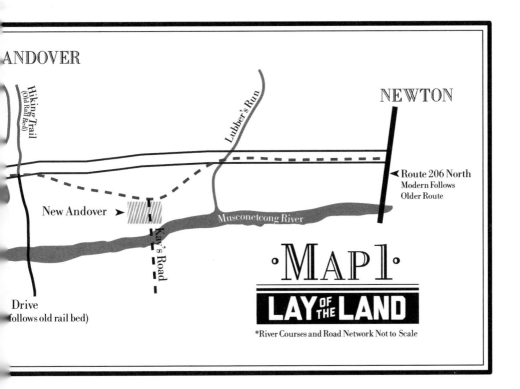

ANDOVER

Hiking Trail
(Old Rail Bed)

Lubber's Run

NEWTON

New Andover ➤

Musconetcong River

◄ Route 206 North
Modern Follows
Older Route

Kay's Road

·MAP 1·

LAY OF THE LAND

Drive
(follows old rail bed)

*River Courses and Road Network Not to Scale

2

The First Period of Growth and Decline

THE FORGE ERA (1760–1830)

The village went through eight distinct phases: four periods of economic growth, each followed by a decline, almost as though dictated by a celestial law requiring affluence to be offset by misfortune. The four periods of expansion were triggered by different sets of economic conditions. Similarly, the four periods of decline were caused by separate and distinct influences.

IN THE BEGINNING

During the forge era, the first economic boom to affect the village changed it, practically overnight, from a largely unoccupied river valley of dense forest into a thriving industrial village that I will call Waterloo. Within a short period of time, probably little more than a year, the Musconetcong River was dammed and an ironworking forge was built. A large stone charcoal house was built to store charcoal for the forge. There were also a timber-framed gristmill and sawmill, as these were the usual accompaniments to forges of this era. To operate the various waterwheels, bellows and forge hammers, a hydropower infrastructure was put in place. Many temporary wooden structures would have been erected to house the unskilled workers, and several permanent stone residences were built to house the skilled workers.

This sudden growth of industrial and residential structures wasn't just happening in Waterloo—forges were being built throughout the colonies, well in excess of the needs of the local population. It wouldn't be an exaggeration to say that, in colonial times, forges were thicker than fleas on a stray dog. To answer the question of what was driving this growth, we have to look at what was going on back in England at the time.

Prior to the colonization of America, England imported most of its iron ore from Sweden. Restrictions that Sweden placed on the amount of ore that it would export left England hungry for more iron. This shortage of iron impeded growth and especially impacted the materials needed for military purposes, most especially for the Royal Navy. Once England became aware of the amount and quality of iron ore that its American colonies possessed, the mother country saw a solution to its iron shortage. England's demand for American iron was insatiable and would create wealth for anyone involved in the new trade (as long as they were Loyalists). To ensure that this wealth creation benefitted the Crown and its loyal citizens, both at home and abroad, Parliament passed the Iron Act of 1750, which removed import tariffs on pig iron and bar iron. The act also, much to the anger of the colonists, forbade the building of new finishing mills, which the Crown intended as a way to induce even more iron imports. (For more information on the Iron Act of 1750, see Appendix B.)

One of the firms well placed to profit from the iron trade was the Philadelphia company of Allen & Turner. Among its many pursuits were mining, sugar production, shipping and ore processing. The company also invested heavily in land for speculation. By 1760, the company was engaged in a number of iron ore exploration projects and was operating ore-processing facilities in several locations in the highlands of New Jersey, including the Union Iron Works in what is now Hunterdon County and the Andover Iron Works in Sussex County, located on a branch of the Pequest River. The Andover Iron Works had two main components: the Andover Mine and Furnace complex and the Andover Forge, which was located seven miles west of the mine and furnace. Wherever mining or ore processing was done, small villages evolved to support these activities, often layered over earlier small hamlets and subsistence farms of the early eighteenth century. The same happened here, and the growing village of Andover assumed its name from the ironworks, while the hamlet of Andover Forge likewise assumed its name from the forge.

The Andover Iron Works was opened in 1760 and was located in an area considered to be the frontier. The remote location, the lack of an

efficient road network and the sparse population were glossed over in the company's desire to tap into the veins of the highest grade of iron ore that was available. In addition to the mine and furnace, the industrial complex at Andover consisted of several mills, farms and housing, all located on over five thousand acres of forested land called the Andover Furnace Tract.

EARLY WATERLOO

Furnaces and forges of the time were both fueled by charcoal, and transporting large quantities of either wood or charcoal over long distances on the poor road network was neither economically nor operationally feasible. Similarly, transporting bulk iron ore any distance was not practical. The sheer weight of the raw ore, much of which included waste material that had no value, made it a difficult and inefficient cargo. It was critical, therefore, that these early complexes were located where the source of ore was closely surrounded by large stands of hardwood forest. Running out of fuel could, and often did, mean the closing of furnaces and forges. A forge such as the one at Waterloo could consume one thousand acres of timber per year as charcoal fuel. Locating the forge close to the furnace would quickly deplete the available fuel source, so the forge was located seven miles away, on the banks of the Musconetcong River, surrounded by five thousand acres of hardwood forest called the Andover Forge Tract. As the land was deforested, the mine owners would be forced to buy timber from nearby wood lots, while converting their own land to agricultural use to provide fodder for animals and food for the workers. (It would not be until the 1820s that commercially mined coal would be available from eastern Pennsylvania and not until the 1830s that the coal could be efficiently transported in bulk on the new Morris Canal.)

We know that the Andover Mine and Furnace began operating around 1760 and the Andover Forge a year later, in October 1761.[4] Most documents indicate that the furnace produced pig iron and that the Andover Forge processed that pig iron into bar iron. Both pig and bar iron from the Andover Iron Works were sold to merchants in New York or Philadelphia who would then ship the iron to England for further processing.

Pre-Revolutionary ironworks put to work a combination of indentured servants, African slaves, free laborers and part-time farmers.[5] Jobs to be filled, depending on the size of the operation, could number into the hundreds and

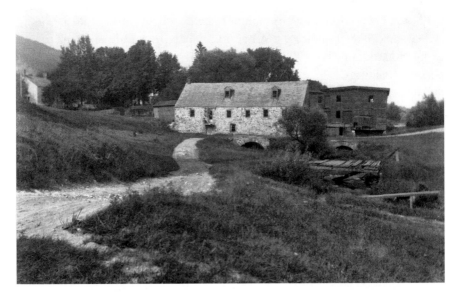

The old charcoal house, on the left, became the gristmill around 1831 .The sawmill, on the right, was built over the old forge foundation, also around 1831. *Courtesy of the Canal Society of New Jersey.*

included clerks, miners, teamsters and woodcutters. Skilled technicians, such as colliers (who oversaw charcoal making), ironmasters and millers, would be held in high esteem within the closed community of a forge village.

The forge at Waterloo was a fairly small operation when compared to the mine and furnace complex at Andover, but it still would have employed a good number of people. The influx of workers to this mostly uninhabited area required the construction of housing, and the first housing structures were probably barracks-style log cabins or temporary timber-framed buildings. The more skilled workers may have initially been quartered in existing farmhouses if there were any nearby. Once the forge and mills were operating, however, there would have been a need for more permanent housing.

At least three stone two-family houses were erected, and these would have been occupied by the families of the site manager (or forge master) responsible for all activities of the forge, mills, farms and everything else. Under him would be the iron master, the two millers (one each for the grist- and sawmill) and the boss collier. The three stone residences from the early 1760s, which still exist today, were renovated and expanded several times over their 250-year histories, so their appearance today is somewhat more architecturally grand than would have been the case in the mid-1760s. There

may have been additional permanent structures built during this period, as at least one later building at Waterloo appears to have been built on an earlier foundation, but we have no definitive documentation about those possible buildings.

The semi-skilled forge and mill workers would have likely been housed in less elegant surroundings, probably in log or timber-framed houses. The nonskilled workers, such as timber cutters, teamsters and laborers, would probably have remained in barracks-style quarters, as would the six slaves, though they would probably be housed separately from the others. (The company had slaves employed at both Andover and Waterloo.)

The stone charcoal house from this period still stands, though it also is not in its original form. All of the timber-framed structures from this period long ago disappeared from the village.

GROWING PAINS

The history of the Andover Iron Works is one of turmoil, uncertainty and confusion. From the late 1750s to 1761, the company invested huge amounts of money in buying land and building the basic infrastructure in Andover and Waterloo to support its mining and iron-processing facilities. For the first decade of its existence, from 1760 to 1770, the Andover Iron Works (including the forge at Waterloo) was operated by the company, and we know from letters of the time that it experienced the expected difficulties of a start-up industry operating on the edge of the frontier. Some of these letters detail production problems related to low water levels in the river, rampant fevers among the workers, fear of possible Indian attacks and waterwheels frozen by ice.[6] John Hackett, one of the minor shareholders in the company, had been the on-site manager at the company's Union Iron Works. The letters describe him as not being of robust stature and often sickly. Though not physically strong, he was experienced, and when the furnace at Andover was put in blast in 1760, he moved there to oversee the new operation. He died in 1766, and this loss would certainly have had a negative effect on the operations.

Pig iron produced by the Andover furnace would be transported by horseback or by wagons over the rough roads to the forge at Waterloo. There it would be melted in the finery forge and excess carbon removed. The resulting bloom iron would be hammered into long thin bars, called "bar iron," which was the most economically transportable form of iron.

The bar iron would be heated again and "bent into 'U' shapes and fitted to the backs of mules for transport overland."[7] If the bar iron was for export to Britain (and up until the second year of the War for Independence, most bar iron was manufactured for export), it would be transported to Philadelphia or New York. If the bar iron was for local use, it would be sent thirty miles to the rolling and slitting mills at High Bridge.[8]

In the 1782 lease agreement, pig iron, in ingot form requiring further processing, was valued at seven pounds ten shillings per ton. Bar iron, in thin strips and ready to be heated and hammered into finished goods, was valued at twenty-eight pounds per ton. Bar iron was easily transportable and became the currency of commerce.

After only ten years of operation, the ironworks in Andover was offered for lease.[9] There's no indication of what caused the company to try to lease out the operation in 1770, nor is it known if it was successful in securing a leaseholder. However, the decision by the company to offer the ironworks for lease could be an indication that things were not going well. The high cost of investment in facilities, the poor road network and inefficient transportation all made the operation financially difficult. Kevin Wright's 2013 book *A History of the Andover Iron Works* has the subtitle "Come Penny, Go Pound."[10] This tellingly refers to the financial challenges that the company faced. There is no clear indication of whether the forge at Waterloo was in continuous operation during this time, either.

Throughout this first decade, the village of Waterloo did not grow beyond the original forge, mills, stone residential houses and temporary wooden structures. It was a difficult time, a period of unfulfilled expectations. But all was not lost. Perseverance still had a chance to pay off.

WATERLOO DURING THE REVOLUTIONARY WAR

A new set of difficulties was approaching, and these would be completely beyond the control of the company.

The Political Environment

In the mid-1770s, the upwelling of dissatisfaction among a large number of colonist reached a point of armed rebellion. However, in northern New

Jersey, as in all other states, there was still a great number of people who were loyal to the Crown. In *Historical Directory of Sussex County*, Edward Webb states, "In consequence of the violent conduct of a few outlaws who took advantage of the retreat afforded by our mountains, Sussex has been stigmatized as a nest of Tories."[11]

Many of the Philadelphia and New York merchants, whose livelihood relied on their trade with England, were Loyalists. These same merchants were often owners of ironworks or engaged in some form of iron mining and/or processing. Though they were not violent outlaws, as described above, these merchants and mine owners were certainly not much interested in providing their iron to the rebels, mindful of how the Crown might view this. Governor Livingston, a supporter of the rebel cause, said in a March 4, 1778 article in the *New Jersey Gazette*: "None of our citizens are more generally disaffected than those that are interested or employed in the manufacture of iron. A strong presumption [is] that the enemy had been particularly industrious in corrupting these men."[12]

By the time that actual fighting broke out in 1775, the company had three major shareholders: the founder of the company, American-born William Allen; British-born Joseph Turner (born in Andover, England, thus the name Andover Iron Works); and American-born Benjamin Chew (whose second wife was William Allen's daughter Elizabeth). The business networks of all three shareholders spanned both the American colonies and Great Britain. Even though two of them had been born in the colonies and the third had arrived as a teenager, they had never really considered themselves to be Americans but rather English entrepreneurs exploiting the New World for their own economic benefit and for the good of England, which they considered to be their homeland. All three shareholders, with large investments at stake, certainly hoped that the differences could be peacefully resolved to the satisfaction of both the colonists and the Crown.

And it wasn't just the wealthy merchants who had Loyalist political leanings. Even among the working class, at least in Sussex County, there were many who were willing to pick up a club or a hoe and chase the rabble-rouser from his soapbox on the village green. The result was a fractured population with tremendous pressure on all to publicly declare on which side they stood. Inevitably, choosing the wrong side had the potential to be ruinous to both fortune and health.

The Shareholders

Trouble had been brewing for many years. Everyone could see it coming. Some, like Allen, could not understand it. He was an aristocrat and could not understand any of the activities of the middle class, nor could he understand their level of dissatisfaction. This may have been one reason for his antagonism toward Benjamin Franklin, who was an outspoken advocate of the common people.[13] Allen, Turner and Chew were all somewhat opposed to the British government's colonial policy. After all, some of Parliament's actions, such as the Iron Act and the Stamp Act, also reflected negatively on their business ventures. But certainly, they hoped, things could be worked out peacefully.

Alas, when the Declaration of Independence was issued and the Continental Congress began making demands for the Andover Iron Works to supply the Continental army with iron to support its military efforts, the tipping point for the owners of the ironworks had been reached. They were forced to make a decision, one that would be final and irrevocable. They declined to provide the iron and closed the mine, furnace and forge. All the slaves at the Andover Works—numbering about forty, including the six at Waterloo—were sent to Virginia to prevent them from being seized by the state.[14] (Lest you think the state had altruistic intentions, the company feared that its slaves would be seized and sold to persons more supportive of the cause, with the profit going into the state's coffers.)

William Allen departed for England in 1774. Though Turner stayed in America, he apparently kept a low profile, as there is nothing heard of him during the Revolutionary War years. This was possibly due to his age, as he was born in 1701. Chew also stayed in the colonies. He was arrested, held as a prisoner at the Union Forge from 1777 to 1778 and then was paroled. He lost all of his prewar political offices, though over time, he eventually regained some degree of respectability.

Confiscation of the Ironworks

In 1778, after much debate, the Continental Congress directed that a contract be executed for the supply of iron from the Andover Iron Works. To achieve this, the New Jersey government was ordered take possession of the works and "put a proper person in possession of [them], the same belonging to persons who adhere to the enemies of these states [meaning Allen, Turner and Chew]."[15]

The New Jersey government determined that the works could not be taken over without legal due process, which it was reluctant to do, especially since Benjamin Chew was a well-connected individual with ties to George Washington and John Adams. Instead, it pursued a lease of the site. When it was not able to arrange that, it formed a three-man commission to oversee the operation of the ironworks. Thus, the Andover Iron Works were never actually confiscated. They were simply borrowed by New Jersey. The state government contracted with Colonel Thomas Mayberry to operate the ironworks.

Truth or Fiction?

Several histories state that the Andover Iron Works and the forge at Waterloo, with their output of high-quality iron, were valuable contributors to the success of the Revolution. When reading some of the descriptions, one might almost think that the Andover Iron Works, and specifically the forge at Waterloo, was the main, if not sole, supplier of arms to the colonist's cause. Let's take a look at some of these claims.

In an article in the *Sunday Herald*, Suzanne Miller says that the Andover Iron Works became known as "the arsenal for democracy" and goes on to say:

> *William Allen…was greatly upset by the English Trade Act restricting the Colonial manufacture of iron and as late as 1775 supplied cannon shot at his own expense to the Continental cause…Yet as radicals in the congress called for political separation from the English Crown, Chief Justice Allen became increasingly conservative. In 1776 he was unable to accept the Declaration of Independence and withdrew from public life a bitter and complaining man.* [16]

Another document states that the Andover Iron Works converted iron and steel into armaments for the Continental army,[17] while still another says that George Washington selected his encampment at Jockey Hollow, Morristown, in part to provide security to the Andover complex.[18]

Finally, a fourth source, and the most reliable, states that on October 26, 1775, the Commissary of the Committee of Safety of Pennsylvania,[19] reported that it had received 175 cannonballs from William Allen, produced at the Union Iron Works. The report detailed the cannonballs received as 16 thirty-two pound, 18 twenty-nine pound, 29 nine pound, and 11 six pound.

From these stories one can almost visualize the hundreds of wagonloads of muskets, cannons, cannonballs and other military materials leaving the Union and Andover Iron Works, heading for the brave Continental army on the front lines, assuring success in the battle for independence and national existence.

There is another document with a different twist on this theme, which is pure fiction. It states that "two prominent Colonial iron makers operated the furnace in which they made farm implements and hardware. At the outbreak of the Revolution they switched to cannon balls. Being Tories, the balls went to the British. Patriots soon chased them out of the state to Canada and the forge was worked for America."[20]

OK, now let's look at the cold hard facts.

First of all, the Andover Furnace, at this time, was not capable of turning iron into steel, which was required for production of muskets and edged blades. That had to be done at special blast furnaces, most of which were located along both sides of the Delaware River.

Secondly, the furnace at Andover produced only pig iron, and there is no evidence that it cast any cannons or cannonballs.

Thirdly (and I realize that I am being rather picky here), William Allen was not in America at this time. In 1774, disgusted with the colonists' attitudes toward his beloved mother country, and prescient of future events, he relocated to England, leaving Joseph Turner and Benjamin Chew to manage the company assets. On April 12, 1774, at Whitehall, he published a letter titled *The American Crisis: A Letter Addressed…to the Earl Gower…on the Present Alarming Disturbances in the Colonies…*[21] A quick scan through this document reveals the depth of his distaste for the colonists. He clearly considers them ungrateful for all of the wonderful things that Britain had done for them, and he was of the opinion that without Britain's past benevolent and just administration, the colonies would have accomplished nothing. It's quite clear from this document that he would never have allowed cannon shot to be provided to the Continental army from his ironworks. It's more likely, then, that Chew, without Allen's knowledge, did this in 1775.

The papers of the Continental Congress show that in 1778 and 1779, after the colonists had taken over the works, the Andover Iron Works did produce a large amount of pig iron, which was then shipped to Easton, Pennsylvania, and stockpiled there.[22] Production at the Andover Iron Works was halted at the end of 1780, when the cash-strapped American government was unable to pay on the terms of its contract with Colonel Mayberry.

Then, in 1780 and again in 1782, various contracts were let by the Continental Congress with many different forges in the Easton area to convert

the large stockpiles of pig iron at Easton into bar iron. Additional contracts were then made to convert the resulting bar iron into steel at furnaces in Philadelphia, Trenton and Schuylkill Valley. Many of these later contracts also collapsed. In 1780, one of these contracts, with Potts & Downing of Trenton, resulted in the company's being delivered sixty-two tons of pig iron from the Andover Iron Works, but by 1785, it had only been able to produce three tons of finished steel.[23] By the war's end, there was still a large amount of unprocessed iron at Easton that never made it to the steel factories.

It's interesting that the papers of the Continental Congress referenced above state that the pig iron was shipped from the Andover Furnace to Easton and that later contracts were made with local forges there to convert it to bar iron when the forge at Waterloo was nearby. It might indicate that the Waterloo facility was not operating during the War for Independence.

Part of this conjecture can be supported by examining the 1782 Lease Agreement, in which both the Andover Furnace and the forge at Waterloo were being offered for lease. By this time, the ironworks was back in the hands of its owners, as hostilities had concluded with Cornwallis's surrender at Yorktown in October 1781. (Preliminary articles of peace would be signed in November 1782, ratified by Congress in April 1783 and formally signed by both England and America in September 1783. In November 1783, the last British troops departed New York City.)

Attached to that lease was a schedule of repairs that a potential leaseholder would be required to perform. The repair schedule for the forge at Waterloo included, in part:

- Hydropower system: Major repairs to the dam, which had suffered an eighty-foot breach; replacement of the gate and posts at the headrace intake; repairs to seventy feet of the headrace flume.
- Gristmill: A new waterwheel sixteen feet high, repairs to a stone wall that had collapsed and new posts and planks for the flume.
- Sawmill: A new roof, new posts and planks on the flume and collapsed foundation walls.
- Forge: All three flumes to be repaired, the four bellows wheels and two hammer wheels to be repaired, a new bridge over the tailrace, new poppel post (whatever that is), new anvil block and half of the lower drum beam and replacement of two of the damaged bellows.
- Roofs: Partial replacement of roofs over the sawmill, wheelwright shop, two of the three stone houses, kitchen, coal house, blacksmith shop, etc.

- Stone house that Colonel Potts occupied: The wall on one of the gable ends collapsed up to the second floor, and half the floor must be replaced.

It is quite clear from looking at this list that the village suffered tremendously from the effects of severe weather. The missing roofs, collapsed walls, ruined waterwheels and bellows and broken dam all point to a major calamity. Several years of neglect probably also had something to do with the severity of damage. We do not know the date or the nature of the disaster, but when it hit, the damage caused certainly prevented the Andover Forge from being able to process any significant amount of iron.

There is one other reference to be considered when assessing Waterloo's contribution to the war. A brochure put out by the Waterloo Foundation for the Arts states that "wounded soldiers were hospitalized here in the Village where the air was healthful."[24]

The foundation, which operated the village as a living history museum in the 1960s and '70s, was noted for making rather inflated claims regarding the village's past. I have seen no other reference that would confirm this statement but cannot dismiss this out of hand, as there are several colonial-era buildings in nearby Succasunna and Flanders that supposedly were used as temporary hospitals for soldiers who were suffering from various illnesses.

Overall, I think it could be said that Sussex County's support for the war was a mixed bag. The Sussex County Archives state that the "failure of Washington to hold the northern part of the states in the campaign of 1776 caused many Sussex people to lose all hope of ultimate victory. Deserting to the British forces occurred all too frequently."[25]

The archives go on to quote General Washington, writing to the governor of New Jersey with the following complaints: "From Sussex Colonel Symmes had arrived, but his following [number of troops] was inconsiderable" and "the Sussex Militia was characterized by General Dickerson as extremely unfriendly to the cause in general."

The archives also state that "on 15 October 1777 Governor Livingston, who a week before called upon Burlington, Sussex, Monmouth and Middlesex counties to furnish 2,000 militia, informed Washington that he had received no answer from Sussex to his appeal."

In the end, much to the disappointment of Waterloo fans, it appears that Waterloo itself did not play a major role in the War for Independence.

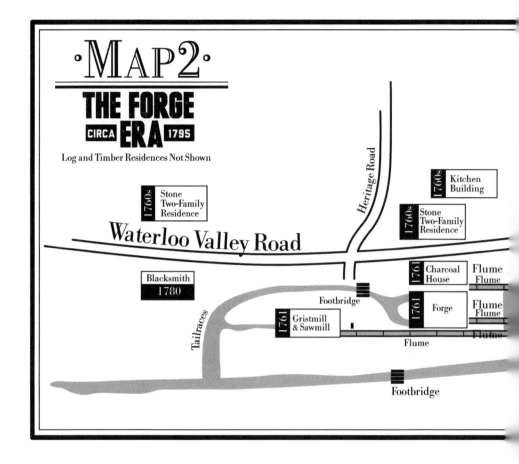

BUILDINGS OF THE FORGE ERA

To recap, the buildings and facilities that were constructed in the village during the forge era are listed below and are shown on Map 2, which should reveal where they were all located:

- ironworking forge
- hydropower system (including dam, forge pond, headrace, flumes and tailrace)
- charcoal house
- gristmill
- sawmill
- three stone residences (and possibly more)
- blacksmith's shop (thought to have been built around 1780)

Stone Two-Family Residence
1760s

Headrace

Dam

- various log or timber-framed buildings (no longer present and not shown on the map)

For a detailed history of each of these structures, refer to Chapter 8.

The First Period of Decline

The Post-Forge Era

Following the successful fight for independence, Benjamin Chew undertook the management of the company's assets, as both Allen and Turner had since died, Allen in 1780 and Turner in 1783.[26] Future prospects for the Andover Iron Works were not good: the company shareholders' previous stance against independence for the colonies would certainly have a negative impact on future operations, the poor economic conditions in the new nation were a major factor in the dismal outlook and, finally, the death of the company's original founders was probably strike three. Chew's and the deceased shareholders' heirs' preference would have been to sell the ironworks, but there was no one willing, at this time, to invest money in such a large complex situated at two separate locations that included a mine, furnace, forge, two large farm tracts and many supporting buildings.

Breaking up the various pieces of the ironworks to make them more saleable was not possible due to confusion about which shareholder (or shareholder heir) owned how much of what part. Prior to 1760, John Hackett, as an agent of the company, had purchased land for the company using the company's funds. At the same time, he purchased some land for himself with

his own money. However, most of the lands he purchased were put under his own name, including the lands purchased with company money.[27]

As dodgy as this may sound, this was not an attempt by Hackett to embezzle; it was done with the knowledge and approval of the company, which had a contentious history with local small landowners. In 1749, John Hackett had informed Joseph Turner that he had arrested squatters on company land at the Union Iron Works. An armed mob had attempted to set their neighbors free, and failing that they "pulled down and destroyed the Furnace and the Develling House."[28] The company had also had prior difficulties when it tried to assert its right to collect quitrents from people who had settled on land previously owned by the Crown.[29] Having Hackett purchase lands in his name was intended to disguise the fact that the company was the true buyer.

In December 1774, the company, possibly sensing future difficulties, attempted to clarify the ownership issues when it published a notice in the *Pennsylvania Journal* that it intended to petition the New Jersey General Assembly for an act to vest in it the legal title for lands purchased by Hackett. Apparently this came to naught, as in 1775 the company petitioned Governor Franklin, seeking clarification of ownership.[30]

Complicating things, during the immediate prewar period, Allen and Turner had transferred various pieces of their personal holdings to relatives in an effort to prevent confiscation. As an example, lots that William Allen owned in the center of Philadelphia were deeded to Edward Shippen Jr. and Tench Cox, but with a life's interest vested in himself.[31] This dilution, added to the issues with Hackett's heirs, who would certainly claim ownership of any land purchased in their predecessor's name, caused much confusion as to who had legal right to the properties, and this confusion about ownership prevented the sale of many (but not all) of the company's assets.

Temporarily, the only solution was to lease the properties out, either as a whole or in parts. From 1795 onward, the Andover Furnace was closed and abandoned, as no one was willing to lease such a large facility. (The furnace would not reopen again until 1847, then under new owners Cooper & Hewitt.[32]) The company's property at Waterloo, including the forge, mills, blacksmith shop, residences and surrounding lands, was offered for lease on three separate occasions between 1782 and 1795. The fact that three successive leases were made to three different operators would seem to indicate that the forge and mill operations were probably not providing an adequate return to the leaseholder.

Forge and mill operators, under a lease arrangement, would, of course, be reluctant to make any long-term capital improvements and would only undertake repairs necessary to operate the facilities for the term of their

lease. Each new lease agreement would therefore specify what repairs were required to be made by the new leaseholder, thus giving us a good description of what facilities were present and what condition they were in.

The Waterloo forge, along with the gristmill, sawmill and blacksmith shop, had provided the main (if not the only) economic support for the village from its founding in 1761. The forge closed in 1795, never again to process iron, leaving only the mills to support the village. Revealingly, the blacksmith shop was the only new permanent construction that occurred during the seventy-year period from 1761 to 1831. That construction, around 1780, was probably a direct result of local needs during the War for Independence, as opposed to a favorable business outlook.

If you compare Waterloo's architectural footprint in the mid- to late 1820s to one from the mid-1760s, it would be a sad comparison. The forge, the lifeblood of the village, was gone, its stone and bricks scavenged by the local populace.[33] The charcoal house, no longer needed, was falling down and probably without a roof. One of the original stone two-family houses was now a barn. Though the grist- and sawmills were probably still operating sporadically, they were likely in their original timber-framed buildings and probably had not been upgraded. Snell's history states that "shortly after the close of the war...the area we call Waterloo became a wasteland."[34]

But that is not to say that nothing was happening. Because of the prior deforestation in the area, commercial farming now became a viable option. In 1790, the Smith family leased large tracts of land in the area for that purpose. Although this would seem to be a rebirth of the village, that would not be accurate. Agriculture would keep the gristmill working but would not create spin-off employment such as colliers, woodcutters, teamsters, forge workers and sawmill workers. Agriculture would support the Smith family and a few farm laborers and millworkers but would not generate sufficient payrolls to keep Waterloo, small as it was, as a viable and active village.

I previously indicated that the period of decline started around 1790, when agriculture began to replace ironworking. In actuality, the decline only became visible around 1790 but was present as early as 1770. The downward spiral started when the main shareholders of Allen & Turner decided to try to lease out the property instead of operating it themselves. The decline accelerated as the movement for independence grew, resulting in the shareholders' political leanings negatively impacting their operations. The death of the company's shareholders made the decline irreversible. The post-independence economic crash, resulting from a new country struggling to establish itself, along with falling iron prices, put the nail in the Waterloo coffin.

3

The Smiths Arrive at Waterloo

The first period of economic growth and decline, the forge era, has been dealt with. The next economic period to cover is the canal era. But before we get to that, I have to interject some background information about the family who would drive the fortunes of Waterloo for the next eighty years. Although the events described in this chapter occurred during the first two decades of the 1800s, while the village was in decline, these events would fortuitously set the stage for the next period of economic growth starting in 1830.

Three main sources provide information surrounding the Smith family's arrival at Waterloo, and their subsequent activities during this period. The most descriptive of the three is James Snell's 1881 *History of Sussex and Warren Counties*. I disagree with much that Snell has printed, and the differences that can be dealt with quickly are included below. Those issues that require a more lengthy discussion are addressed in Appendix C, which provides a detailed interrogation of Snell's account. The other two sources are two family genealogies that were compiled in more recent times.

EZEKIEL SMITH AND FAMILY

According to Snell, around 1790, Mr. John Smith, who had been the boss collier at the Andover Iron Works, leased land in the Waterloo area and

farmed it, assisted by his younger brothers Samuel, Nathan and Daniel. Snell also states that the brothers occupied the best of the original stone houses at Waterloo during the next ten years.[35] This account is repeated in many later published documents, often verbatim, but without reference to Snell's work.

Right off the bat, I disagree with this account. My assumption is that it was John's father, Ezekiel, who leased the land around 1790, as at that time, John Smith was only fifteen years old, and it is unlikely that, at that age, he would have been the leaseholder. I am also of the opinion that John was never the boss collier at the Andover Iron Works. I continue the story under these assumptions.

Not much is known about John's father, Ezekiel. He apparently was born in England and immigrated to New York around 1770, marrying Johanna shortly afterward.[36] Later, when Ezekiel moved from New York State to the Waterloo area in Sussex County, New Jersey, he took out a fifteen-year lease on land suitable for farming. His three oldest boys—John (fifteen), Nathan (thirteen) and Samuel (eleven)—would have certainly helped out on the farm from the very beginning. The younger boys Daniel (five) and George (one) were too young, at least during the early years of the lease, to have worked this farm. It is possible that Ezekiel died during this period, as there is no further mention of him. I have seen no information regarding the date or location of his death. If Ezekiel did die during this period, the lease could have been transferred to John, the oldest son, which could have led to the impression that John was the original leaseholder. This is all conjecture, as I have not seen that original lease.

As the boys reached their maturity, John was the only one who appears to have had a lasting relationship with Waterloo. The other brothers moved on, pursuing their own careers elsewhere, though still in the northern New Jersey area.

JOHN SMITH

Most accounts state that the Smiths moved away from Waterloo in 1800, ten years into a fifteen-year lease, turning the lease over to Isiah Wallin.[37] I disagree with this date, as an 1802 deed transfer, when John purchased a piece of land near Waterloo, still lists his residence at that time as Byram Township. This deed details a purchase of 50.27 acres from Martin Ryerson and was situated along both sides of Dragon's Brook, near the falls.[38] (The

falls on Dragon's Brook are a short ten-minute walk from the parking area at the intersection of Waterloo Road and Continental Drive.)

This was not John's first land purchase, as one of the beginning points of this survey references "a heap of stones in John Smith's field." For whatever reason, sometime after 1802, John Smith moved away from Byram Township. Some accounts say that he moved to Schooley's Mountain, others say Smithtown and others say Roxbury Township in Morris County.[39] So which is it? My conclusion is that sometime after April 1802, he moved to Roxbury Township in Morris County (see Appendix C). Though no longer living in the immediate Waterloo area, John continued to invest in land suitable for farming all around the area but not in the old Village of Waterloo itself.

This shift at Waterloo from ironworking to agriculture in 1790 would sustain and support the Smith family for the next forty years, but their total disinterest in the village, as evidenced by their relocation away from their leaseholds in 1802, resulted, by some accounts, in Waterloo's being abandoned. The village essentially became a ghost town (for the first, but not the last, time).

LAND PURCHASES

Now I am going to get down into the weeds a bit. The story of Waterloo is not complete without first understanding how ownership of the land came about, and that, unfortunately, is a twisted trail.

In 1795, Benjamin Chew, administering the estate of Joseph Turner and managing the assets of the company, had advertised for sale the large parcel of land around and including Waterloo. This effort was unsuccessful for the reasons I have previously noted. In 1808, after an appeal by the Chew family to the general assembly, an act was finally passed authorizing the appointment of commissioners to settle the ownership issues between the shareholders.[40] The resolution of these issues then allowed the Andover Furnace and Forge Tracts to be divided. Parcels began to be sold, and over the nineteenth century, these parcels were sold multiple times. Each successive sale, for the most part, resulted in breaking up large parcels into smaller ones. However, even before the commissioners had solved the land distribution problem, parcels of land around Waterloo that were not in dispute were being bought and sold, and many of these transactions have the appearance of land speculation.

Lemuel De Camp

One of the most active purchasers of land during the early 1800s was Lemuel De Camp. Between 1804 and 1816, he purchased at least eighteen tracts of land totaling over 900 acres. These tracts included most, if not all, of the land at New Andover and Waterloo, as well as large tracts around Dragon's Brook. Lemuel operated a Bloomery forge on the Musconetcong River, just below its confluence with the stream called Lubber's Run. It appears that the forge was already in existence before Lemuel bought the property because the 1804 deed transfer, which appears to include the forge site, has a reference to an existing "forge pond."[41] Lemuel bought this 3.86-acre tract from Henry Luce, so Luce may have originally built the forge. Or it could have been built by an even earlier owner.

Lemuel had a financial setback in 1817 when four judgments were entered against him for nonperformance.[42] I am uncertain if these judgments had anything to do with his forge operations. As a result of the judgments, Sheriff Daniel Swayze seized almost all of Lemuel De Camp's land holdings. Coincidentally or not, Lemuel De Camp passed away on September 26, 1817, at age forty-eight, shortly after the judgments were entered against him.[43] Perhaps ill health had caused the nonperformance mentioned in the judgments, or perhaps his death was a result of his legal difficulties. I have been unable to locate a death certificate or any other record that would provide his cause of death.

No bidders appeared at the first sheriff's auction, but at the second auction, on November 26, 1817, Elias Haines and Joseph Miller purchased seventeen of the seized parcels for $1,143.10. Haines and Miller then sold off a few small pieces of the land on various dates, and on May 1, 1820, they sold a half interest in the twelve remaining tracts of De Camp lands to Mr. George Thomas for $2,500.00.[44]

Hannah De Camp

In August 1820,[45] Hannah, Lemuel's widow, purchased a half interest in a 16.65-acre tract from Miller. This purchase is curious, as the price paid for her half interest was one dollar. The 16.65-acre plot was in the heart of Waterloo Village and included at least one of the original forge-era stone residences, which the deed refers to as "the Andover Forge Mansion House." Per the description in the deed, this appears to be what would later

For Your Information

Buying a partial interest in an undivided tract of land was quite common in those days, especially if it was in anticipation of a later sale at an increased price (land speculation). It would be difficult for a partial owner to farm the land or to operate a business such as a forge or mill. Any attempt to do this would require some type of agreement with the co-owners, either charging rent to the business or dividing the profits of the business. Either way, one or other of the parties would inevitably become unhappy, leading to hurt feelings and maybe even a court appearance.

become the Waterloo Hotel. This deed also reserves Miller's right of ingress and egress to the property for maintenance of the Andover Forge tailrace. Even though it specifically says the "Forge" tailrace, I believe the race was for the mills, as it appears that the forge was not operating at this time.

Surprisingly, on February 8, 1821, Hannah was able to buy the other half interest in the twelve parcels of her late husband's land from Haines & Miller.[46] At the conclusion of these transactions, George Thomas and Hannah De Camp each held a half interest in land that both Waterloo and New Andover were situated on, as well as large tracts of farmland north and east of the two villages.

John Smith

Sometime in the early 1800s, perhaps even earlier, John Smith began purchasing parcels of land around the Waterloo area, much of it the same land that his father had leased for farming. He made two purchases in March 1802, a two-hundred-acre farm and a plot of slightly over fifty acres along both sides of Dragon's Brook, northeast of Waterloo.[47] At the time of these purchases, John was still living in the Waterloo area.

In May 1807, he bought a 115.5-acre tract located around what is now the Jefferson Lakes area, in the upper reaches of the Lubber's Run drainage area, and to the east of his previous purchases.[48] At the time of this 1807 purchase, John was listed on the deed as living in Morris County, so even though he had moved away from the immediate Waterloo area sometime after March 1802, he was still buying land there. Unlike other landowners of

44

For Your Information

The Lawrence Line is a boundary line that was intended to define the partition line between two proprietary colonies originally set out in the 1676 Quintipartite Deed.[50] The partition line was used as a reference point in many early deeds, but disagreements about where the line actually passed caused many disagreements between the early landowners. In 1743, John Lawrence was tasked to survey and mark this line, thus defining land boundaries that would hold up in the courts. The line's description in the original deed was "a straight line from the northernmost branch of the Delaware River which is in 41.4 degrees latitude, to the most southerly point of the east side of Little Egg Harbor." Though several other surveys were conducted before and after that of John Lawrence, the New Jersey Supreme Court in 1855 declared his to be the correct one. There are several claims that a metal stake, one of Lawrence's markers, was unearthed near the gristmill and that the Lawrence line actually passed directly through the Waterloo Hotel. It's hard to tell if those claims were accurate or if it was just an attempt by the 1980s owner of the village, when it was a living history museum, to burnish the village's legacy.

the time, John was apparently not speculating in land but was buying the land to farm.

In November 1812, he made a major purchase of 282 acres, known as the Forge Farm.[49] This tract was located in both Morris and Sussex Counties, spanning both sides of the Musconetcong River between the two mountain ridges, west of the Lawrence line. This land had been part of a larger tract called the Andover Forge Tract.

In August 1821, John made his next major purchase, buying George Thomas's half interest in the twelve tracts of De Camp's seized land.[51] After this transaction, John and Hannah now each had a half interest in almost all of the land around New Andover and Waterloo.

As I previously mentioned, owning a half interest in a plot usually only provides a benefit when that plot is later sold and the profits are divided among the sellers. This scenario probably did not appeal to John Smith, as he seemed more interested in putting his land to productive use. That is probably why, in April 1823, John and Hannah took part of their shared land, totaling 172

acres, and split it, each then becoming the sole owner of eighty-six acres.[52] No money changed hands, though both deeds show a one-dollar purchase price to make it a legal transaction.

From the survey descriptions of this split, it appears that John's eighty-six-acre tract included the forge at New Andover, which is probably what he was after. As you will recall, the forge at Waterloo was largely dismantled after it closed in 1795, when ownership of the land was in dispute. The forge at New Andover, however, was probably largely intact. I am quite certain that those land speculators who originally purchased this land at the sheriff's auction would not have allowed the forge at New Andover to fall into disrepair, even if it was not operating.

In the split of jointly owned land mentioned above, Hannah received two plots, the larger one, 85.44 acres, being adjacent to John's, while the smaller plot of 0.56 acres included "an old dwelling house known as the Boarding House" and must have been quite close to the forge. After completing his 1823 acquisitions, John seems to have been content with his holdings, as I did not locate any deed transfers in his name for the next four years.

JOHN SMITH RETURNS TO THE WATERLOO AREA

With this 1823 division of jointly owned property and the existence of a working forge at New Andover on property that John Smith now wholly owned, the stage was set for Smith to return to the Waterloo area. Sometime during or after December 1823, John, along with his three youngest sons, relocated from Smithtown to the New Andover site. Snell's account says that John actually moved to New Andover in 1820, but that is incorrect.[53] Deeds that describe land purchases made by John as late as May 1822 show him still living at Roxbury in Morris County, and he was still on the rolls of the Morris militia until December 1823.

Up to 1823, though land at New Andover had been split, most of the land that included Waterloo was still held jointly by John Smith and Hannah De Camp. As long as this land at Waterloo was jointly held, it is unlikely that John Smith did much to develop it, and he seemed to show little interest in the village itself.

One last thought here regarding John's move to New Andover. Snell says, along with many others, that John Smith moved to New Andover and operated the forge there. If, from this description, you have a vision of a grubby, sweaty, charcoal-stained John Smith pounding away on hot iron

For Your Information

Many documents of this and later periods refer to a "General John Smith" as the owner of large tracts of land in and around Waterloo Village. This is the same John Smith that we have been discussing. In 1809, while living in Morris County, he became an active member of the Upper and Western Regiment of the Morris Militia.[54] He was a member of this organization throughout the War of 1812. A photocopy on file at the Sussex Library that appears to have been made from a book states that "during the War [of 1812] he was a recruiting officer and thus gained the name 'General' by which he was called." The book that it was copied from was not indicated, so I cannot identify it further. This description seems to grossly understate his position in the Morris militia. He may have been a recruiter at one time or another, but he also held a senior command assignment during the War of 1812. The phrasing of "gained the name 'General' by which he was called" would also seem to imply that it was an informal level of rank, something akin to Colonel Sanders, our favorite Kentucky colonel. In actuality, he was serving as a lieutenant colonel commanding an infantry regiment during the War of 1812. By 1818, he had achieved the rank of brigadier general. He resigned on December 9, 1823, which is about the time that he moved from Morris County to New Andover (in Sussex County).

with his hammer, forget it. At this time, John was forty-eight and owned large amounts of land. The forge may have been in operation, but it would have been his employees, not John Smith, doing all of the dirty work.

THE SMITH FAMILY AT WATERLOO

An Abbreviated Family Tree

The following abbreviated family tree shows the main Smith family members who were most active in and would have the most impact on Waterloo Village.

Ezekiel Smith (b. and d. unknown)
 John Smith (b. 1775; d. 1859)

John's youngest three sons:
 William O. Smith (b. 1805; d. 1877), moved his family to Illinois after 1850
 Nathan Smith (b. 1806; d. 1852), no children
 Peter Smith (b. 1808; d. 1877)

Peter's four sons:
 Samuel T. Smith (b. 1833; d. 1898)
 Peter Decker Smith (b. 1845; d. 1918)
 Seymour Royal Smith (b. 1847; d. 1932)
 Nathan Augustus Smith (b. 1850; d. 1936)

Absent from this brief family tree are John's brothers, Nathan, Samuel, Daniel and George, who settled in the area but had no active role in Waterloo's development; children who did not survive to adulthood or who did not have any leadership roles in Waterloo Village; John's four oldest children, James, Samuel C., Joseph and Anna, who remained in Smithtown when John relocated to New Andover with his three youngest sons; Peter's daughters Matilda and Caroline, who lived in the village but did not operate any of the village businesses; and wives of those shown on the family tree. (Leaving off the wives is not intended to diminish their roles. The reality of those days was that cooking, cleaning, running the household and caring for children were arduous tasks requiring the full attention of the women of the household. We know that wives and adult daughters often had a significant impact on decision making, but those influences are generally not recorded.)

The Smith family members, especially Peter's sons, were active community leaders holding many important elected positions, in both politics and business. Space limitations in this document prevent me from including many of those accomplishments here. For detailed information about the entire Smith family, I refer you to *The Genealogy of the Smith Family of Waterloo, New Jersey* by D. Alden Smith and Robert H. Smith.

I leave this chapter (sometime after December 1823) with John Smith having sole ownership of New Andover, where he also lived and operated a forge. Smith also held sole ownership of large amounts of farmland all around the area. Most of the land where Waterloo Village itself was located was jointly held by John and Hannah De Camp.

4

The Morris Canal

In the mid- to late eighteenth century, the northern New Jersey road network was young, inefficient and poorly maintained. Wagon travel about the hilly countryside was slow and heavily dependent on weather conditions. By the 1820s, the road network had been enlarged and improved somewhat, especially with the opening of the Union Turnpike in 1801, but transportation of goods, especially bulk goods, was still slow and expensive.

A Morristown businessman, George P. McCulloch, supposedly while on a fishing trip in the early 1820s, had the thought that a canal across the Jersey highlands connecting the Delaware River to the Passaic River could be the answer. The Passaic flows into Newark Bay, which then connects to the Hudson River, giving access to New York City, the East Coast port cities and transatlantic trade.

Canals had been in use for hundreds of years in Asia and Europe. The Erie Canal in New York State was already in an advanced stage of construction (it would open in 1825) and would span 350 miles, carrying boat traffic between the Great Lakes and the upper Hudson River. The Champlain Canal, linking Lake Champlain with the Hudson River, was also nearing completion. When these canals were opened, they would have the potential of shifting all meaningful commerce away from northern New Jersey, turning the entire North Jersey area into an "abandoned wasteland," just as Waterloo had become.

The distance that the Erie Canal would traverse was much greater than the distance across New Jersey, which was barely sixty miles, the same length

as the Champlain Canal. So why not build a canal across New Jersey? Even without considering the looming competition, the increased efficiency alone would make the project a no-brainer.

At that time, bulk cargo, especially iron ore, was transported either by pack animals, carrying up to 250 pounds each, or by Conestoga wagons, carrying six tons of cargo, pulled by up to six specially bred heavy draft horses, which at best could manage fourteen miles in a day. Compare that carrying capacity to a canal boat, which could carry eighteen tons of cargo pulled by one or two mules and could travel up to twenty miles a day. (Later, after the original canal was widened and larger canal boats were used, cargo tonnage increased to seventy tons but could still be pulled by the same two mules.)

The efficiency of canal transportation could tremendously decrease the cost of shipping, increase the volume of goods being shipped and spark an economic boom throughout the New Jersey northern highlands, connecting the coal fields, steel mills and agriculture of east and central Pennsylvania with the East Coast population centers and also provide easier access to the transatlantic markets. Commercial mining of anthracite coal in eastern Pennsylvania had begun barely ten years prior, and this would be a perfect cargo for the canal. It could fuel the charcoal-starved furnaces and forges of New Jersey. And it was in great demand for heating the homes and businesses in the large East Coast cities.

The canal would also carry finished products westward to the new homes and villages that would soon grow on the banks of the canal and provide quicker access to the developing western states of Pennsylvania and Ohio. It would even transport the expensive imported fineries that the newly rich demanded.

A company called the Morris Canal and Banking Company was formed, funds raised, surveys completed, contracts issued and construction started. (Appendix D provides more information about the Morris Canal and Banking Company.)

Individual construction contracts were made for various sections of canal; there were seventy-five sections on the western branch and ninety on the eastern branch.[55] There were also contracts for the dams, locks and planes. This way, work on all sections of the canal could be going on at the same time. Individual contractors could bid on and be awarded contracts for multiple sections if it was felt that they had the capacity to handle that volume of work. Detailed engineering plans were provided for the contractors to follow, and canal engineers made frequent inspection of the work. As various sections of the canal were completed, they were opened for local use. The first season

when the canal was open for the entire stretch between Phillipsburg and Newark was in 1832.

The full length of the original canal totaled 102 miles. This was 40 miles longer than the width of the state, as terrain prevented a straight-line route. The crossing from one side to the other would take five days. However, not all boats traveled the total 102 miles, as some boat captains might be contracted to transport goods only part of the way.

It was originally calculated that the outflow of water from Lake Hopatcong would be sufficient to water the entire Morris Canal. The 1826 Annual Report to the company board optimistically reported that Lake Hopatcong had an annual discharge of 55.0 million cubic yards of water while the annual consumption of the canal was estimated at 13.5 million cubic yards, so there was thought to be plenty of water.[56] But that calculation was done while the canal was being built. Once in operation, it soon became evident that these calculations were unreliable, and the watershed was soon increased to include Greenwood and Cranberry Lake Reservoir. Smaller rivers or streams, such as Lubber's Run and Dragon's Brook, were also captured.

WHY IT CAME THROUGH WATERLOO

As the plan for the construction of the canal advanced, the survey confirmed that the highest point along the planned route with a significant supply of water was at Lake Hopatcong. It was determined that this would be the summit of the canal.

From Lake Hopatcong, the canal would descend in both directions, eastward to Newark and westward to Phillipsburg on the Delaware. When we talk about the canal descending eastward or westward, we are referring to the change from the higher to the lower elevations. However, the boat traffic was two-way traffic along the entire length of the canal. While this book may describe the canal as going west, understand that boats are moving in both directions along the canal's entire length.

Lake Hopatcong, in addition to being the headwaters of the canal, was also the headwaters of the Musconetcong River. The river flowing out of the lake generally heads westward until it enters the valley at Waterloo. Shortly after leaving the village, it turns to the southwest, eventually flowing into the Delaware River. Similarly, the route planned for the western branch of the canal was westerly from Lake Hopatcong, generally paralleling but south of

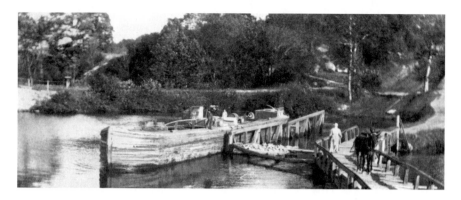

Canal boat leaving cradle in a "slackwater" lock pond. Note the wooden bumpers that protect the mule bridge and also help guide the boat into the lock. *Courtesy of the Canal Society of New Jersey.*

the river (as dictated by the terrain). Beyond Waterloo, however, the route of the canal would have to continue more westerly than the river, so the canal engineers knew that, at some point, the canal would have to cross that river. They determined that the best place for this crossing was the narrow valley at Waterloo.

How a Canal Worked (A Very Basic Discussion)

Water

Most important to understand is that canals have to be dead level even though they may be built on land that is not. Having a thirty-foot-wide, five-foot-deep sloping canal with water flowing downhill, even gradually, would require a huge and constant resupply of water. Even if an abundant supply of water were available, having mules pull the heavy boats upstream, against the current, would not work. Conversely, boats going downstream would not be able to steer, as a boat or ship of any size or type must have water resisting its rudder in order to steer, and mules, not the fleetest of foot, would surely never outrace the current going downstream. Any unpowered or underpowered vessel floating with the current is, by definition, out of control.

Mules were generally used for several reasons. They were less skittish than horses, which was important because a frightened horse jumping into the

canal, or jumping off the side of an elevated towpath, could be troublesome. And with so much water around, there were lots of snakes to scare the horses. Another reason was that mules were cheaper to buy (canal boat captains rented the boat but owned the mules). Mules were also more durable and less expensive to maintain. Once a team of mules was trained, it pretty much operated on automatic pilot.

So yes, a canal has to be dead level at all times. Even on the level stretches of canal, water would be lost for various reasons. Operating a lock had a significant impact on water usage, as did evaporation, soaking, seepage and occasional breaches in the walls of the canal (often due to muskrats tunneling into the bank of the canal, for which reason muskrat hunting was encouraged). Canal creators very jealously guarded their water supply and were always looking for sources of replenishment. Canal surveyors constantly sought out streams of any size near the proposed route, and the engineers routed the canal to either intersect that source of water or else divert some (or all) of that nearby stream to the canal.

Elevation Changes

Minor elevation changes could be overcome by filling small depressions or cutting through low hills. More severe elevation changes had to be overcome by building either locks or inclined planes that were used to connect two stretches of canal that were on different levels.

LOCKS: These were nothing more than stone-lined, water-filled channels large enough to hold a boat with gates at both ends. If a boat were locked from a higher stretch of canal to the lower, the downstream miter gates would be closed, allowing the lock to fill with water. The boat would enter the lock from the upper canal, and then the upstream drop gate would be closed. Water would gradually be let out of the lock until the water level was even with the lower canal. The downstream gate would be opened, allowing the boat to float into the lower stretch of canal. A boat waiting to go upstream would follow the same procedure in reverse. Locks did not require any mechanical apparatus and were quite simple to operate. However, a lock did use a significant amount of precious water. Each time a boat was "locked through," regardless whether the boat was going up or down, water had to be drawn into the canal from some source to replace the amount of water that was being used in the lock.

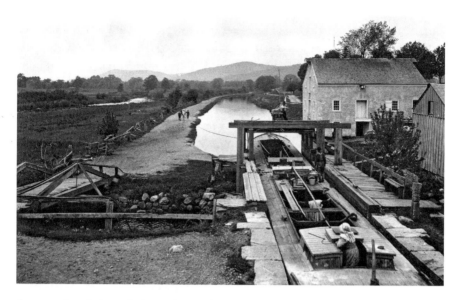

An empty boat being pulled out of the lock as the boat captain's wife stands in the doorway of their home. *Courtesy of the Canal Society of New Jersey.*

The amount of water consumed to lock a boat through varied, depending on such things as whether the boat was being "locked down" or "locked up," the level of water in the two stretches of canal and how much cargo the boat was carrying—a heavily loaded boat required less water. (Yes, that seems to be counterintuitive, but it has to do with the amount of water that the boat displaces.)

INCLINED PLANES: An inclined plane is simply a railroad that carries canal boats, in wheeled cradles, from one level of canal to another over a set of rails. The power to operate the planes was provided by waterwheels, using water from the upper level of canal, fed through a flume, to turn the waterwheel, which then turned a winding gear whose chains were attached to the boat cradles. These cradles were lowered into the canal, and the boats were floated in and attached to the cradle. The cradle and boat were then pulled up out of the canal and then lowered (or raised) to the next stretch of canal where the boat would float free. Mules were not attached to the boats during this procedure. The power generated from this system had its limitations, so initially, the inclined planes were double. If a boat were heavily loaded, it would be matched

with a similarly loaded boat going the other direction: one boat going down the plane while another was coming up at the same time, with the weight of the boats acting as counterweights. Inclined planes used very little water, other than that used to power the waterwheel. (After the Morris Canal was enlarged in the 1850s, the waterwheels were replaced by more powerful reaction turbines, though these were still powered by water drawn from the upper canal. The winding chain was replaced by stronger wire cable.)

COMPARISON BETWEEN PLANES AND LOCKS: The construction of a lock was fairly simple, and no complex machinery was required for its operation; however, it did use a lot of water. A single lock could only handle an elevation change of up to around ten feet. If the required elevation change exceeded that amount, then a series of locks could be used. A single plane was much more expensive to build than a single lock and required a significant amount of equipment, including flumes, waterwheels (later turbines), wire rope, rails, carriages, etc. On the

The mule bridge and an empty cradle. The bottom of the inclined plane is to the right. *Courtesy of the Canal Society of New Jersey.*

For Your Information

The web page Catskill Archive (catskillarchives.com) contains a formula that can be used to estimate the amount of water used in lock operations. It says that to "lock through" a fully loaded boat, the lock used 23 times as much water as an inclined plane moving it the same elevation change. For an empty boat, the lock required 836 times as much water as a plane. The huge differences between these two figures seems implausible to me. I have double-checked the website and have quoted it correctly; however, I cannot vouch for the correctness of its calculation.

other hand, a single plane could handle an elevation change of one hundred feet or more.

The 1826 Annual Report for the Morris Canal stated that the cost to install a fifty-foot plane would be $6,300 and could lift a boat up that height in twelve minutes.[57] A series of five locks raising a boat the same height would cost $22,500, and the passage would take forty-five minutes. And this did not include the cost of the water lost through the locks. Considering all factors, including cost of construction, equipment, additional plane tenders and water replacement concerns, it was determined that only small elevation changes would use locks: whenever an elevation change was ten feet or less, a lock was installed; where it exceeded ten feet, a plane was installed.

CONSTRUCTION AND CONFIGURATION OF THE MORRIS CANAL AT WATERLOO

As the canal approached the Musconetcong River Valley at Waterloo, it was turned sharply north to make a perpendicular crossing of the river. From the ridge on the south side of the valley, the canal boats would have to drop about ninety feet to the river below, cross it, turn left and then continue on their westward journey toward the Delaware River. (Refer to Map 3.)

The decline into the valley would be by way of an inclined plane. However, the natural slope of the hillside leading down into the valley below was steeper than what the engineers desired (an 11 percent grade was close to the limit), so the first thing that had to be done was to dig a cut through the top section of the hillside to reduce the plane's angle of descent.

To cross the river, the boats needed calm, deep water, and the river itself was too shallow and the current too strong to accommodate this. The needed "slackwater" was provided by damming the river just downstream of where the inclined plane would enter it. The dam created a pond of relatively calm water, but its level was now ten feet higher than the level of the new stretch of canal being dug. The solution to this problem was to install a lock at the western edge of the pond to allow the boats to be locked down the final ten feet to the new stretch of canal (or, if in the lower stretch of the canal heading east, to be locked up to the level of the lock pond). (For those wanting more information about the Morris Canal, where it went and how it worked, there are many very good books available in bookstores, the Internet or libraries. Or you could become a member of the Canal Society of New Jersey.)

While the construction of the forge-era dam in 1760 had a minor impact on the valley floor, the construction of the Morris Canal between 1827 and 1830 had a major impact. The new canal dam, just downstream of the village center, flooded a wide portion of what formerly had been dry land, possibly where old building sites had been located. The water rising behind the new dam interfered with the hydro system supplying water to the mills and also made the tailraces ineffective. In an agreement between John Smith and the canal company, dated November 22, 1830, the canal company would "by January 1st 1833, erect a culvert or aqueduct and raceway under the Canal at Old Andover on the Northwest side of the River…sufficient to drain the water as low as the bottom of the old tail races of the old forge and gristmill."[58]

The canal company would also maintain the culvert or aqueduct and raceway at all times. Since the old forge is mentioned then, in November 1830, it must not yet have been built over, and the ruins would still be visible. The canal engineers designed a combined stone-lined lock joined on the downstream end to a timber aqueduct, and together they functioned as a single lock. The mill tailrace was reconfigured so that it flowed beneath the aqueduct. Waterloo is the only site on the entire canal that had both an inclined plane and a lock, and the only site that had a lock and aqueduct together. That's some engineering!

How the Canal Benefits the Surrounding Region

Just because the canal happened to pass by your farm did not mean that you would become rich. Sure, you could have your youngest child stand on

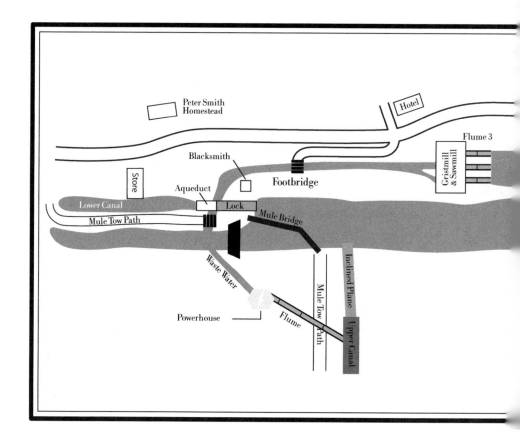

the bank of the canal and offer to sell fruits and vegetables to the passing boat captains, but that is not where the real economic benefit of a canal was felt. It was felt when small hamlets began appearing along the canal and eventually grew into villages containing a wide array of businesses that the boatmen needed. OK, so you have a canal passing through your farm—how do you start up a little hamlet? Well, geographic luck is a prerequisite. This book is about Waterloo, not canals, but at this point, I need to address some additional basics of canal design.

The time it took for a boat to traverse an inclined plane was about ten to twelve minutes, measured from the time the loaded cradle was pulled from the water. To pass through a lock required about twenty minutes. Consequently, wherever a lock or inclined plane was located along the canal, there would certainly be boats lined up waiting to pass through them. Let's call them transit points from now on, referring to both locks and planes.

Samuel T. Smith House

·MAP 3·

CONSTRUCTION
OF THE
MORRIS CANAL
Through Waterloo Village

To accommodate the waiting boats, the canal was widened above and below the transit points, providing room for waiting boats to tie up out of the way and also giving room for boats to maneuver when entering the transit points. These widened areas were referred to as canal basins or lock ponds. Sometimes, the wait could be considerable. Additionally, the canal only operated during daylight hours and was closed on Sundays, so these basins, located at every transit point, became a convenient place for the boat captain and his/her family to spend the night or the weekend. (Yes, there were some well-known female boat captains on the Morris Canal.)

Since the boats would be spending some time at these transit points, a forward-thinking businessman (or nearby farmer) might consider opening a small store there so the boat captain could refill his larder with fresh fruits, eggs and produce, which the store owner obtained from the local farms. And why not also build a stable and charge the captain for stabling his mules overnight and sell grain for their feed? And if a blacksmith shop were opened there, the boat captain could have his mules reshod if needed or have repairs made to his boat. And if a tavern were opened, drinks could be served to the boat captain, the stable hand, the blacksmith, the storekeeper and anyone else who happened by. And maybe the tavern would eventually become a small inn as well. And since all these business required housing for their staff, perhaps some homes would be built nearby. And now maybe that small store was enlarged and began buying grain from nearby mills and shipping it on the canal to the big cities. And before you knew it, a town had appeared on the banks of the canal.

WHAT MADE WATERLOO UNIQUE AMONG CANAL TOWNS?

Many new canal towns sprang up along the canal, but few, especially on the western branch, did so as quickly and robustly as Waterloo. Waterloo was blessed in many ways:

- It had both a lock and a plane, which meant many more boats tied up here waiting to transit.
- It also had a basic village infrastructure already in place, left over from the Andover Forge days, which included the mills, stables, sheds and residential buildings. True, many of the buildings needed major repairs to be serviceable, but at Waterloo, this was not a severe handicap because the village also had, in the form of John Smith, a single owner with the foresight and financial ability to provide all of the needed and desired services.
- The village also had John's sons William, Nathan and Peter. In 1830, when canal construction was well underway, John Smith began his major reconstruction at Waterloo. At this time, he was already fifty-five years old. Though he certainly provided the vision for the changes that would be made at Waterloo, it was his youngest sons, William O. (twenty-five), Nathan (twenty-four) and Peter (twenty-two), who would be the driving force to complete the many projects over the next few years, remodeling some of the existing buildings and constructing new ones as needed. These were young, smart and energetic men who were available to operate and manage the various family businesses being established in the village.

So the gradual evolution of a canal town became, at Waterloo, a much quicker process. The stars above Waterloo were certainly in alignment.

5

The Second Period of Growth and Decline

THE CANAL ERA (1830–1870)

At this point we have discussed the first period of growth and decline, the forge era, which was dependent on the ironworking industry and the expertise, leadership and influential connections of William Allen, Joseph Turner and Benjamin Chew. When those shareholders declared their allegiance to the Crown, the future of their colonial enterprises was doomed. The forge and mills continued to operate after the Revolutionary War—the forge for only a few years, the mills for much longer as agriculture in the region actually expanded. However, only a few families benefited from the switch to agriculture, and the village itself became a minor player in events between the Revolutionary War and 1830.

The background was then set for the next period of growth by discussing the arrival of the Smith family, the land transactions that occurred in the first two decades of the nineteenth century and the purpose and operation of the Morris Canal. Now, let's tie everything together and see what happened in the village's second period of growth, the canal era.

In the early 1820s, the idea of spanning the northern highlands of New Jersey with a canal began to take shape. The idea was turned into a plan, and in 1827, construction of the Morris Canal was begun. It was officially opened in 1831. The presence of this canal through Waterloo, along with the vision of John Smith and his sons, led to the second, and by far the greatest, period of economic growth that the village would experience. The derelict forge village of Andover Forge would soon become the prosperous canal town called Waterloo Village.

THE SMITHS PREPARE FOR THE FUTURE

By 1827, the route of the canal had been fixed and construction started. Being an astute businessman, John Smith could see the potential that the decrepit Waterloo Village now had. However, the land at the heart of the village was still jointly owned by John and Hannah De Camp. In order for John Smith to take full advantage of the canal coming through Waterloo, he would have to acquire Hannah's half interest in these parcels, and he did so in December 1828, paying Hannah $2,000 for her remaining half shares.[59] The way was now clear for a resurgence of Waterloo Village.

While the rest of this chapter will deal with canal-related topics, we must not forget that John Smith was a farmer at heart. Though busy with various construction or renovation projects in the village, he still continued to purchase land for farming. In January 1833, John bought an additional 200.0 acres from Silas Harvey and 77.0 acres from John Lowery.[60] In April 1833, he bought an additional three tracts of land totaling 207.4 acres from John Wills.[61] Much of this land was in the Dragon's Brook and Lubber's Run drainage areas and seems to have filled in the gap between his Forge Farm tract and his holdings farther north and east of the village.

THREE STAGES OF GROWTH

The forty years of economic growth at Waterloo Village during the canal era did not happen all at once. It took time for the village renovations to be made, and it took time for the canal operations to mature. Let's break the canal-era changes into three separate periods.

FROM 1830 TO 1840

When the Morris Canal route was finalized to include crossing the Musconetcong River at the largely abandoned village of Waterloo, John Smith saw the opportunity to diversify his holdings, adding transportation-related business to his agriculture and iron ore processing. Snell states that John's sons William O. and Nathan quickly relocated to Waterloo,

abandoning New Andover, and prepared to take advantage of the boat traffic that would soon pass through on the new canal.[62]

One conundrum was that, although John was eager to take advantage of the canal business, he did not seem willing to sell any of his newly acquired land to the Morris Canal and Banking Company. Its records indicate that it was unable to secure an agreement with the Smith family to purchase land it needed in the village and had to acquire 3.3 acres of land via condemnation proceedings, consisting of a strip of land 1,800 feet long in Byram and 1,100 feet long in Morris County (for the inclined plane).[63]

However, one should not construe from this that John Smith was against the canal passing through his village. On the contrary, John Smith was a strong supporter of the canal and was certainly in favor of its planned route. It's possible that his preference was not to sell land to the canal company, but instead to lease to it. Another alternative is that the act that created the canal company gave it additional rights regarding land that it needed for the canal, including rights to raw materials on adjacent lands. Perhaps a private contract with Smith would not have included such rights, whereas a condemnation would. Of course, neither of these assumptions is supported by any evidence.

This first decade of the canal saw the Smith family initiating a spate of construction in the village buildings for both commercial and residential use. Many of the old buildings were relocated, repurposed, enlarged or modified. This would be a nervous, tentative period for the Smith family. They were investing time, money and energy in growing the village footprint, betting on trade from the canal but not sure that the canal would succeed.

The initial changes to the village included the relocation of the gristmill and sawmill to make room for construction of the new lock. The old decrepit charcoal house was renovated and became the new gristmill. The stone footings of the long-abandoned forge became the site of the new sawmill. The old blacksmith shop was renovated, probably on the original foundation. One of the original stone residences, which had been converted into a barn in the 1770s, was converted back into a single-family residence. There certainly was also some new construction of timber buildings, both residential and commercial, but we have no evidence of it, either from written records or archaeological remains. The one real major investment, which was later to be the cornerstone of the Smith family fortunes, was the building of a new store on the north bank of the canal, just below the lock. The opening of the store was of such importance that I will give it a separate paragraph later in this section.

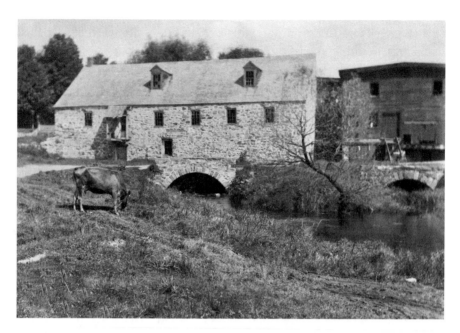

The gristmill and sawmill. Water from the millpond powered the waterwheels, then flowed through tailraces (under the stone arches) and was returned to river. *Courtesy of the Canal Society of New Jersey.*

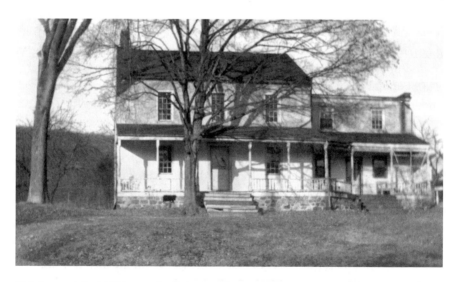

This is an original 1760s two-family home. The extension was added in 1837 for use as a tavern, and the building was converted to a hotel in 1847. *Courtesy of the Canal Society of New Jersey.*

All of the changes listed above occurred early in the first decade of the canal. These changes, however, are more a measuring stick of the Smiths' hope for the future rather than an indicator of the level of economic growth realized. Up to this point, the changes to the village infrastructure were cases of building first and hoping it paid off. The canal's early years were marked with operational problems and growing pains, not unlike any new enterprise. Just one example is an article in the *Sussex Register* on July 13, 1836, which reported that the "shaft of the waterwheel broke at the inclined plane at Old Andover, sending one boat rushing up and one down the plane, causing much damage."

The number of canal boats and the cargoes they carried grew from year to year, but slowly. Over time, as the canal operations stabilized and the traffic increased, the canal traffic began having a positive economic impact for the entire region. The first hint that the Smiths' investment was beginning to pay off was the 1837 conversion of one of the 1760s-era stone residences into a tavern and inn. This change, made six years after the canal opened, is the first hard evidence that the canal operations were themselves beginning to have a tangible impact on growth in the village.

The Smith General Store

The building of the Smith General Store in 1830 was the only major new construction during the early canal period and was the first since the blacksmith shop was built around 1780. Although I have said that these were nervous and tentative times for the Smith family, there was nothing tentative about the design of this store. It was large, with robust design, and was well thought out. It would operate over the next one hundred years without any major changes. Many canal stores of the time were located a short distance from the canal itself, requiring boat cargoes to be transported back and forth between the store and the canal by wagons. (A good example of this is the King Store in Ledgewood, New Jersey.) The Smith General Store, however, was built right on the bank of the canal, with its foundation actually being lapped by the canal water. Boats could tie up to the back of the store, and their cargo could be lifted out and easily moved into any of the store's three levels. The lifting mechanism was a large wheel-and-pulley system located on the third level of the store but operated from the main floor of the store itself.

The store became the key link that connected the canal to the people living in the region. It was the "go between" that was critical to the growth

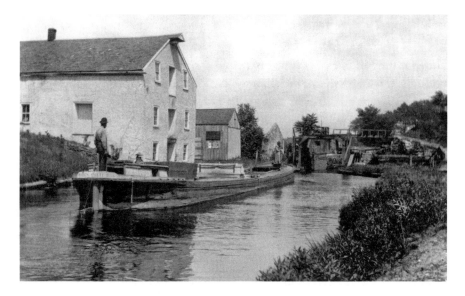

A boat passes the Smith General Store as it approaches the lock. It will be raised to the level of the pond and then will enter the plane. *Courtesy of the Canal Society of New Jersey.*

of other businesses. Local farmers could purchase their daily necessities from the store on credit throughout the year and settle their bills with a portion of their grain at harvest time. They could sell the reminder of their grain to the store or ship it on the canal for sale in the East Coast cities. Local residents could also trade their eggs, chickens, handicrafts, etc., to the store in exchange for flour, coffee, a pair of shoes or whatever else they needed. The store would then sell those acquired goods to the canal boatmen. In December 1847, the store also became a post office, with Peter Smith as the first postmaster.

The Smith family also owned the mills, the blacksmith shop, the inn and large tracts of farmland, so they benefited from practically every transaction done in the village. While it may sound like the Smith family were the typical robber barons, taking unfair advantage of their monopoly, this would not be a fair accusation. The Smiths took the risk and made the investments, and the region developed. And it happened at not only Waterloo but also every canal store and canal village along the canal's entire length. So while the canal itself was not profitable, it was a cornerstone of growth throughout the northern New Jersey region.

From 1840 to 1860

During this phase, the responsibility of overseeing the Smith family businesses changed hands. In June 1848, John, then age seventy-three, had sold large amounts of his land holdings to sons Nathan and Peter, in effect turning over the reins to his children. Nathan passed away in 1852 at forty-six. William O., John's eldest son involved with Waterloo, moved to Illinois sometime after 1850. Peter, the youngest son, now became the guiding force in the village.

This period could be considered the beginning of the golden age at Waterloo Village. There were several significant changes in the village during this period, including construction of new buildings, the enlargement of the canal and the utilization of railroads to facilitate transportation of bulk iron ore.

New Construction

Around 1840, new permanent housing was added in the form of two stone, two-family houses, the only new construction of permanent housing in the village since the mid-1760s. By 1844, the village had fifteen dwellings.[64] These would most likely have consisted of the original three colonial-era two-family houses (and possibly one more) and two newly constructed two-family houses, plus several log or timber houses, though the location of these latter houses is not known. The enlargement of the canal and the construction of the railroads, along with increasing canal traffic, brought construction-related business to the village, as the many additional workers needed to be housed and fed. A school (1842) and church (1859) were also established during this period, reflecting the level of maturity and profitability that the village had reached.

Canal Enlargement

In 1835, the canal company borrowed $150,000 and began lengthening the canal by about seven miles, with the eastern terminus now being Jersey City on the Hudson River, directly across from New York City. The canal itself was also enlarged in stages between 1841 and 1845 to allow larger boats to be used. Between 1847 and 1860, the waterwheels on the inclined planes

were replaced with a reaction turbine of immensely increased power, and the chains attached to the carriages were replaced with wire rope that was much stronger. The locks were widened from nine to eleven feet and were lengthened from seventy-five to ninety feet. The more powerful turbines also meant that it was no longer necessary to have dual planes, as using boats as counterweights was no longer necessary. In addition to these modifications, the canal bed was lined with clay on many stretches to reduce seepage and an additional feeder canal was constructed at Pompton.

Significantly larger boats could now be handled. The original boats were limited to a cargo weight of twenty-five tons, but after the 1845 upgrade, the cargoes increased to forty-four tons. After 1860, it was raised to seventy-five tons, but it was the same two tired mules pulling the load.

The larger boats were 87.5 feet long and 10.5 feet wide and drew 4.5 feet of water.[65] One potential problem in increasing the length of the boats was the transition point where canal boats were pulled out of a canal, over the lip of the bank and then started down the inclined plane. A larger boat could not negotiate this lip without the very real danger of breaking its back. The solution was that the large boats were actually two boats connected together by a short length of chain that allowed the two halves to be disconnected to negotiate the transition point. The cradles were likewise dual cradles.

Increasing Canal Traffic

Throughout this twenty-year period, traffic on the canal was also increasing steadily. Coal shipped from the anthracite fields in eastern Pennsylvania now became available as a fuel for the charcoal-starved New Jersey furnaces and forges. Many area mines reopened, including the Andover mine in 1847, and iron processing was reignited. Iron ore could also now be economically transported to the furnaces throughout the region. Total tonnage carried on the canal in 1845 was 58,259 tons. In 1866, the year with the highest tonnage carried in its history, it reached 889,220 tons.[66]

Of course, bulk goods such as coal and iron ore were not the only cargoes carried on the canal. Just about any product imaginable would have been transported on a boat at some point: vinegar, alcohol, limestone blocks, bags of grain, hay, powdered limestone, lumber, bricks, cast-iron stoves, lace goods, construction supplies, etc.—maybe even a new bonnet from France!

The Railroads

The arrival of the railroad at Waterloo would be a momentous event with long-lasting impact, though this was certainly not evident at the time.

THE SUSSEX MINE RAILROAD: In 1847 the heirs of the Andover Iron Works sold the property to the Trenton Iron Company, owned by Peter and Edward Cooper and Abram Hewitt (among others). By 1848, the mine at Andover (but not the furnace) had reopened. Wagonloads of ore totaling between five to six hundred tons per month were being transported to the canal at Waterloo via the Morris Turnpike for shipment to the furnaces in Pennsylvania.[67] The toll on the Union Turnpike for the six-mile journey was set at one dollar per ton. A high percentage of this tonnage was waste material, so the owners had a strong incentive to not only avoid the turnpike but also find a way to increase the volume of ore being moved to the canal.

The Trenton Iron Company accomplished this by building a mule-powered traction railroad from the mine at Andover to the canal at Waterloo, following the valley where Dragon's Brook ran. This rail line also had connections to other nearby mines. Construction was supervised by Nathan Smith and was completed in 1850. Three or four mules pulled the ore cars ("Jimmies"), with a capacity of over six tons of ore from the mine,[68] up the slight grade until they reached the top of Whitehall Summit. Then two mules would take it the rest of the way to the ore-loading docks on the bank of the canal near where the Methodist Church would soon be built. This traction railroad was named the Sussex Mine Railroad.

The ore-loading dock at Waterloo was located on a rectangular piece of ground between the canal and Waterloo Valley Road. It began at a point on the canal bank 117 feet west of the Smith Store and ran 333 feet along the canal and 75 feet from the canal to the road. John Smith deeded this land to the Trenton Iron Company in April 1847 for one dollar.[69] We can assume that placing the loading dock in this location would have been an inconvenience to passing canal traffic, as boats traversing the canal in either direction would have had to maneuver around the boats tied up at the loading dock. In June 1850, John Smith sold the Sussex Mine Railroad the right of way to a strip of land 33 feet wide where this rail bed crossed his land along Dragon's Brook.[70]

THE SUSSEX RAILROAD: Though the mule tramway was a more efficient operation than wagons, increasing tonnage up to two to three hundred

tons per day, new technology was available to improve it exponentially. The owners were granted a charter that allowed them to replace the mules with a steam locomotive, running on tracks that now crossed the river upstream of the village and then turned west along the south bank of the canal pond, thus moving the tracks and ore-loading operation away from the center of the village. This new line was named the Sussex Railroad, and the land for which the Sussex Mine Railroad had held the right of way through John Smith's land was deeded to the Sussex Railroad and the parcel widened to sixty-six feet.[71]

A new ore-loading dock was built along this rail line just east of the inclined plane. This new location enabled loading of the boats while they were in the lock pond, out of the way of passing boat traffic. An amendment to the railroad's charter allowed it to carry passengers, and plans were begun to extend it northward from Andover to the county seat at Newton. The new charter also allowed it to connect to the Morris & Essex (M&E) Railroad at a point west of the new ore docks, thus extending it on both ends.

THE MORRIS & ESSEX RAILROAD: The M&E had been chartered in 1835 to construct a line from Morristown to New York Harbor. It began slowly expanding westward in the mid- to late 1850s, and its planned expansion to Hackettstown, southwest of Waterloo, would have it passing close by Waterloo Village. Connecting to the Sussex Railroad there would also give the M&E a branch line that ran from Waterloo, through Andover, north to Newton. This, however, was not a merger of the two lines but rather an agreement to connect the two lines and share traffic.

The M&E offered the Sussex Railroad a 33⅓ percent "drawback" (similar to a rebate) on all traffic that the Sussex Railroad delivered for transport over the M&E line.[72] The stipulation, however, was that the drawback would only be valid if the Sussex extension was ready when the M&E reached the point of connection at Waterloo. This would require the Sussex Railroad to extend its tracks westward from the new ore docks, over the inclined plane and laterally across the steep face of Schooley's Mountain. In March 1853, Peter Smith deeded the land needed for this construction to the Sussex Railroad, and construction began.[73] The route, though short, was a difficult one, requiring much cutting and embanking.

Once the Sussex Railroad had committed to the extension and started work, the M&E then tried to delay the Sussex line's construction.[74] If the Sussex did not finish the line in the time agreed, then the M&E would still benefit from the additional traffic but would not have to pay the drawback.

The Trenton Iron Company even shut down the Andover mine for a time and sent four hundred miners to help work on the roadbed.[75] Much to the dismay of the M&E, the connection was completed on time, and the two railroads connected in January 1855. A turntable and station house were built at this junction, with the Waterloo Train Station being about a half mile west of the new wagon bridge (also built by the Sussex Railroad) that crossed the river in Waterloo at the mill site.[76]

On July 4, 1855, the *Sussex Register* reported that the Sussex Railroad was running five trains each way between Newton and Waterloo. On June 16, 1858, the same paper reported that, at the Morris & Essex annual stockholder's meeting, the volumes of passengers carried by the M&E Railroad over the previous twelve months was 273,350 (not including commuters). Of these, 8,177 were from Dover, 30,085 from Morristown, 3,226 from Stanhope, 8,726 from Waterloo and 6,280 from Hackettstown. Additionally, there were 49,929 "Way" passengers (whatever they are).

Changing of the Guard

John Smith died on December 22, 1859, at age eighty-four. He would be the first burial in the cemetery behind the new church. With John's death, Peter became the patriarch of the Smith family at Waterloo, which consisted of his six children and their families.

THE FINAL DECADE OF THE CANAL ERA:
1860 TO 1870

The outbreak of the Civil War in 1861 required a massive nationwide effort over the next four years to feed, clothe and arm a huge army in the field. This placed a tremendous burden on all transportation networks: road, rail and canal. The business on the canal increased dramatically, and with it came a third period of substantial canal-based growth in the village. This latest growth was evidenced by the construction of several new residential houses to meet the needs of the continually increasing number of workers and travelers residing in, or passing through, the village. New railway lines were being constructed all though the region during the Civil War, including several close to Waterloo. The Civil War expansion of

railroads was to prove their effectiveness, and their growth would continue to escalate in the postwar years.

The Smith family continued to be involved in processing iron ore throughout this period, which many might find surprising. At this late date, one might think that relatively small, local iron-processing operations would have been economically unfeasible, given the evolving transportation network that would favor larger and more efficient plants. The Smiths' continued involvement in iron processing is evidenced by two documents. On March 21, 1866, the *Sussex Register* reported, "[the] Forge near Waterloo, owned by Peter Smith & Sons, accidently took fire and burned. Loss, $2,000; Insurance $1,000. At the time of the fire it was turning out regularly 1,400 lbs. of charcoal iron per day, and employing quite a number of hands." Where this forge was located is not defined, though it probably was the forge at New Andover. This forge, a bloomery, was processing iron ore mined from the Roseville mine, located halfway between Andover and Waterloo, as well as from other nearby mines. The other document was an agreement made on May 4, 1869, by Peter Smith with Morris Applegit and Elisha Allis. The agreement gave Applegit and Allis mineral rights to a twenty-three-acre tract of land that Peter owned on the east side of the railroad bed, above the falls on Dragon's Brook.[77]

The vastly increased traffic on the canal, the proximity of the new railroads to the village and the developing cargo and passenger traffic on these railways continued to support the village's growth and importance. From 1830 to 1870, life in the canal town of Waterloo Village was good—very good.

CHANGES TO THE VILLAGE FOOTPRINT DURING THE CANAL ERA

Please refer to Map 4 on page 75. A detailed description of each structure is provided in Chapter 8.

By the end of the canal era, the footprint of the former forge village now more closely resembled a vigorously growing canal town. The listing of buildings that follows includes those that were remodeled or newly constructed during the canal era and points to the level of business that had been generated by the canal:

- The Smith General Store, newly constructed, opened in 1831.
- The 1760s charcoal house was converted into a gristmill, replacing the original colonial-era timber-framed mill.
- The abandoned 1760s forge site was rebuilt as a new sawmill, replacing the original colonial-era timber-framed sawmill.
- The hydropower system for the relocated mills was reconfigured.
- The blacksmith shop was rebuilt.
- Two new stone two-family houses were built around 1840.
- Of the original 1760s stone residences, one was converted in 1837 first to an inn/tavern and then to a hotel, a second was converted from a horse barn back to a residence and the third was converted to a single-family home and updated.
- A school (1842) and church (1859) were built.
- Four permanent, timber-framed residences were constructed around 1860: the parsonage, the Poyeur house and two other tenant houses.

THE SECOND PERIOD OF DECLINE

1870 and Beyond

Looking back at the period from 1830 to 1870, we see a village that appears to be blessed with continual growth and vitality. Many new buildings were constructed while many others were remodeled or repurposed. Canal traffic steadily increased, and new railways generated even more business. The enlarging and updating of the canal brought many visitors and workers to the village, and the Civil War generated a tremendous growth. Things were good—or were they?

Waterloo, up to this point in its history, had mostly been a one-dimensional village. First, it depended on the forge, and when the iron industry dried up, so did the village. The grist- and sawmills continued to operate, and commercial farming moved into the area. These enterprises may have made the land and mill owners wealthy, but they were not the types of businesses that would cause a "spin off" effect.

The canal, on the other hand, would. The coming of the canal benefited a wide range of complementary businesses, including blacksmithing, stabling, tavern keeping, hotel keeping, agriculture, mining, retail, travel (the stage line), etc. Throw in the reengineering of the canal and the impact of the Civil War and

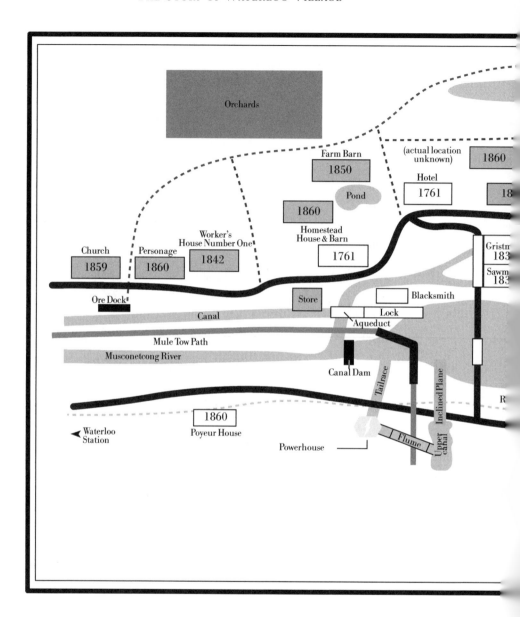

you would expect exactly what we see—tremendous growth. But the lifeblood of the village was still based primarily on one source—this time, instead of an industrial forge, it was based on commerce derived from the canal.

Waterloo was located in an isolated river valley. The canal made it accessible. In the late 1860s, the new rail lines made it even more so. As long as it stayed accessible, the village businesses had a chance to survive and the

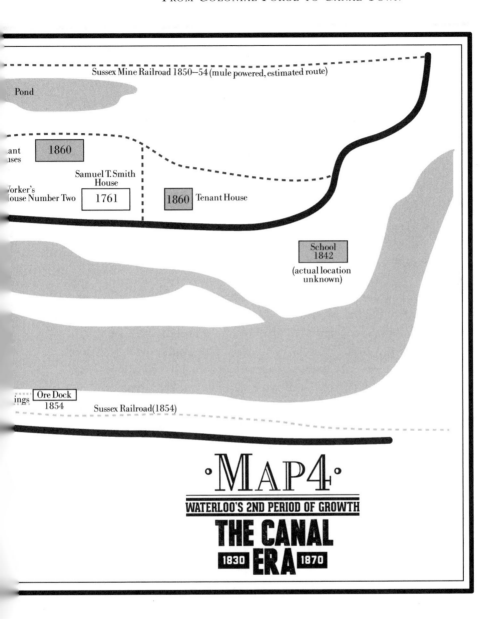

Sussex Mine Railroad 1850–54 (mule powered, estimated route)

Pond

ant
ses
1860

Samuel T. Smith
House

Jorker's
ouse Number Two 1761

1860 Tenant House

School
1842

(actual location
unknown)

ings Ore Dock
1854 Sussex Railroad (1854)

·MAP 4·
WATERLOO'S 2ND PERIOD OF GROWTH
THE CANAL
1830 ERA 1870

region to thrive. Without the canal, or rail traffic as an equal substitution, the village would collapse on itself again. And the canal was struggling. On December 31, 1853, the *Sussex Register* reported that for the year, the Morris Canal had earned receipts of $20,000 and had incurred operating expenses of $70,000, plus an interest and dividend expense of $100,000. It appears that Waterloo may have hitched its wagon to a three-legged horse.

If you look at the number of people staying at the Waterloo Hotel at various points in time, you also get an inkling that perhaps the village was operating on borrowed time. The 1850 census, a period right in the middle of the canal upgrade, shows that eleven boarders were staying at the inn at that time. Among them were the stagecoach proprietor and stage driver, two civil engineers, two blacksmiths, a millwright and four laborers. This is certainly a robust group, and all (more or less) are related to the canal or village industries. The 1860 census, which is the period after the canal upgrade had been completed and before the Civil War started, shows only two boarders staying at the inn, both listed as laborers—not very encouraging.

The 1870 census, well after the Civil War had ended, shows only four boarders at the inn: a stable groom, a telegraph operator, a locomotive fireman and a railroad laborer. This list would seem to reflect the growing impact of the railroad and perhaps appear to forecast a bright future for Waterloo as the railroads expanded. But let's look at what actually was happening.

During the early years of rail development, the railroads had a symbiotic relationship with the Morris Canal. The early rail lines provided a more efficient way to get bulk ore to the banks of the canal, from where it was loaded on boats and shipped to the furnaces of eastern Pennsylvania. There was no competition between the two—the railroads owed their existence to the canal. Eventually, short rail lines began to link the local population centers together, and where such a line passed near or intersected one of the early mine-to-canal lines, it was easy to connect them. These lines were still short and were much more conducive to local passenger transport than they were for efficient movement of cargo other than iron ore, so they still did not compete with the canal.

In the late 1860s, the small railroads throughout the region began to expand and interconnect with one another, filling in some of the gaps that had previously only been served by the canal. The railroads also began to merge, gaining both efficiency and standardization. Soon it was possible to travel from the Delaware to the Hudson by rail in two hours instead of the five days it took by canal.

At this same time, several other factors conspired to inflict life-threatening wounds on the canal. The post–Civil War period was one of great demand for steel. Across the globe, wind-driven, wooden-hulled sailing ships were being replaced by steel-hulled, coal-fueled steamships. Expansion of railroads required high-grade steel rails, as well as wheels and undercarriages for the rolling stock and the locomotives themselves. On its face, this would seem to

be a potential boon to the canal, as high-quality iron ore, preferred for steel making, was abundant in the Jersey highlands and the canal was in place to transport it. However, the Morris Canal's benefit from this new opportunity was short-lived for three reasons.

First, steel was produced in blast furnaces, and there were several of those located in western New Jersey and eastern Pennsylvania, built during the first half of the century because of the nearby anthracite coal fields. However, the blast furnaces operated best using coke as their fuel, and coke was made from the bituminous coal of western Pennsylvania. New blast furnaces were now being built, but not in eastern Pennsylvania. They were being built near the new coal fields in the west.

Second, in the mid-1800s, huge amounts of high-quality iron ore were found in the Great Lakes region in the Mesabi Range of Michigan and Minnesota, though transport of any sizeable amount of ore from this rough wilderness proved to be almost impossible. However, over the next twenty years, canals were dug and rail lines laid through this western wilderness (sound familiar?), and by the 1870s, steel mills were operating all over northern Ohio and northwestern Pennsylvania.

The result was that both the iron and coal industries had moved west. There continued to be demand for the ore from the Jersey highlands to keep the eastern Pennsylvania furnaces operating, but after the railroads had become interconnected, much of the ore was carried by rail rather than by canal. Within only a few years, the canal traffic began to decline dramatically.

Third, at the same time, increasing amounts of commercially grown, large-farm agricultural products, grown in the new Midwest region and carried cross-country by the expanded railroad networks, meant that the small, inefficient commercial farms of the East (including the farms around Waterloo) could no longer compete. So not only had Waterloo lost its major source of business, the canal trade, but it also lost its secondary source of income, the local farms. This, of course, negatively impacted both the gristmill and the Smith General Store.

The canal was dying, but the railroads were growing. Wouldn't they provide stimulus to the village just as the canal had?

The answer is no. Remember, canal towns grew up around canal basins, where boats were tied up for periods of time during their long and slow transit across New Jersey. The canal villages grew because people were forced to spend time waiting at canal transit points. The railroads, on the other hand, passed through towns and villages, stopping only long enough

to load or unload cargo or allow passengers to board. This cargo, or these passengers, would be at their final destination within a matter of hours. There was no need for a tavern, a store, a blacksmith's shop or any of the other conveniences that were offered by a canal town.

The economic decline in the village, which started around 1870, would continue for the next eighty years.

6

The Third Period of Growth and Decline

THE VICTORIAN ERA AND EARLY TWENTIETH CENTURY (1870–1950)

Something's not right here. We ended the last chapter by saying that the second period of economic decline in the village started around 1870 and lasted for eighty years. And now we are saying that the next period of growth started around 1870. That doesn't make sense! How can you have decline and growth at the same time?

Let me explain. This third period of growth was not an economic growth. It was not the result of new industry, commerce or any other new and exciting economic stimulus. The village did not reinvent itself. No new businesses were started during this period (with a few minor exceptions), and previously existing business were in continual decline.

The growth during this period was not self-sustaining, but rather, it fed off the wealth accumulated by the Smith family during the previous canal era. As the grandchildren of John Smith reached maturity and married, they used the family wealth to construct new Victorian mansions and carriage houses and renovate (again) the older colonial-era homes. Waterloo, the old forge village, the bustling canal town, would now become a village of wealthy Victorian gentlemen. The canal was dying. So what? It had served its purpose, and it was no longer needed. The nearby railroad was merely a convenience for village life rather than a necessity. This is not intended as a criticism of their attitude or a suggestion that they had a feeling of entitlement. Rather, it is a reflection of reality.

The one-dimensional village had lost, for the second time, its source of income. The canal would still be in place and open until the 1920s, though

boat traffic after the 1870s would be negligible. The mills continued to operate, at least sporadically, during this period. The Smith General Store continued to serve the community. But the income being generated by the Smiths' businesses was nowhere near what it had been in the past. The Smith family, however, did not abandon the village. All four of Peter's sons, who had grown up in the village, continued to live there. As they reached maturity, they married, moved out of their father's house and located in their own homes in the village. The building of Victorian mansions was a matter of necessity—there was insufficient appropriate housing in the village for these expanding Smith families. Although they all pursued interests outside the village, it was still their home.

Of the eleven children born of Peter and Maria, only six reached adulthood, and all six maintained strong ties to the village. Matilda lived in the Peter Smith Homestead with her parents and, later, her husband and inherited it after her mother passed away. Caroline grew up in that same house, and after living in Fish Kill, New York, she returned to it in 1870 for the last years of her life. Samuel T. Smith married in 1866 and moved into the other colonial-era stone residence, which became known as the Samuel T. Smith House. Nathan A., though the youngest of the four brothers, was the next to marry, sometime before 1869 (at age nineteen). With no other suitable housing available, he and his wife occupied the house that eventually would become the parsonage.[78] When the next two brothers married, Peter D. in 1871 and Seymour R. in 1873, they built their Victorian mansions.

At the time the canal was being built through the village, John Smith, the first generation of Waterloo Smiths, was already getting long in the tooth (he was fifty-six in 1831). He still had enough vitality and vision to oversee the necessary construction that would turn Waterloo into a successful canal town and would live long enough to see the fruits of his labor (he died in 1859).

John Smith's youngest son, Peter, the second generation of the Waterloo Smiths, was born in 1808 and died in 1877, still mentally alert and active. When the canal was being built through the village, he was twenty-three. His entire life was spent in building up the village businesses and guiding them through a period of growth and maturity, especially beginning in 1852, when he took over management of the family businesses from his late older brother Nathan. Only in his last years of his life did the village businesses begin to decline.

Peter's sons, the third generation of Waterloo Smiths, would close out the Smith era. Samuel T., the eldest of Peter's sons, was born in 1833, and he grew and prospered along with the village. However, Samuel, who was in

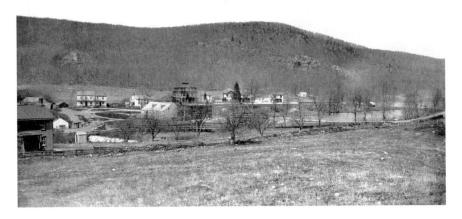

This photo taken from across the river shows deforestation. In the foreground, far left, is the Poyeur house, and in the distance on the middle-right is the white schoolhouse. *Courtesy of the Canal Society of New Jersey.*

line to become the next village patriarch after his father passed away, was busy with outside interests. He left the running of the family businesses to his brothers Peter D. and Seymour R. In 1874, he sold his interests in the general store and the mills to them. He would be the first of the Smith family to disengage himself from the village businesses.

Samuel's younger brothers, Peter D. (born in 1845), Seymour R. (born in 1847) and Nathan A. (born in 1850), all reached their maturity about the same time that the village began its long descent. They, even more than Samuel, must have had great concerns for their future, as a family can only live off accumulated wealth for a finite period of time. These were all smart, well-educated men. Although they lived the life of Victorian gentlemen, they were no slackers. They had ambition, pride and a sense of community responsibility. While growing up they could well understand the changes that were occurring, both in the village and outside it. They certainly understood that the future would not reflect the past, and this would be especially so for their children.

Changes to the village's industries during this era included lumber harvesting, ice harvesting, iron ore mining and quarry operations.

LUMBER HARVESTING

The lumber business must have seen renewed growth during this time. The census reports from 1850 to 1910 show one or two sawmill workers living in or near the village on each census, indicating that the mill was still operating throughout this period.

However, beginning with the 1880 census, we start seeing a new occupation: "woodsman." The number of such workers increased significantly in the 1910 census. It appears that the hillsides, deforested to provide charcoal for the old colonial forge, had regenerated enough harvestable timber to support a renewed lumber business. This could also be a result of the decline in farming so that much of the land had reverted to new-growth forest.

ICE HARVESTING

Commercial ice harvesting was one of the few new businesses that opened in the village during the Victorian era. Unfortunately, trying to explain these operations is a bit difficult, as there were four different ice-harvesting companies operating at three different sites from the late 1880s to the 1920s, and not all of them were directly tied to the Smith family. But we will give it a go.

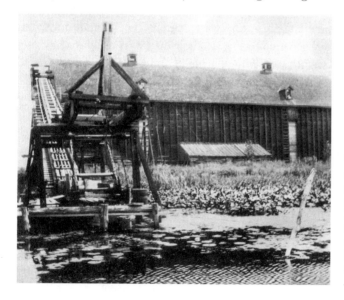

This appears to be an early version of an elevator at one of the icehouses. Later photos show them positioned directly in front of the buildings. *Courtesy of the Canal Society of New Jersey.*

Lake Waterloo

In a last-gasp effort to reenergize the village industry, Peter D., Samuel T. and Seymour R. Smith joined with the Swift Brothers & Company, a national supplier of beef headquartered in Newark, and started the Waterloo Ice Co.[79] In December 1889, the Smith brothers leased the waters of Lake Waterloo, including the land on both sides of the lake, to this company (of which they were principles). Initially, this was a twenty-year lease.[80]

The corporation built a new dam just east of the village, creating a fifty-acre ice pond behind it. The mill headraces were, once again, reconfigured to their present location, taking in water from the new pond and using the former headrace as a bypass to channel excess water back to the river, just below the ice dam. Swift-flowing water would result in thin and weak ice, so the company dug a channel around the ice pond so it could divert the Musconetcong River away from the pond when it was freezing up. That channel is still visible from Waterloo Road. This latest dam created several islands and also inundated a large part of the former shoreline.

Five large timber warehouses were built on the south shore of the lake, each measuring 150 by 200 feet, and could hold a total of thirty thousand tons of ice. There were coal-fired powerhouses that powered elevators for carrying ice into the warehouses. Also in the complex were an administration building made of terra-cotta blocks, various small outbuildings and three rail sidings branching off the Sussex Railroad. Rail cars delivered sawdust to the factory to be used as insulation of the ice and coal for use in the engine houses. Blocks of ice were loaded on the rail cars for return shipment, mainly used by the meatpacking industry in Newark.

With Samuel T. Smith's passing in 1898, the remaining two partners amended the lease to reflect the fact and, at the same time, extended the lease for another ten years, up to January 1920.[81]

Panther Pond (Later Known as Panther Lake)

Concurrent with its operation at Waterloo, the Waterloo Ice Co. also established an ice-harvesting business at Panther Pond, just north of Cranberry Lake and close to the Sussex Railroad tracks.

In January 1890, the company signed a twenty-year lease with Mr. Philetus Chrispell, giving it "all that pond of water known as Panther Pond...together with so much land as needed to lay railroad tracks and to

erect the necessary buildings…for the harvesting and storing of ice."[82] This pond, located at Whitehall, just above Cranberry Lake, was three hundred feet east of the Sussex Railroad tracks. In February of that year, the company also bought a two-acre plot from Augustus Spitzer that adjoined the land it had leased at Panther Pond.[83]

Jefferson Lake

Although the fourth son of Peter Smith, Nathan A., was an adult in 1890 when his brothers entered the ice business (he was forty), for some reason, he was not included as one of the officers of the company, nor was he part of the original lease that his three older brothers made to that company. Though this might seem to indicate a schism between him and his brothers, I do not believe that this was the case.

In their father's will, the three older brothers, who had been active in operating the mills and store at Waterloo, were left that property jointly.[84] In that same will, Nathan was left a 338-acre tract of land that included Jefferson Lake and large land holdings in the area north and east of the village that was well suited to agriculture. The will reflected the fact that Nathan had not been involved in operating the village's businesses. This could be because by the 1870s and '80s, the declining village industries could provide gainful and meaningful employment to only so many managers from the family, and the older brothers had already assumed those positions.

In September 1900, Nathan sold this 338-acre tract to the Jefferson Ice Company, a company that the Smith family had no association with.[85] The lease does not indicate if any ice harvesting had previously been done at this lake, nor does it mention anything about the presence of any warehouses, rail sidings or any other ice-related structures. My assumption is that no ice harvesting occurred here while Nathan owned the property. (There is more to tell about the ice harvesting businesses, but that will be covered in the section dealing with the decline of this period.)

IRON ORE MINING

Surprisingly, even into the 1880s, Samuel Smith continued to have an interest in mining for iron ore. In November 1872, Samuel T. Smith signed a

lease giving him mineral rights on a 130-acre tract of land owned by Robert Shotwell.[86] Unfortunately, though Robert Shotwell owned the land and lived on it, he did not own the mineral rights and, therefore, had no legal right to sell them, as these rights had previously been sold to Alexander McKain in April 1853.[87] To correct this oversight, the lease between Samuel T. Smith and Robert Shotwell was voided and a new deed was executed between Samuel T. Smith and William McKain.[88]

Additionally, in January 1882, Samuel T. Smith sold a large parcel of land to James McPeek.[89] This land appears to be north and to the west of Lubber's Run. Per the deed, Samuel retained a half interest in any and all iron ore or other mineral rights.

So reports that the iron industry in New Jersey died shortly after the Revolutionary War were about one hundred years premature.

Quarry Operations

Sometime around 1875, a quarry was opened just above the old Sussex Mine Railroad track bed (now Waterloo Road). Snell mentions this date in his work, published in 1881, so we have to believe that date to be correct.[90] The stone was considered to be of good quality, able to take a high polish and esteemed for use in buildings, though he indicates that this business was soon abandoned due to the high cost to transport the stone.

The 1880 census is not complete, and the 1890 census is missing; however, the 1900 census included "quarryman" Charles Wilson (thirty-one); "quarry worker" John O'Brian (thirty-six); "foreman, stone quarry" James Denigan (sixty-seven); and "quarryman" (name unreadable) (sixty-two). So the quarry must not have been "soon abandoned" as Snell described.

Changes to the Village Footprint during the Victorian Era and Early Twentieth Century:

Refer to Map 5, which shows the footprint of the village during this period. Chapter 8 will discuss all of the buildings in detail.

One of the most visible examples of the Smith family's wealth included the building of two Victorian mansions and the building of several carriage

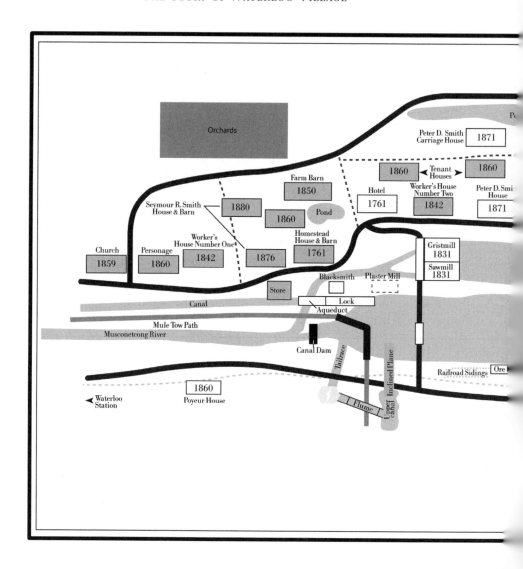

houses and gentlemen's barns during this period. Though not a huge expense, and certainly functional, the building of these new carriage houses or barns would not be considered as a necessary expense (unless of course, you were wealthy), as there were certainly still many older barns and stables in the village. Construction of these carriage barns demonstrates disposable wealth, which we could equate to a present-day purchase of a small pleasure craft or perhaps a 1960s muscle car.

It is likely that many of the old canal-era timber structures—such as workers' residences, stables, etc.—were demolished during this period, as

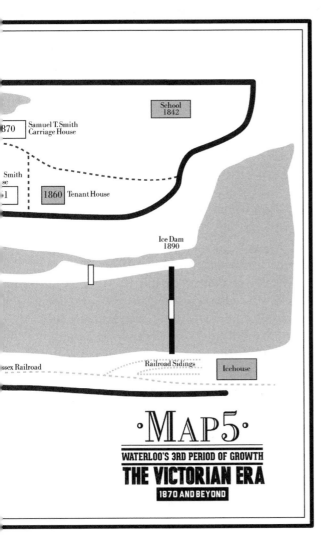

School
1842

370 | Samuel T. Smith
Carriage House

Smith
se
1 | 1860 | Tenant House

Ice Dam
1890

ssex Railroad

Railroad Sidings

Icehouse

•MAP5•
WATERLOO'S 3RD PERIOD OF GROWTH
THE VICTORIAN ERA
1870 AND BEYOND

the dying businesses no longer needed large numbers of workers. There is no indication that any of the old industrial buildings were remodeled, expanded or upgraded during this period.

Buildings constructed or renovated during this period included:

- Victorian mansions (new construction) for Peter D. Smith (circa 1871) and Seymour R. Smith (circa 1876).
- Colonial-era stone houses occupied by Peter Smith and Samuel T. Smith were renovated and updated during the late Victorian period.
 • The Waterloo Hotel: There is some question about whether the old hotel was operating as such at this time. Census records from the 1850s, '60s and '70s clearly show that it was operating as a hotel during those years. The 1880 census, however, is inconclusive on this issue, and the 1890 census was destroyed by a fire. I do not believe that the old Waterloo Hotel was functioning as a hotel in 1880; it may have been occupied as a residence.
- Various carriage houses: Among such buildings constructed were two carriage houses for the two stone residences and two carriage houses for the two Victorian mansions, plus a wood and ice storage shed.

Upon Peter's death in 1877, his will divided up his land to his remaining five children (Caroline died a few years before Peter), giving them ownership of the land on which their residences sat. A series of quitclaim deeds were executed by the children in April 1878, and the boundaries of these various properties were further adjusted in December 1881.[91]

THE THIRD PERIOD OF DECLINE

Many major changes in the village occurred starting in the mid- to late 1880s, and none of them were good. The decline that began in 1870 accelerated in the 1880s, and the downward spiral continued unabated for the next seventy years. Though the new construction in the village during the Victorian era covered the decline with a thin veneer, it could not stop it.

Concurrent with the decline of the village businesses, the need for operational oversight by Peter Smith's four sons decreased dramatically. Peter D. seems to have been the one mostly engaged in the village during the late 1800s, while his three brothers pursued their outside interests, which included being appointed or elected to positions in business and politics unrelated to the village. They began to sever their ties to village life, though they did not abandon them entirely. Let's look at what was going on during the period.

The Canal Closes

There was a succession of events that led to the canal's quickly becoming obsolete. The western migration of the iron business in the late 1860s was a major factor that resulted in the village's second period of decline. But the canal continued to limp along, carrying coal and iron ore for local usage. Two new setbacks, both stemming from railroad competition, resulted in the canal's final curtain being dropped.

First was the loss of the coal trade. Since 1856, the Delaware, Lackawanna & Western Rail Road (DL&W), lacking direct access to the East Coast cities of Newark, Jersey City, and New York City, had been delivering significant tonnages of coal to the Morris Canal in Washington, New Jersey, for eastbound transport to those large cities. However, in 1868, the DL&W leased the Morris & Essex Railroad, now giving it direct rail access to the East

Coast. Within two years of that lease agreement, the amount of coal being carried on the canal and passing through Waterloo had dropped by a third.

The canal had never been profitable, except for a short period toward the end of the Civil War. With this latest blow to its business, the Morris Canal and Banking Co. sought an amendment to its charter that would allow it to lease its property. It deemed this to be a necessity, as it could now see no improvement in its future financial position, especially with the continued maturation of the railroads. This request was granted by the New Jersey legislature in 1870.

In 1871, the Lehigh Valley Railroad leased the canal for 999 years, but not because it wanted the canal. It only wanted access to the canal's terminals on the Delaware and Hudson Rivers. Since the canal company would not lease just the terminals, the Lehigh was forced to take the entire canal. The Lehigh was required to keep the canal open and operating for the entire period of the lease. Though the canal was now in the hands of a competitor and cargo shipments were a mere shell of what they previously had been, it still continued to operate, though barely.

Second was the loss of the ore trade. In 1881, the other shoe dropped. Since 1865, the Ogden Mine Railroad had been delivering a significant amount of bulk iron ore to loading docks at Lake Hopatcong, where it had been loaded into boats for shipment to various destinations along the canal. In 1880, this tonnage had amounted to 108,000 tons, or 1,543 boat loads. In 1881, the Central Railroad of New Jersey took over the Ogden Mine Railroad and connected it to its High Bridge Branch. From that time on, all ore from these mines would be carried by rail.

The losses of these two major cargoes, coal and iron ore, as well as many smaller ones, sealed the fate of the canal. In 1903, boat traffic on the canal was nonexistent, and in that year, the state legislature commissioned a study that determined that the canal no longer had any economic justification and included a plan of abandonment. It's likely that the Lehigh Railroad was a strong advocate of such a plan, as it continued to incur expenses keeping the canal open, per the lease agreement, with no income or benefit to offset those costs. Nothing happened. Another such study was conducted in 1912 with the same recommendation, but again, nothing happened.

In 1918, the North Jersey District Water Supply Commission wanted to build the Wanaque Reservoir to supply much-needed water to a growing Newark, as well as to other cities. This reservoir would be fed by waters from the Wanaque and Pompton Rivers, which had been major feeders to the canal. The Morris Canal and Banking Company, along with the Lehigh

Valley Railroad, filed suit to stop construction of the new reservoir, ostensibly to protect the canal's water sources. It's probably safe to say that they really did not care about losing the water from the two rivers. Instead, they used the suit, which they won, as leverage. The state legislature, realizing that the canal lease agreement was stifling further development and would continue to do so in the future, approved an act in 1922 that would transfer the canal to the State of New Jersey. The Lehigh retained the two terminals that it had originally desired, while the rest was signed over to the state. Over the next six years, the canal was systematically demolished.

On July 28, 1928, the Morris Canal and Banking Company transferred the canal property at Waterloo to Seymour R. Smith in exchange for a payment of $1,119. Seymour immediately transferred half ownership to his son S. Roy Smith.[92] The canal had done what it was designed to do, act as an economic generator for northern New Jersey. Now it could be laid to rest.

The Railroad Departs Waterloo

Apparently, as early as 1871, there had been talk of rerouting the Sussex Railroad away from Waterloo, as on January 26 of that year, the *Sussex Register* carried an article that said, "We understand that it is the intention of the Sussex Railroad Company to discontinue the running of trains to Waterloo after this season; but to lay a new track from Whitehall to Stanhope, thus shortening the distance very materially, and accommodating the Delaware, Lackawana and Western railroad with a direct route for limestone, etc., etc."

Thirty years later, it became a reality. In 1901, the DL&W changed the southern terminus of the old Sussex Railroad from Waterloo to Stanhope, thus bypassing Waterloo. A connection to the icehouse rail sidings was left in place, but by 1902, the Waterloo Station was closed and the telegraph operator withdrawn. Waterloo Village was no longer a key stop on the railway. The village was now to begin a long period, again, as a backwater town.

The Ice-Harvesting Business Changes Hands

Industrialization of the Midwest had resulted in huge amounts of air pollutants being carried eastward by the prevailing winds. Many of these suspended particles found their way into the Jersey highland's waters,

including the ice being harvested at Waterloo and the other lakes. With the great majority of this ice being used to cool foodstuffs, there were certainly some concerns. By the second decade of the new century, steam-powered ice machines were becoming available. They could produce ice on location, using piped-in filtered water.

Although these events would seem to harbinger a quick demise of the natural ice-harvesting business, surprisingly, this did not come about, and instead, ice harvesting was to have a long, lingering death.

Panther Pond

In April 1892, less than two years after it had leased the pond, the Waterloo Ice Co. filed a bill in the Court of Chancery against Mr. Chrispell, owner of Panther Pond, disputing the terms of payment that the owner was demanding under their lease agreement. The suit was settled on January 1, 1901, with the result that the company's lease on Panther Pond and its adjoining land was voided.[93] It is unknown how much, if any, ice harvesting was done by the company at Panther Pond during those intervening nine years while the suit was unresolved. On the same date that the settlement was reached and the lease was voided, the company sold its two-acre plot at Panther Pond to the North Jersey and Pocono Mountain Ice Company,[94] and Mr. Chrispell leased the pond and land to it as well.[95]

Waterloo Lake

On November 1, 1900, the Waterloo Ice Co. signed over its lease on all properties at Waterloo, which would include the ice pond, warehouses, buildings and equipment, to the North Jersey and Pocono Mountain Ice Co.[96] The company received in return "valuable considerations" and one dollar. What those "valuable considerations" were was never clarified.

With the abandonment of the Panther Pond operations and the assignment of the lease on the Lake Waterloo operations, the Smith family, after a little more than ten years, had ended its venture into ice-harvesting operations. From 1901 on, their only involvement would be as the landlords of the leased land at Lake Waterloo.

In 1910, the North Jersey and Pocono Mountain Ice Company transferred the lease of the Lake Waterloo site to the Mountain Ice Co.[97]

Most documents state that ice harvesting at Waterloo ceased around 1917. Mr. Burge (in his interview with Henry C. Beck for the book *Tales and Towns of New Jersey*) says that it ended in 1913. However, the Mountain Ice Company was active in the Waterloo area much later than either of those dates. The company took over the leases at Jefferson Lake in 1923 and extended that lease in September 1926.[98] It also took over the lease at Panther Pond in October 1924.[99] Its last season of ice harvesting, probably at Lake Hopatcong, was 1934.[100]

Changes to Village Employment

Viewing the census reports during the last quarter of the nineteenth century and the first decade of the twentieth century for people living in or around the village and examining the occupations listed on those reports gives a general idea of what was happening in the village.

FARMERS AND LABORERS: During this period, the number of farmers decreased substantially, as did the number of laborers, with the 1900 census being the last one showing this occupation.

SAWMILL AND LUMBER WORKERS: The listed occupation of "sawyer" or "sawmill worker" appeared on all census reports up to 1910, indicating that some lumbering was taking place continually throughout the region. The 1900 census shows, for the first time, an occupation of "woodsman," and the number of people with this occupation increased significantly from 1900 to 1910. The sawmill burned down in 1917 and was not replaced.

CANAL WORKERS: The occupation of boatman disappeared from the census after 1880, though lock or plane tender continues to appear until 1900. The reason for this was that the Lehigh Railroad, which leased the canal, was obligated by its lease agreement to keep the canal open, regardless of whether or not there was any boat traffic. After 1880, there was almost no cargo business, thus no need for boatmen. However, the planes and locks had to be maintained and operated, even if infrequently. Eventually, there was no longer a need to employ plane or lock tenders at each site, and instead, a canal employee would ride on the boat itself and run ahead to operate the lock or plane as needed.

GRISTMILL WORKERS: The last entry for a "miller" is in the 1870 census, though the gristmill continued to operate up to about 1895. With the disappearance of the farms, the mill was probably used only occasionally.

THE HOTEL: The historical architects Connolly & Hickey, in their 2013 submission for the Waterloo boundary increase, state that in 1880 the hotel was operating with a Mr. Lawrence as the proprietor.[101] My research disagrees with that. On the microfilm of the 1880 census, page eight does show five separate dwellings occupied by the Smith family, so we know that those dwellings were at the center of the village. The next page on the microfilm shows "Mr. Lawrence, Hotel Keeper," with his wife, two sons and three daughters. This is the second dwelling listed on that page, so it would appear that this is the hotel at the center of the village, close to the Smith residences.

However, this listing is not the Waterloo Hotel. Pages nine through twenty-two of the census are missing from the microfilm. It skips from page eight to twenty-three, and the listing for Mr. Lawrence is actually on page twenty-three, not on page nine. So there is no way to know if the hotel was still in operation in 1880. I suspect that by then it may have been closed and possibly even have been converted into a residence. This is just a guess, as no proof is available.

PLASTER MILL: A 1939 WPA description of the village states that Waterloo was "a slumbering hamlet, stranded when the iron industry went west...to this mill the canal brought as a backload from tidewater the famous Nova Scotia stone which was ground in the mill and used as a soil sweetener in cornfields."[102]

A pile of this limestone, awaiting grinding, is shown in a late nineteenth-century photo. This mill was located in a timber-framed building on the bank of the Lock Pond and is clearly shown in photos taken around 1900. By this time, there was no need for a mill to rely on water power, so it did not have to be located along the old mill races.

BLACKSMITH: There is no entry for a "blacksmith" after 1880, and it is evident from photographs that the Blacksmith shop was in ruins by 1900.

THE SMITH GENERAL STORE: The store was leased to a Mr. Cassedy in 1898, and he operated it until 1916. The post office closed at that time, as rural home delivery made it unnecessary. In the 1920s, the store was operated by

Shafer C. Smith, a grandson of John Smith. In the 1930s, the store building was leased out as a headquarters for the New Jersey Forest Fire Warden.

THE SCHOOL: There was still, as late as 1910, a teacher listed in the census as living in the village.

THE SMITH'S DEPART WATERLOO

The 1870 census shows Peter Smith, his sons Peter D. and Seymour R. as well as his daughter Matilda all living within the same residence in the village. His other two sons, Nathan and Samuel T., lived with their families in separate residences but still within the village.

By 1880, Peter had passed away, and his four sons and daughter Matilda, all married with families, were all living close together in the heart of the village. This would be the period when the most Smith family members were occupying homes in the village. Photos of the period show well-dressed family members holding picnics and playing lawn games. It was a good time to be a Smith.

There is no 1890 census (it was destroyed by fire), but by the 1900 census, Peter D. and his family are the only Smiths remaining in the village. Within a span of less than twenty years, all the Smith families except one had moved on, pursuing outside interests. The homes in the village were mostly either summer homes for the Smiths or had been rented out. Of the fourteen residential buildings listed in the village in the 1910 census, all were occupied by tenants. Mr. Cassedy continued to operate the store and live in the village as a tenant. Joining him were the icehouse superintendent and foreman, who were employed by the North Jersey and Pocono Mountain Ice Co., and they were certainly renting some of the prime residential buildings.

Peter D. died in 1918. The 1920 census shows that his son Sanford was living with his wife in South Orange, at the home of his mother-in-law.

The village patriarchs, John Smith and his son Peter, lived in the village from the 1830s until 1877, when Peter died. Peter's sons and one daughter continued to reside there and thrive through the end of the century. Peter D. Smith, the last Smith resident in the village, died in 1918, ending almost ninety years of continual Smith occupation at Waterloo. It was the end of an era and the end of Waterloo as a village; the good times are over.

ONE LAST GASP

In the late 1920s, Seymour R. Smith, along with other Smith family members, decided to try to develop Waterloo Village into a housing development. To this end, they formed the Waterloo Lakes Estate and Development Company in 1929 and consolidated various family lands into a 2,300-acre property they would call Waterloo Estates.[103] The development would include a country club and golf course, an expanded lake for water sports and a small airstrip. There were to be three different types of subdivisions: the premier subdivision, aimed at the wealthy, would have five-acre estates ranged along the ridge tops on both sides of the Musconetcong River; another development would have half-acre lots for somewhat less substantial homes; and the third would have small cottage-style houses on plots of sixty-five by one hundred feet.[104] One model home was constructed at the east end of the village, and it still stands today.

Seymour R. Smith died in 1932, and his son Peter Louis Smith continued in his stead. For once in their family history, the Smith family's timing was off. The full force of the Depression hit before the plan could be put into action, and the plan, as well as the remaining Smith family fortunes, collapsed. The land was foreclosed on by the Hackettstown Bank in 1935. The land the Smith family had owned for 120 years was now in the hands of strangers.

Times were tough. The bank had no interest in maintaining the properties, let alone modernizing them. Properties were rented out "as is" when a tenant could be found. Parcels of land or houses were sold off when a buyer with money appeared, which was not often in these times. Buildings that could not be sold or rented were left to decay. One report states that, during the 1930s and '40s, the only thing keeping the buildings from total ruin was the squatters living in them. The nearby Lackawanna freight trains had to slow for a step grade, providing ample opportunity for these Depression-era hobos to hop on or off. They adopted Waterloo and, in a way, protected it, probably patching holes in the roofs or walls, but only so far as their basic comfort required and only when such repairs could be done with no expenditure of money.

Waterloo Village, for the third time in its history, had only a past and no future.

7

The Fourth Period of Growth and Decline

THE MODERN ERA (1950–PRESENT DAY):

Unlike the earlier periods of economic growth, the one that occurred in the modern era was well documented in newspapers, Internet postings and court documents. The wealth of information available, including detailed attendance records, gate receipts, expenditures, etc., is much too lengthy to include here, so I will only provide a brief summary, drawn from several sources.

For anyone looking for the specifics, one resource rich with data is the 2011 copyrighted six-part posting on Kevin Wright's blog (www.rivendell. patch.com). The specific information in that article is not referenced, and some aspects of the blog may represent his personal opinion; however, the general theme matches other published articles, so I am comfortable in relying heavily on his work.

Another great source is the October 1996 article in the *New Jersey Monthly* magazine titled "New Jersey's Waterloo," by Robert Hennelly. This article digs very deeply and insightfully into the personal relationships that Percy had with the high and mighty of New Jersey politics, as well as with important and influential businessmen. These relationships made Percy Leach practically bulletproof. Mr. Hennelly is a superb storyteller, and he has quite a story to tell.

These two sources, along with others, have been combined and condensed into the "vanilla-flavored" summary that follows.

ART VERSUS HISTORY VERSUS POLITICS

The Depression was over. The war had ended. A housing boom was spurred by returning servicemen, eager to settle down and start families, assisted by the excellently crafted veterans' benefits program. People began buying property again.

Percy Leach Arrives

In 1945, a real estate investment company, the Lake Waterloo Association, seeking to take advantage of the booming economy, purchased from the Hackettstown Bank over 1,800 acres of what had been Smith land in Waterloo.[105] It began to subdivide properties for sale. In 1946, a Mr. and Mrs. Percival Leach purchased one of the colonial-era stone houses (the Samuel T. Smith House) as a residence. When their son Percy returned from the service, he became acquainted with the village and, eventually, saw an opportunity for exploiting this community of historic, though decrepit, buildings. Eventually, he and his partner, Louis Gualandi, through their interior design company, Colony House Interiors, began buying up Waterloo property with the intent to renovate the buildings and open them to the public as a historic village.

Their first purchase, in 1962, was an 1840s stone two-family residence (worker's house number one), which they began restoring. The following year, they acquired the Waterloo Hotel (then in the process of being converted into an old age home), followed by the Seymour R. Smith Victorian mansion, along with its carriage barn and ice shed. Next, they added the Peter Smith Homestead and its carriage house and farm barn in 1965.

Their restorations, however, were more geared to showing their expertise as interior designers rather than as historians. They did not attempt to restore the buildings to a specific period, nor did they remove modern amenities or later period additions that were not original to the buildings. Likewise, the furnishings selected were more based on eye appeal than historical accuracy. This is not a criticism of the work that they were doing, only a statement of fact. They were challenged on this point several times by local historians but made a conscious decision to continue renovating buildings as they saw fit and as convenience dictated. This was not a matter of "selling out," as their plan had never focused on strict historical accuracy. They opened a few of the restored buildings to the public in 1964 and continued to purchase

properties. Percy and Louis incorporated the Waterloo Foundation for the Arts in 1967 and transferred the property that they owned to the foundation. However, they continued to be the driving force behind that foundation. By 1969, they had reportedly invested around $2 million of their own money in their project.

The State of New Jersey Arrives

While the above was taking place, in 1962, the U.S. Corps of Engineers, in response to major flooding that had occurred a few years earlier, recommended that a series of dams be constructed along the Delaware River Basin. Included would be a dam on the Musconetcong River at Saxton Falls, a few miles downstream from Waterloo. The water impounded by this dam would completely cover the Waterloo site. In furtherance of this plan, in 1966, the state used the Green Acres Program to acquire the majority of the remaining land holdings from the Lake Waterloo Corporation, including some of the historic buildings at Waterloo that had not yet been purchased by Percy and his partner. The state's initial acquisition included the Smith General Store, the blacksmith's shop, the gristmill and several historic houses. In 1974, it added more purchases to its holdings, including worker's house number two and Peter D. Smith's mansion and carriage house. The state's planned damming of the river presented a threat to Percy Leach's plans for a historical village under his control. The state's plans for the Hackettstown Reservoir at Saxton Falls were eventually abandoned, likely with some assistance from Percy's friends in high places. The state now owned property that it did not know what to do with. Thus began a period of uncertainty over the future of Waterloo Village.

The Foundation for the Arts

Though the restoration of buildings had been the beginning of Leach's plans for the village, the thrust now changed significantly. The foundation's charter was more directed toward cultural and artistic events. Whereas the village itself had previously been the main focus of Percy and Louis, the village now became merely a location to stage other events. Percy, through the foundation, began organizing a series of concerts and festivals, and Waterloo became a popular center for the performing arts.

Eventually, there was a resident orchestra, a school of music for gifted young performers, pop concerts with the headliners being some of the biggest stars of the period, bluegrass festivals, jazz and blues picnics and many other types of events. Percy Leach was well connected with the state's leading politicians, including the governor, and was equally influential with leaders in the arts community, not just in New Jersey but throughout the entire region.

Interests of the State and the Foundation Merge

In 1976, the public's interest in historical buildings and events was energized by the bicentennial activities taking place that year. By this time, the state owned the majority of the historic properties at Waterloo. It could not afford to maintain these properties but was reluctant to give them up in light of the bad press that was sure to accompany such a decision. It had no resources to run a living history museum there, as Percy was doing, and certainly had no desire to be involved in any part of the concert or festival business. The state needed a way out.

That way out was a no-cost lease of the state's Waterloo properties to the Waterloo Foundation for the Arts. The foundation had free reign for improving and operating the site. A significant amount of funding would be allocated in the state budget for building maintenance and other purposes. At that time, Leach claimed that he owned nine of the twenty properties in the village and all the antiques, including those in the state-owned buildings.

Thus began a period of collaboration between the State of New Jersey and the Waterloo Foundation for the Arts. Because of its unusual relationship with the state, the foundation was able to expand without getting approval from planning or zoning boards.[106] In the 1980s, the foundation erected several modern buildings, generally in the open area to the northwest of the historical buildings, to provide services needed by the increasing number of visitors.

With the new steady stream of funding provided by the state, the foundation could upgrade many of the village's historical properties. The foundation repurposed several of the historical carriage barns in the village to display early village crafts, such as broom making, a pottery barn and an apothecary. Knowledgeable guides in period costumes were stationed throughout the village.

Over an extended period of time, the state pumped much money into Waterloo Village for the upkeep of the state's properties, but in reality, much of the state's money was actually going, with or without the state's knowledge or approval, into the arts festivals and cultural events Percy's foundation sponsored and into the buildings that the foundation owned. Whatever Percy wanted, Percy got. Percy was happy. The state was happy (ignorance is bliss). All was right with the world. (A map of the modern-era village is provided in Chapter 8.)

THE FOURTH AND FINAL PERIOD OF DECLINE

2006 to Present

From various accounts, Percy Leach can be described as a brilliant, talented, artistic, flamboyant, persuasive, cunning and politically well-connected individual who basked in the glow of internationally famous musical and artistic friends and acquaintances. His main focus was on the arts and music, not on history. Louis Gualandi, equally talented and more enamored of architecture than arts and culture, seems to have been more grounded in reality and was probably more of a behind-the-scenes, "wait a minute lets look at this some more" type of fellow. He was less outgoing than Percy and probably somewhat limited in his ability to rein in Percy's plans. However, together they made an effective pair, and without them, Waterloo Village would have languished while the historical buildings would have fallen to the bulldozer and been lost forever.

Louis Gualandi died in 1988, and without his voice of reason, there was no one to hold Percy back. The music festivals grew much larger, with the entertainment drawing in a younger, more rowdy crowd. The local authorities were incapable of controlling these crowds, and local residents were becoming quite upset.

In 1981, Waterloo was reported to be on the brink of bankruptcy, but was rescued by a consortium of banks, again probably thanks to Percy's connections. The historical buildings were used as collateral on these loans. In October 1986, an article in the *New Jersey Monthly* by Tom Dunkel questioned the level and use of state funding that was being given to the Waterloo Foundation for the Arts. Local newspapers began to dig deeper into Waterloo's operations, as were some minor voices in state government.

In 1993, there was an issue with the foundation's inability to account for a $300,000 grant from the state. Though this issue was later resolved, a state audit of the foundation's books showed additional bank overdrafts and technical insolvency. This led to the cancelation of several events and activities during the 1994 season and brought the foundation under intense scrutiny. A former state treasurer, Clifford Goldman, was named acting director of the foundation, though Percy continued as president.

In 1996, in an effort to quell the continuing complaints of the local residents, the foundation was forced to place a limit on the number of people attending rock concerts. In 1997, the New Jersey Performing Arts Center opened in Newark, and many of the cultural, operatic and classical music performances began to shift to that venue. In the next few years, especially after the 9/11 terrorist attack, attendance at Waterloo events, including the living history museum, declined, reflecting a general trend seen in other concert and festival venues around the country.

Between 2000 and 2006, the foundation had received $303,000 in state funding for building repairs, and between 2003 and 2006, it received $900,000 for general operating expenses. The state budget forecast for 2007, under a new governor, did not allocate funds for Waterloo, and the foundation's management notified the state that Waterloo could not continue operations.

On December 31, 2006, the contract between the state and the foundation was terminated, Waterloo Village was closed and the state assumed ownership. Waterloo was a victim of poor management, lack of state oversight, dreams that went beyond reach and pervasive insolvency. A short time later, in February 2007, the visionary Percy Leach passed away at age eighty.

Upon cancellation of the agreement with the state, the foundation, believing that it was the owner of all of the furnishings in the village buildings, loaded them into trailers and removed them from the village. The state sued but eventually, due to lack of adequate record keeping, was not able to prove ownership. In 2008, the foundation was allowed to sell over four thousand items at auction to pay off its debts. Fortuitously, the Canal Society of New Jersey, using its own money, was able to buy back many of the items at auction, and these artifacts were restored to the Rutan Cabin and the Smith General Store.

WHERE WE ARE TODAY

Since the closing of the village in 2006, Waterloo Village has been operated as a state park. The term *operated* is a bit misleading. Visitors are free to picnic along the beautiful banks of the old canal or just walk among the old buildings. However, the buildings themselves are not open to the general public, and until recently, no state employees were stationed there.

Several of the historical buildings have fallen into an advanced state of disrepair. In 2008, the state Department of Environmental Protection repaired and expanded the replica Indian village that had been one of the most popular draws and made structural repairs to several other buildings, but much more needs to be done to save the village as a viable future display of history. Kevin Wright in 2011 expressed his disgust when he wrote, "After an investment of perhaps $10 million in taxpayer money, Waterloo Village now looks more like Desolation Row than a thriving heritage village."[107]

In 2012, things began to improve when four staff members were assigned to Waterloo. This included a full-time resource interpretive specialist, who acts as the coordinator for activities at the village, aided by a part-time employee and two full-time maintenance workers. Tours can be arranged with the on-site coordinator, and selected buildings are opened as part of those tours, but only for those who are members of the tour.

The Canal Society of New Jersey, with approval from the state, hosts an annual "Canal Day" at Waterloo on the last Saturday of June, and Heritage Day events at Waterloo on the second and fourth Saturdays from July through October. At these events, several of the village buildings are open and operating, such as the gristmill, the general store, the blacksmith's shop and the Canal Museum. There is a pontoon boat ride on the stretch of canal. All buildings that are opened on these days are staffed by volunteer guides from the Canal Society, and they are very familiar with the history of the canal and the village.

Additionally, other activities are provided, such as craft exhibits, historical presentations, vintage baseball and period music performances. Most of the craft exhibits are likewise provided by volunteers who dedicate their time showing off their skills. Some of these craftsmen are volunteers, while others are paid a small honorarium, and their attendance depends on their personal schedules.

The Canal Society, along with the Friends of Waterloo Village, another volunteer organization, hopes to preserve the history of the village and, where possible, assist the state in protecting and/or restoring the buildings and facilities.

8

The Buildings at Waterloo Today

In this chapter, I will describe and discuss in detail the history of each of the key structures that existed or still exists at Waterloo.

In the earlier maps and narrative discussions of the various eras, I tried to follow the progress of the village in chronological order. I am now going to deviate from that approach. This chapter and map six provide descriptions of the existing buildings listed in the order that I would expect a visitor to follow during his or her tour of the village. Of course, this guide is just a suggested sequence—you are certainly welcome to wander about aimlessly, haphazardly and without a clue if you so wish.

The description of the colonial-era forge, which was originally located where the sawmill (17) now stands, is included separately as Appendix E due to the length and depth of its description.

1. Waterloo Methodist Episcopal Church and Cemetery, circa 1859

The majority of the residents of Waterloo, led by the Smith family, professed the Methodist faith. In the early years, Methodist circuit riders (saddlebag preachers) would deliver sermons from courthouses, barns, fields or haystacks.[108] As settlements developed, the preachers would tend to their flocks from private residences, though a regular schedule was difficult to

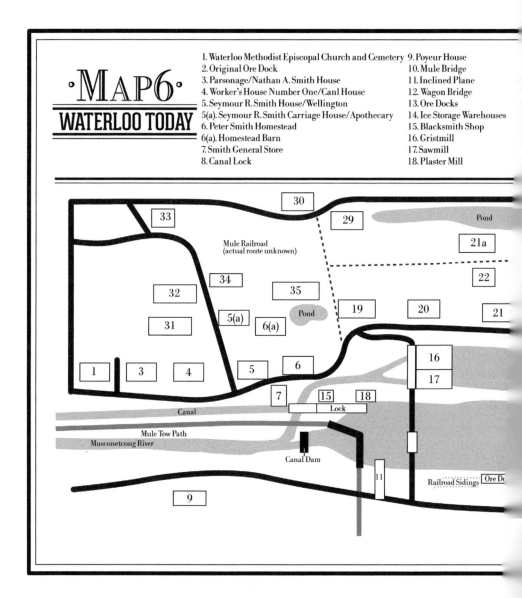

·MAP6·
WATERLOO TODAY

1. Waterloo Methodist Episcopal Church and Cemetery
2. Original Ore Dock
3. Parsonage/Nathan A. Smith House
4. Worker's House Number One/Canl House
5. Seymour R. Smith House/Wellington
5(a). Seymour R. Smith Carriage House/Apothecary
6. Peter Smith Homestead
6(a). Homestead Barn
7. Smith General Store
8. Canal Lock
9. Poyeur House
10. Mule Bridge
11. Inclined Plane
12. Wagon Bridge
13. Ore Docks
14. Ice Storage Warehouses
15. Blacksmith Shop
16. Gristmill
17. Sawmill
18. Plaster Mill

maintain. In 1835, a Methodist church was built in Lockwood, several miles from Waterloo. This provided an important measure of stability in the religious lives of the Waterloo faithful, but traveling to Lockwood in bad weather was still a challenge.

When a stone schoolhouse was built at Waterloo around 1842, it soon became a place for religious worship. Alas, the little unheated schoolhouse was totally unsuited for this purpose. Efforts were made

19. Waterloo Hotel
20. Worker's House Number Two
21. Peter D. Smith House/Maples
21(a). Peter D. Smith Carriage House/Blue Barn
22. Jake's Cottage
23. Samuel T. Smith House /Ironmaster's House
23(a). Samuel T. Smith Carriage House/White Barn
24. Tennant House /Canal Musuem
25. Tennant House/Administration Building
26. Waterloo Estates Cottage and Barn
27. Lenape Indian Villiage
28. Village School
29. Rutan Cabin
30. Farm Buildings
31. Meetinghouse
32. Comfort Station
33. Pavillion
34. Gazebo
35. Farm Barn

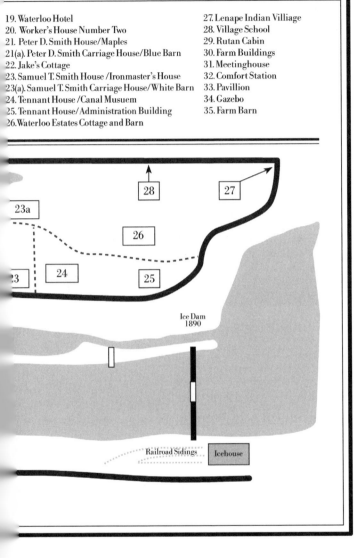

in 1855 by the village leaders to raise money for construction of a real church, but without success. Finally, in 1859, spurred by pledges from John Smith, Peter Smith, Samuel T. Smith and many other community leaders at Waterloo, sufficient funds were raised to begin construction. Peter Smith donated the land, deeding a third of an acre to the church trustees in August 1859.[109] The construction contract was awarded to Clawson & Hazen of Hackettstown. The church cost $2,800 to construct and was dedicated on February 9, 1860. At the time of dedication, it was debt free.

The cemetery at the rear of the church contains graves dating back to the time the church was dedicated. The first burial was that of John Smith, first patriarch of Waterloo's Smith family.

The church has held services continually for 154 years, including up to today. Services are held every Sunday at 10:00 a.m. (9:30 during the summer), and all are invited to attend. The beautiful church, located on the scenic canal, is also a popular venue for weddings. If you are planning to

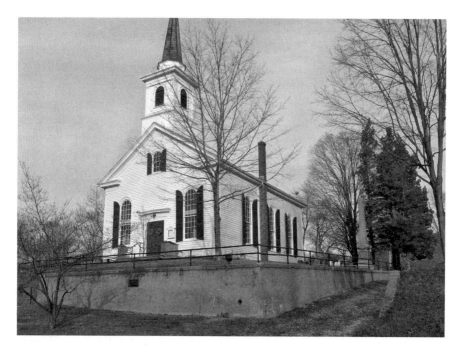

Waterloo Methodist Episcopal Church. It has been holding services for 154 years. *From the author's collection.*

visit Waterloo on a Sunday, attending services here and talking to the local congregants would be a good way to start a memorable day.

2. THE ORIGINAL ORE DOCKS, CIRCA 1850 (NO TRACE REMAINS TODAY)

The road that runs between the church and the parsonage was at one time the rail bed for a mule-powered railroad that was built in the late 1840s, before either building existed. The rail line ran from the Andover mine to the ore-loading dock on the bank of the canal. Here iron ore from the mine would be loaded onto canal boats and transported west to the furnaces and steel mills in eastern Pennsylvania. In 1854, the railroad route was altered to cross the Musconetcong River east of the village and terminated on the south bank of the canal lock pond, where new ore docks were built.

3. The Parsonage, circa 1860
(Also Known as the Nathan A. Smith House)

The next building along the road, just east of the church, was originally a two-family timber-framed residence built around 1860. There is a two-story addition on the back of the structure, and it has renovations dating to the modern era. It was occupied by Nathan A. Smith, youngest surviving son of Peter Smith, following his marriage in the late 1860s. It currently is used as a parsonage for the Methodist church next door. A brochure produced by the Waterloo Foundation for the Arts says that railroad station manager William Gray lived here in the late 1850s, though there is no supporting evidence for that claim. It is privately owned by the church trustees and is not open for visitors.

The parsonage was originally a two-family home. Nathan A. Smith lived here after his marriage, around 1868 or 1869. *From the author's collection.*

4. WORKER'S HOUSE NUMBER ONE, CIRCA 1840 (ALSO CALLED THE CANAL HOUSE)

This structure, also on the left side of the road, is one of two residential structures that originally were identical in design and construction. The designation as "worker's house" was assigned by the historical architects who studied the village and is not a very attractive title. The house's construction was in response to an increase in commercial and industrial activity in the region, spurred by the 1831 opening of the canal.

This was a two-family house built of stone, and apparently, the designers felt that function, rather than form, was paramount. It lacks any aesthetic pretenses. It filled the need for additional living space in the village and was probably occupied by skilled workers rather than by any member of the Smith family. There are some modern alterations, such as the shutters, sills and roofing, but it generally retains its original footprint and appearance. There are three levels, including a below-grade basement entrance at the front of the structure.

The name of "the Canal House" was likely chosen by the Waterloo Foundation for the Arts, when it operated Waterloo as a living history museum.

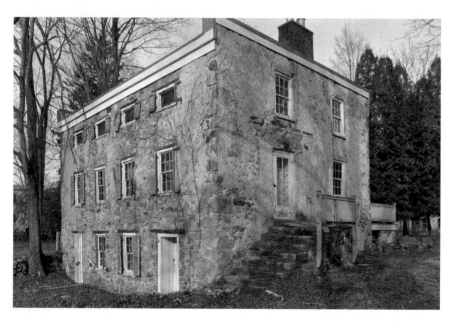

Worker's house number one was one of two two-family residences built around 1840 to house workers in the growing village. *From the author's collection.*

This is understandable as the original promoters of the village during the 1970s and '80s were interior designers, keen on public opinion. Thus their brochures would certainly not have referred to this building as a worker's house. This building was their first purchase. (The companion, worker's house number two, will be discussed later, as it is farther up the road.)

5. SEYMOUR R. SMITH HOUSE, CIRCA 1876 (ALSO CALLED THE WELLINGTON)

The next building along the route is the Victorian-era mansion built by Seymour R. Smith, grandson of John Smith and third oldest of Peter Smith's sons. Samuel was born in 1833 and, along with his brother Peter D., operated the Smith General Store and the mills. He married in 1873, and construction on this popular Italianate-style mansion would have been started shortly afterward to house his family. This residence is an example of the wealth that had been created by the Smith family from their early days

The Seymour R. Smith House is a Victorian-era mansion in the popular Italianate style. Sections may have been built on an earlier foundation. *From the author's collection.*

as farmers, then wealthy landowners and finally as scions of the canal-era family with businesses centered at Waterloo Village. The historical architects tell us that the center portion appears to be raised on an earlier foundation.

I am not sure how the building came to be known as the Wellington. You may recall that the Duke of Wellington was the victorious British commander at the 1815 Battle of Waterloo. Perhaps this building's name was selected by Seymour to continue the Waterloo theme, or perhaps it was selected by the foundation.

5(a). Seymour R. Smith Carriage House, circa 1880 (Also Referred to as the Apothecary)

Located some distance behind and to the left of the main house, this gentleman's barn was built at the same time, or shortly after, the main house was built. Note the architectural detail of the cupola, which also attests to the Smith family wealth. It has twentieth-century additions on its east side.

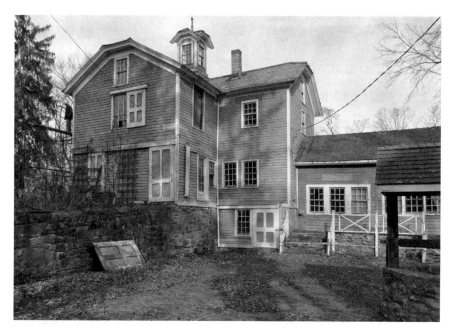

The carriage house for the Seymour Smith House, with later addition. *From the author's collection.*

During the living history period, it was used to display items that would have been found in an early American apothecary and also was used to demonstrate herb drying.

6. The Peter Smith Homestead, circa 1761

The next building on your left is the homestead. This was one of the three stone two-family residences that were constructed during the forge era. (The other two are the Hotel and the Samuel T. Smith House.) The historical architects who have studied these buildings indicate that they were each built as two-family residences and each built in two stages. The two-stage construction would indicate that the first stage was probably built around 1761, the same time that the forge was being built, and that the second stage was probably added a few years later as forge and mill operations matured and the village started to grow. These three stone residences were ranged along the higher elevations on the north side of the village road and are oriented facing the industrial complex on the riverbank below.

Of the three original stone residences that formed the core of the colonial-era village, the homestead was the farthest to the west. At some point in the 1770s, it was converted into a barn, as it is described in a 1782 lease agreement as "Jack Cook's stone house that is now a barn."

This residence was probably converted back from a barn to a single-family home sometime during the early canal period, when the Smith sons moved from New Andover to Waterloo. Kevin Wright, in his six-part Internet series, states that "in 1832, Nathan Smith remade an old stone barn of the Andover Iron Company into a dwelling, later known as the Smith Homestead." If this is correct, then Nathan may have lived here until his death in 1852, and Peter may have then moved into this house. Peter became the principal operator of the village industries from the late 1840s, when his father, John, began handing over the reins to him, and he became the Smith family patriarch in 1859 when his father died.

Peter lived here until his death in 1877. His will, drawn up in 1875, gave his wife, Maria, use of the house for her lifetime and then ownership passed to their daughter Matilda. The 1880 census shows Maria, Matilda, her husband (Ogden Van Doren) and infant daughter Carrie living in the homestead. Maria died in March 1900. In the 1900 census, Matilda and her

The Peter Smith homestead is one of the three original 1760s two-family residences, though it has undergone many major renovations. *From the author's collection.*

husband and daughter were living in Newark. In that census, all the village residences are rented out, except Peter D. Smith's house.

The building was upgraded many times over its history, with the later period architectural enhancements and interior furnishings being appropriate for the residence of a distinguished gentleman of those times. Among the later additions were the bay extensions at the left front and the right corner, added during the Victorian era. The porch was also added in later years.

6(a). The Homestead Barn, circa 1860

This barn is situated just behind and slightly to the left of the homestead and served as the carriage house for that residence. During the living history museum period, it housed a craft display for broom and cabinet making.

As you return to the dirt road that you have been following, look back at the homestead and then look left at the previous two buildings that you have toured. From where you are standing you can see a colonial-era residence built during the forge era around 1761 (the homestead), a Victorian mansion

The Peter Smith homestead barn. *From the author's collection.*

built around 1876 (the Seymour R. Smith House) and a worker's house built in 1840 during the early canal days—all without moving a step. How much history these three buildings must have witnessed.

Having finished your inspection of the homestead, move across the road to the stone building directly across from the homestead. This is the Smith General Store.

7. The Smith General Store, circa 1831

One of the most fortuitous decisions by General Smith was to build a general store hard on the north bank of the new canal, just west of the lock. While several existing buildings were relocated or repurposed to fit the needs of the canal and the revitalized village, the store was purposefully built. It represented a significant investment in a new business.

The Smith General Store was built in 1831 to take advantage of the expected canal traffic. *From the author's collection.*

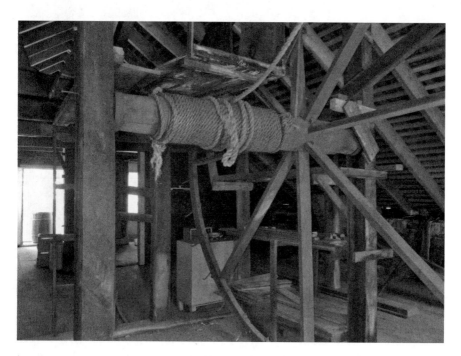

A wheel-and-pulley system in the top level of the store was used to load or unload boats docked at the back of the store. *From the author's collection.*

This three-level stone building was opened around 1831, just as the canal came into full operation. Boat captains awaiting transit through the lock or plane or overnighting in the canal pond could conveniently shop in the store for foodstuffs or whatever else was needed. Additionally, the increased number of travelers to or through the village, along with the increasing number of village residents, provided a steady flow of commercial trade handled through the store.

The store featured a large wheel-and-pulley system in the top level that facilitated loading and unloading of boats. Unlike most stores along the canal, the one at Waterloo allowed boats to tie up to the back of the store and load or unload cargo into or out of the store without requiring any intermediate transfer by wagon.

Beginning in 1847, the store also functioned as the village post office, with Peter Smith as the first postmaster. By the middle of the nineteenth century, this store had certainly become a key focus of the village's economic and social life. When the railroads later came to the village, train tickets could be purchased here, and the store would also arrange transportation to the Waterloo station for those who did not wish to walk.

Samuel T. Smith purchased the store from his father in 1853 and operated it until he sold it to his brothers Peter D. and Seymour R. in 1874. It was leased out to a Mr. Cassedy in 1898, and he operated it until 1916. In the 1920s, it was operated by Shafer C. Smith, son of Joseph Smith (one of the "mountain" Smiths). In the 1930s, it was used as a New Jersey Forest Fire headquarters. It was one of the first two buildings to be restored after the State of New Jersey acquired it in 1964.

The various census reports that appear to cover Waterloo Village show the following village residents listed as store workers, with their ages in parentheses:

- 1850: Charles Kern (thirty-five), clerk
- 1860: John Burrell (forty-one),[110] clerk
- 1870: none listed
- 1880: Census not complete
- 1890: Census not available
- 1900: Linn Cassedy (thirty-seven), merchant; George P. Smith (eighteen), clerk
- 1910: Linn Cassedy (forty-seven), grocery store; Charles Hoagland (sixty-eight), store clerk

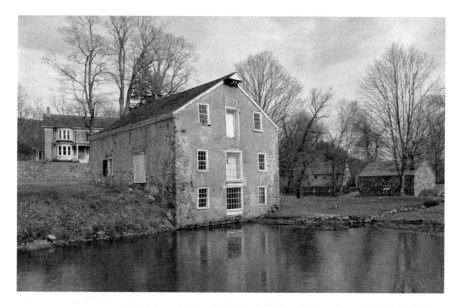

The Smith General Store, with the homestead to the left and the gristmill and blacksmith shop to the right. *From the author's collection.*

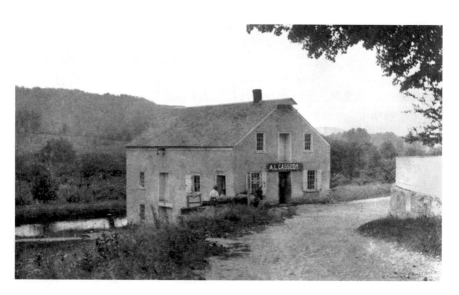

The Smith General Store after being leased to Linn Cassedy, late 1800s to around 1916. *Courtesy of the Canal Society of New Jersey.*

The Waterloo Foundation for the Arts, upon its lease being canceled by the state, removed all the furnishings and antiques from the village and auctioned them off to pay the foundation's debts. When the Canal Society of New Jersey learned of this, members attended the auction and, with society money, bought as many items as they could afford. These items now populate both the Rutan Cabin and the General Store.

This would be a good time to explore the remains of the canal infrastructure. Follow the road that passes along the left side of the store, down toward the canal, until you a see a small man-made waterfall on your left.

8. The Canal Lock

The shallow stone channel that you see water pouring from is the remains of the canal lock. It originally was about twelve feet deep but was filled in with rubble when the canal was abandoned. The masonry lock is eighty-seven feet in length and had a forty-five-and-a-half-foot timber aqueduct

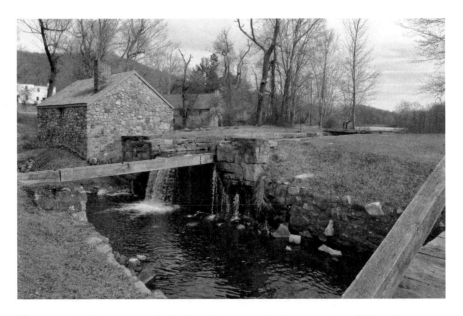

The west end of the masonry lock. The timber aqueduct (now gone) would have been joined to the lock at this point and spanned the tailrace below. *From the author's collection.*

attached that spanned the tailrace passing under it. The two rows of stone on the ground outline where the sides of the aqueduct would have been, and its depth would have been well below the level of the canal. There was a drop gate on the pond side of the lock and miter gates on the canal side of the aqueduct. It's really hard now to imagine what the lock and aqueduct looked like before they were dismantled, but you can understand that, at one time, there was a very robust structure where you are now standing.

9. THE POYEUR HOUSE, CIRCA 1860

Of similar design to other 1860s timber-framed residences constructed in the village (which you will see later on your tour), this single-family dwelling was built on the south side of the river. Its location places it at some distance from the village itself, and it is the only surviving residential structure on that side of the river. Its residents were likely employees of the canal company. Though it still stands, it is not clearly visible from this side of the river, being obscured by trees.

Now continue across the small wooden bridges and move to your left, to a point of land on the edge of the lock pond, where the ramshackle wooden bridge spans the pond.

10. AND 11. THE MULE BRIDGE AND THE INCLINED PLANE

This mule bridge was built in 1978 and is a replica of the original bridge used by mules and pedestrians to cross from the lock to the other side of the pond, where the inclined plane was located. Unfortunately, this replica bridge is in too poor a condition to allow people to cross, so there is no access to the Morris County side of the river for the casual visitor.

In the winter and early spring, before the trees are fully leafed, you can look across the pond and see the trace of the inclined plane ascending the ridge opposite you (just to the left of the mule bridge in the photo). That plane leads to the upper stretch of canal, some eighty feet above the water level in the pond.

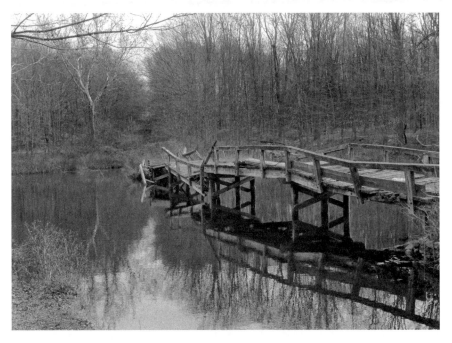

This photograph shows the replica mule bridge built during the 1970s and the inclined plane leading up Schooley's Mountain. *From the author's collection.*

The various census reports that appear to cover Waterloo Village show the following residents listed as canal workers, with their ages in parentheses:

- 1850: James Brown (twenty), lock tender; Samuel Stout (twenty-two), boatman
- 1860: James (?) (twenty-eight), boatman
- 1870: Charles Dublin (forty-four), lock tender; James Medlay (forty-five), canal boatman; Charles Smith (thirty-five), canal boatman
- 1880: Census not complete
- 1890: Census not available
- 1900: Arthur Hunt (twenty-nine), canal lock tender
- 1910: No listing after 1900

12. WAGON BRIDGE

Prior to the construction of the canal, there was a footbridge spanning the river, probably near the gristmill. When the canal dam was built, widening the river, that bridge was probably replaced by a footbridge that was erected over the top of the lock that provided access from the village to the mule bridge and from there to the Morris County side of the river.

If you look upstream, you will see bridge abutments jutting into the lock pond, but no bridge. In the 1850s, the Sussex Railroad built a wagon bridge here to allow the passage of wagons and carriages between the village and the new Waterloo train station, located about a half mile farther downstream. The abutments seen today are from that period. After its construction, the footbridge over the lock was no longer needed and eventually removed. The wagon bridge collapsed in 1964 due to an overloaded dump truck.

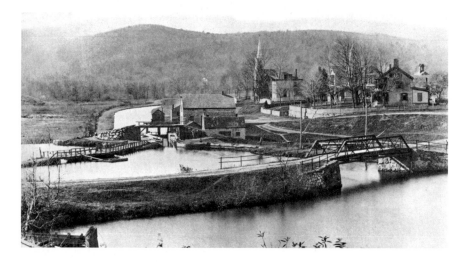

Picture of the wagon bridge, taken from the ore dock on the south side of the lock pond. *Courtesy of the Canal Society of New Jersey.*

13. ORE DOCKS

The original mule-powered Sussex Mine Railroad was replaced in 1854 by a steam engine, running on new tracks that had been rerouted away from the village. The new track alignment passed east of Lake Waterloo, and its

abutments are visible from Waterloo Road, about two hundred yards west of the intersection with Continental Drive. The tracks crossed the marshy area on a causeway and then followed the southern shore of Lake Waterloo to the new ore docks (located just beyond the wagon bridge abutment). There is no visible trace of the ore docks from the north side of the river, and the lack of easy access to the south shore prevents casual investigation of this site, as well as the next site, the ice-harvesting buildings. The photo of the wagon bridge (on page 120) was taken from the ore dock, with part of the rail siding visible at the bottom corner.

14. Ice Storage Warehouses

If you look even farther upstream, you will see the remains of the dam used to create the ice pond. Ice-harvesting facilities, which were established in the late 1880s, included five ice storage buildings, powerhouses, administration offices and rail sidings, all of which were located on the south side of the river, across and about a quarter mile upstream from the main village.

The various census reports that appear to cover Waterloo Village show the following residents listed as working in the ice business:

The dam built for ice harvesting and the five ice storage buildings. They were built around 1890. *Courtesy of the Canal Society of New Jersey.*

- 1900: No workers listed, though in this census, Peter D. Smith lists his occupation as "ice dealer." The commercial harvesting of ice at Waterloo was just beginning at this time.
- 1910: Edward Best (twenty-eight), icehouse superintendent; Harrison Smith (forty-one), icehouse foreman; Walter Burge (thirty), icehouse foreman[111]

The Smith family, as principals in the Waterloo Ice Co, operated the ice-harvesting business at Waterloo and Panther Pond from about 1889 to about 1901. They then ended their twelve-year venture in ice harvesting, though continued to lease their land at Waterloo to the North Jersey and Pocono Mountain Ice Co., a company not related to them. The ice workers living in the village in 1910 worked for that latter company.

15. THE BLACKSMITH SHOP, CIRCA 1780

The shop that exists today is not the original one but a replica that was built for the living history museum.

An advertisement in the *Pennsylvania Gazette* dated October 4, 1770, advertised the forge property for lease. In the advertisement, the site is described as having a forge, large tracts of well-timbered land, a gristmill and sawmill. There is no mention of a blacksmith shop. The earliest reference to the existence of the blacksmith's shop is a 1782 lease agreement. The location of the blacksmith's shop was not indicated in that agreement, so its exact location is subject to guesswork.

What that lease agreement did describe was a combined blacksmith shop and magazine, measuring twenty-one by forty-five feet. The reference to a magazine is intriguing. There is no other documentary evidence that indicates why the magazine was in the village or what it was used for. The 2013 Application for Boundary Increase speculates that the magazine may either have dated from the Revolutionary War period when military defense of the forge was needed or, less likely, the 1760s during the French and Indian War, when the settlement was on the frontier.[112]

This explanation doesn't take into account that any military munitions would have been stored under military guard, and there is no documented evidence that any soldiers were ever stationed at or near Waterloo prior to the Civil War. Since others are speculating, I will do the same. Perhaps the

The blacksmith shop was rebuilt in the 1970s. *From the author's collection.*

magazine was used to store black powder used in blasting. Construction of various buildings and the water channels for the tailraces serving the forge and mills may have required such blasting and, therefore, would require secure storage facilities for the powder.

I am also speculating that the magazine may have been a separate wooden structure that shared the same roof as the blacksmith shop. It does not seem likely that black powder would be stored in the same building as an operating forge, where there are white hot metal, glowing coals and flying sparks. As a matter of fact, I would not even store black powder in a structure sharing a roof with a forge. So the issue of what a magazine was doing here will go unanswered. It is well known that Colonel Jacob Ford built a powder mill near Morristown in 1776 and that this was only the beginning of an industry that remained in the Morris County area for over two hundred years.

The next question is where the colonial-era blacksmith shop was located. The original blacksmith shop was rebuilt by the Smiths in the 1830s. There is a photograph of that blacksmith shop, dated around 1900, and it shows the shop at that time, with no roof and the stone walls crumbling. It was rebuilt again, on the same site, for the living history museum and is still operational. The current shop is twenty-one feet deep, the same as the original 1780s shop. It appears that Smith rebuilt his blacksmith shop on the original

colonial-era foundation. Additionally, we know that, with the coming of the canal, both the gristmill and sawmill had to be relocated. However, nothing is mentioned about relocating the blacksmith shop. That could support the assumption that the Smiths rebuilt it on the original foundation.

The width of the current building, however, does not match the one in the 1782 lease agreement, now being twenty-seven feet wide compared to the original forty-five feet. This difference could be explained if there was an eighteen-foot wooden extension added to house the magazine. If that's true, then the wooden structure was removed some time later, perhaps when the mill tailraces were reconfigured with the coming of the canal.

The various census reports that appear to cover Waterloo village show the following residents listed as blacksmiths, with their ages in parentheses:

- 1850: Terry Horton (fifty-four), blacksmith; (?) Chamberlain (twenty-two), bloomer; Jacob Lyon (twenty-four) and Philip Lyon (nineteen), blacksmiths (both staying at the hotel)
- 1860: Samuel Stackhouse (thirty-three), blacksmith; Isaac Hull (nineteen), blacksmith
- 1870: Samuel Stackhouse (forty-three), blacksmith
- 1880: Byram Pitney (fifty), blacksmith
- 1890: Census not available
- 1900 and later: no blacksmith listed

Now retrace your steps back to the main road that passes the store, turn right and continue your tour. The next building, on your right, is the gristmill.

16. THE GRISTMILL

Originally this was the 1760s charcoal house, which was used to store charcoal needed for the forge that was located next door. Early documents reveal that the charcoal house measured forty by seventy feet, and those dimensions exactly match today's gristmill.[113] Since wet charcoal won't burn, charcoal houses were built watertight. They also were quite large, providing space to spread out the charcoal, to aid in drying (and also to help spot any embers). After the forge was abandoned around 1795, both the charcoal house and the forge fell into disrepair. When John Smith rebuilt the gristmill prior to 1831, the major grains processed were wheat, corn, rye and

Background on Gristmill and Sawmill

Almost all early furnaces and forges generally had a gristmill or sawmill, or both, located with them. Since water was being diverted to power the forge bellows and hammers, it was a simple next step to take advantage of the water power to operate a mill, thus increasing the forge owner's income. According to the 1782 lease agreement, both mills at Waterloo were operated by a single flume. They are thought to have been timber-framed structures located somewhere between the blacksmith shop and the current stone gristmill. Nothing else is known about the original gristmill, such as how many grinding stones it contained.

The construction of the canal lock interfered with the tailraces from the mills, and the canal company was required to reconfigure them. Nothing indicates that the canal company was required to relocate the mills themselves, so that may have been something that John Smith decided to do on his own. The old charcoal house was renovated and reconfigured as the new gristmill prior to 1831, as the January 1831 agreement with the canal company mentions "the seat of the old gristmill." The foundation of the old forge, which adjoined the south side of the charcoal house's foundation, was used as the foundation of the new sawmill.

buckwheat. Peter Smith operated the mill and updated it again in 1863, with the upgrade being overseen by his son Peter D. Smith, who reportedly was quite mechanically capable. In 1870, the gristmill was reported as operating with three grinding stones.[114]

The gristmill was completely restored in the mid-1970s by Charles Howell, according to a website dedicated to his memory.[115] The funding for this was provided by a grant from Nabisco. At that time, there was no attempt to restore it to its original configuration, and instead it was restored using the same design as a mill that existed at Phillipsburg Manor. In the basement of the gristmill, in a departure from authenticity, an open hearth was added. A working gristmill would never have had an open flame due to the risk of dust explosion.

Samuel T. Smith, Peter's oldest son, bought this mill from his father in 1853, and in 1874, he sold it to his brothers Peter D. and Seymour R. Though the

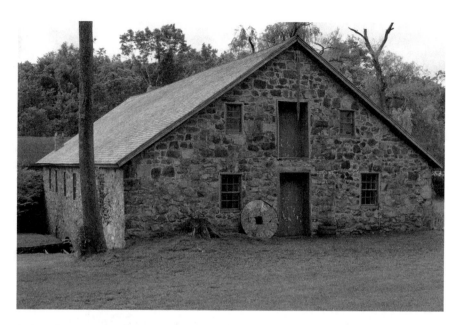

Artists often used this popular view of the gristmill to sketch, paint or photograph. *From the author's collection.*

mills were owned by the Smiths, they may have leased them out from time to time, as an article in the *Sussex Register* dated August 6, 1856, lists Charles D. La Rue as the leaseholder of the mill. Whether he actually leased the mill or merely managed it for the Smiths is not known. The newspaper article read as follows: "Charles D. La Rue, lease holder of Waterloo gristmill, had his left arm torn off below the elbow by entanglement in the gearing."

Apparently being around mills was a hazardous undertaking, as an article in the same paper, dated May 21, 1868, said:

> *Miss Crater, a young lady engaged in teaching school at Waterloo entered the plaster mill of Samuel T. Smith, in company with Mrs. Hunt, wife of the Miller. While looking at the crusher her clothing caught in the shaft…and [she] was doubled completely around it…for three or four minutes, her hair sweeping the floor and her feet just touching, the shaft making about fifty revolutions per minute. Mrs. Hunt, in an effort to release Miss Carter, was struck violently by the shaft and somewhat hurt…Miss Crater was saved…but was unconscious for many hours afterward, and suffered much from her experience.*

The various census reports that appear to cover mill workers living at Waterloo show:

- 1850: Joseph Smith (fifty), miller (no relation to John Smith); George Raymond (forty-seven), millwright
- 1856: Charles D. La Rue, miller, per above article in the *Sussex Register*
- 1860: John Vandover (forty-five), miller; Odem Vandover (nineteen), miller
- 1868: William Hunt, miller, per above article in the *Sussex Register*
- 1870: William Hunt (forty-five), miller; Elmer Hunt (twenty-three), unspecified gristmill laborer
- 1880: Census not complete
- 1890: Census not available

The mill closed around 1896,[116] and the 1900 census does not show any mill workers living in the village.

17. The Sawmill

It is not known if the single-blade sawmill was in constant operation throughout the same period, but it was still in operation in 1910 and apparently burned in 1917.[117] A replica sawmill was built in the 1970s as part of the living history museum on the same site as the 1830s timber sawmill. The historical architects believe that successive sawmills may have reused portions of the old forge foundation.[118] The original forge measured thirty by fifty feet, and those dimensions are very close to those of the current sawmill.

The various census reports that appear to cover Waterloo Village show the following residents listed as "sawyer" or "sawmill worker":

- 1850: John Slack (twenty-eight), sawyer
- 1860: none listed
- 1870: none listed
- 1880: Census not complete
- 1890: Census not available
- 1900: Jacob Fisher (forty-four), sawyer
- 1910: Walter Bellis (thirty-three), sawmill foreman

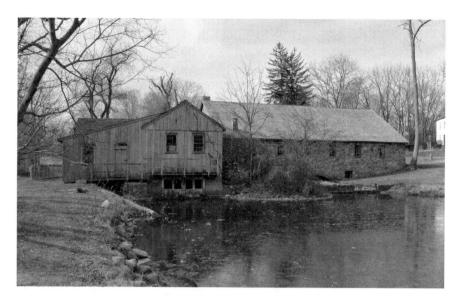

The sawmill (on the left) and the gristmill, taken from the head of the millpond. *From the author's collection.*

The seemingly endless supply of wood available on the early frontier led to the mismanagement of resources. After a few furnaces were forced to close for lack of fuel, the owners began to adopt better practices as had been followed in Europe for many years. By then, however, it was too late to benefit some of the already affected forests.

Large trees were not suitable for charcoal making, so if a sawmill was not located nearby, the large trees would have been left standing. Hardwood trees with a diameter of twelve to twenty-four inches would have been felled by the woodcutters, who were usually employees of the mill. The early forge owners would also purchase timber from nearby wood lot owners in order to make their own timber holdings last as long as possible.[119] Similarly, when a sawmill was leased out, the owner, in an effort to preserve his timber, often included in the lease agreement that he would compensate the leaseholder a specific amount for wood the leaseholder purchased locally. (In the 1782 lease agreement, the company offered to reimburse the leaseholder six pence for each cord of wood he purchased from a neighbor.)

If there was a sawmill nearby, those larger trees would be felled, milled and used for construction of company buildings, sold locally or, especially after the canal was built and transportation of lumber became more economical, shipped to large cities. This clearing of the land then led to

increasing emphasis on commercial farming and increased profits from the mill operations but was to the detriment of mining operations.

18. The Plaster Mill (No Trace Exists Today)

The Smiths operated a plaster mill at different periods of time, even up to the early twentieth century. There is a photo from 1905 that shows a pile of limestone blocks on the banks of the pond, waiting to be ground up. The mill itself was located about halfway between the blacksmith shop and the sawmill. The mill ground Nova Scotia limestone, brought to the village by canal boats, to be added as soil sweetener for cornfields. There is no trace of this mill remaining. The historical architects state that the plaster mill operating in 1870 had two grinding stones.[120]

19. The Waterloo Hotel, circa 1761

This structure—also known as the Dwelling House, the Andover Forge Mansion House, the Canal Tavern or the Stagecoach Inn—was built at roughly the same time as the homestead also in two stages and also with the same floor plan and purpose as the homestead. To the rear is a two-story wood-frame addition, also constructed in two parts.

The 1782 lease agreement mentioned all three colonial-era residences, but in that description, this building is the only one that included any mention of supporting structures. The lease agreement described it: "the dwelling house measuring 25 by 35 feet in plan, a smokehouse and two log stables behind the dwelling house, a kitchen belonging to the dwelling house measuring 18 by 30 feet." The kitchen and other outbuildings are long gone.

Of the three early structures, this building was the most centrally located, directly above and overlooking the early forge and charcoal house (now the stone gristmill). The next mention of this residence was an 1820 deed in which Hannah De Camp took half ownership of a plot containing the "Andover Forge Mansion House."[121] In later periods, around 1837, an extension was added. There are some disagreements on the purpose of this addition. Most reports state that, during this period, it was used as a stagecoach inn, with a tavern on the ground floor and dormitory-style housing above.

The Waterloo Hotel as it looks today. *From the author's collection.*

However, Kevin Wright offers a different opinion. He states in his Internet blog that "Waterloo first became a stagecoach stop on the route from Morristown to Stroudsburg, Pennsylvania, in 1847. This was a dwelling house in [the] eighteenth century and not a stagecoach inn." He goes on to state that the building was licensed to Charles Crane in 1847 "to keep an inn and tavern in the Tavern House wherein Samuel B. Hubert now dwells…and owned by John Smith and Sons."

At a risk of misinterpreting his comments, I think he is saying that the 1837 addition was used as a tavern while Samuel Hubert occupied the main building as his residence. Then, in 1847, concurrent with the establishment of a stagecoach stop at Waterloo, Charles Crane leased the entire building to be used as an inn and tavern. From that time onward, documents referred to this building as the Waterloo Hotel; therefore, it was never really called a stagecoach inn. My apologies to Mr. Wright if I am incorrect in this interpretation.

The hotel was adjacent to the main road intersection, with Heritage Road running alongside the hotel and intersecting with Waterloo Valley Road, then continuing past the gristmill and over the bridge to the southern bank

of the river. Because of its prime location, and the number of outbuildings, it is likely that it originally was the forge manager's house during the forge era and was probably the focal point of the early village activities. The forge manager would have had overall responsibility for the forge, mills and farm.

The hotel appears to have been leased out, as the Smiths did with many of their business properties, as the proprietor changed several times. A review of census records shows the following:

- 1850 census: Between 1845 and 1860, the canal was enlarged along its entire length. This must have been a busy time for the Waterloo Hotel, with many travelers and canal workers passing through or working in the village. The 1850 census shows that it was operated by Charles Crane; his wife, Sarah; their sixteen-year-old son, Isaac (employed as the tavern barkeep); and his two younger children. Also living with them was a sixty-eight-year-old female, possibly Sarah's mother. Boarding at the hotel were the stagecoach proprietor, the stage driver, two blacksmiths (brothers), two civil engineers (brothers), a millwright and four laborers (three of them born in Ireland). There is a thirty-two-year-old female also staying at the hotel with no occupation listed. She might have been a relative of the Cranes, an employee of the hotel, or perhaps both.

- Between 1850 and 1860: There are records that indicate a Mr. Bartow was operating the hotel during this period, as on December 14, 1854, the Sussex Railroad made the inaugural run of the new extension connecting to the Morris & Essex. Following this momentous event, "Mr. Bartow, proprietor of the Waterloo Hotel, served dinner for the excited travelers."[122] In 1856, there was an article in the *Sussex Register*, dated January 18, that referenced the "Annual Oyster Supper" at Bartow's Waterloo hotel. (Mr. Bartow also owned Bartow's East Stanhope Hotel.)

- 1860 census: By 1860, the reconstruction of the canal had been completed, and it appears that business had slowed somewhat at the hotel. This census shows James Case, age forty-nine, as the hotelkeeper, with his wife and two children. There were only two boarders, both occupied as laborers. A few years later, during the Civil War, with the much increased canal traffic and the expansion of the railroads, the inn must again have done a booming business.

Unfortunately, no census was conducted during the Civil War period. If one had been conducted in the early to mid-1860s, it would most likely have shown the hotel having many boarders.

- 1870 census: With the advent of the railroads, people could travel between destinations in a few hours rather days, and it must have had a significantly negative impact on the hotel business. In 1870, Joseph Case (possibly James Case's younger brother), age forty-five, was the hotelkeeper, along with his wife and three children. At that time, there were four boarders: a telegraph operator, locomotive firemen, stable groom and railroad laborer. The railroads were being interconnected and enlarged at this time, and the impact of that can be seen in the occupations of the hotel boarders.

- 1880 census: This census is not complete, so it is not possible to tell if the hotel was still operating at that time. I suspect that, by then, it may have been closed and possibly even have been converted into a residence.

In 1963, this building, which was in the process of being converted to an old-age home, was purchased by Percy Leach.

20. WORKER'S HOUSE NUMBER TWO, CIRCA 1840 (ALSO KNOWN AS THE MILLER'S HOUSE OR THE SCHUMAN HOUSE)

Located just east of the village center, this residence was a duplicate of worker's house number one. It has received several upgrades over time, including a stucco exterior, a kitchen extension (on the right) and a two-story garage extension (on the left).

The name Miller's House was probably chosen by the foundation. A 1984 brochure produced by the foundation states that in the mid-1850s, this two-family building was occupied by the gristmill operator William Hunt and the blacksmith Byram Pitney. The brochure seems to be off a bit on its dates. William Hunt and his son Elmer were living in the village in 1870, per the census, with occupations of millers. Byram Pitney is listed as blacksmith in the 1880 census.

Worker's house number two, also called the Miller's House or the Schuman House. The central core of the building is an architectural duplicate of worker's house number one. *From the author's collection.*

This building was an occupied residential structure until 2001 and, therefore, contains many modern-day conveniences and amenities, including a furnace on the lower floor. The widow Schuman lived here (note the large letter *S* on the chimney) while the surrounding buildings were open as part of the living history museum.

If you compare this photo with the photo of worker's house number one (on page 108), you will note that the central core of both buildings are architectural duplicates. In addition to the later additions on this house, the roofline has been changed from a flat roof to a peaked roof.

21. Peter D. Smith House, circa 1871 (Also Known as the Maples)

This Second Empire Victorian–style mansion is one of the most beautiful buildings in the village, and the historical architects describe it as a structure "of symmetry, repetition and extensive detailing."[123]

Peter Decker Smith married in 1871 at age twenty-six, and this would have been his matrimonial home. This is a rather grand domicile for someone so

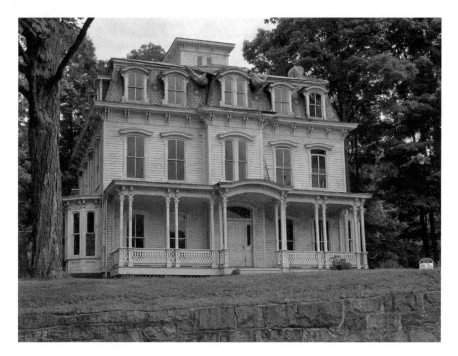

The Peter D. Smith House is a Second Empire Victorian and one of the most beautiful buildings in the village. It is also known as the Maples. *From the author's collection.*

young. (Unless, of course, they had hit the lottery. And it would appear that all of Peter Smith's children, John Smith's grandchildren, had done quite well when it came to the lottery of birth.)

Peter lived in this house until he died in 1918 at age seventy-three. He was the only one of John Smith's grandsons to stick with the village until the bitter end; the 1900 and 1910 census pages show that he was the only Smith still living in Waterloo. One wonders if his last years were spent pining for the good old days when the village was filled with sons and daughters, brothers and sisters and nieces and nephews.

21(a). The Peter D. Smith Carriage House, circa 1871
(Also Known as the Blue Barn)

This beautiful cupola-topped barn is located some distance behind the main house, on the other side of a road that passes at the back of

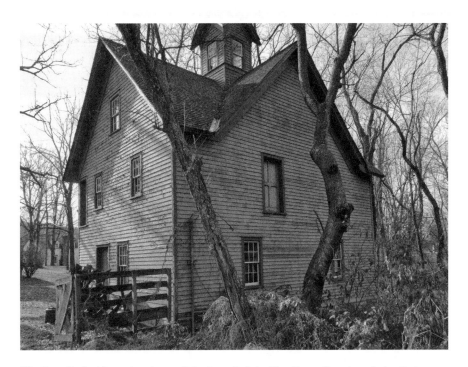

The Peter D. Smith carriage house. It is also called the Blue Barn. *From the author's collection.*

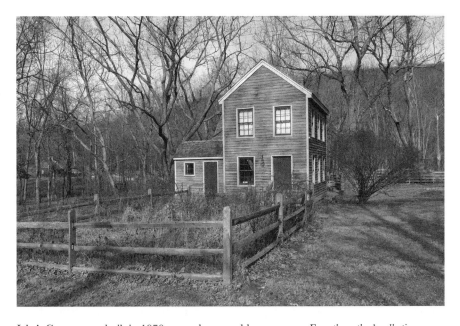

Jake's Cottage was built in 1970s to replace an older structure. *From the author's collection.*

the village. This gentleman's barn was used during the living history museum period to demonstrate weaving and included early cloth-making equipment.

22. JAKE'S COTTAGE, CIRCA 1980S

This structure, sitting between the Peter D. Smith House and its carriage house, replaced an earlier building, dating back to the 1870s. The original building has been variously reported as being used as a chicken coop, a woodworking shop, a playhouse for the Smith children, a tenant house and the 1940s home of a well-known local character named Jake.

Some accounts state that it burned down in the modern era, but people involved in its reconstruction refute that, saying instead that it was purposely demolished in 1974 and rebuilt, now including a fireplace, which did not exist in the original building. During the living history museum era it was used to demonstrate candle dipping.

23. THE SAMUEL T. SMITH HOUSE, CIRCA 1761
(ALSO KNOWN AS THE IRONMASTER'S HOUSE)

This is the third of the 1760s stone two-family houses that were constructed during the forge era, along with the homestead and the Waterloo Hotel. A 1770 advertisement in the *Pennsylvania Gazette*, in which the owners offered the forge and supporting structures for lease, added that there were "commodious Houses for a Manager and Forgeman." If the forge manager lived in what is now the hotel, as I suspect, and the homestead had already been converted into a barn, as is known, then the forge man (or ironmaster) responsible for all aspects of the forge operation would have probably occupied this building, thus the alternate name.

The architects mention that the major interior and exterior renovations that were made to this structure over time make it difficult to tell if it was built at the same time and of the same design as the other two buildings. I believe it was built at the same time as the other two and that those major structural changes were as a result of a flood or storm damage. The 1782 lease agreement mentions all three stone residences as follows: "Jack Cook's

The Samuel T. Smith House, dating to the 1760s, has been renovated many times over the years but is now in dreadful condition. *From the author's collection.*

stone house that is now a barn," "The Dwelling House" and "Pott's Stone House." In this description, "Jack Cook's House" would have been the future homestead, and the "Dwelling House" would have been the future hotel.

The schedule of repairs attached to the lease states that Pott's stone house needed a new roof, a whole under floor and half an upper floor. It also states that the "gable end of the stone wall as far as the upper floor is down." This damage was caused by a severe weather event of some kind that also washed out eighty feet of the dam, washed away the bridge and caused major damage to the forge, mills and hydropower system. This catastrophe was one of the reasons that Waterloo was unable to provide the iron desperately needed for the struggle for independence. This building is in dreadful condition.

Kevin Wright states that "John Smith converted the old Forge Masters Dwelling into a Tavern House."[124] I believe that this refers to the forge manager's house, meaning the Waterloo Hotel, and not this Ironmaster's House. The terminology is a bit confusing. This building, similar to the other two colonial-era stone residences, was remodeled many times over its history.

Samuel T. was the oldest surviving son of Peter Smith, and the 1860 census shows him still living in Peter's household, probably in the homestead. Samuel married in 1866 at age thirty-three, and it's more than likely that he made major modifications to this building prior to moving into it with his bride. As the oldest son, he would have been considered the patriarch after Peter died in 1877. Within a few years, though, he had moved out of the village to pursue his many duties as a community leader. He would shortly be followed in this move by Seymour and Nathan, leaving Peter D. as the sole Smith residing in Waterloo.

23(a). The Samuel T. Smith Carriage House, circa 1880 (Also Known as the White Barn)

Located some distance behind the main house, the cupola atop this barn is an architectural duplicate of the one on the 1870s Peter D. Smith Carriage House.

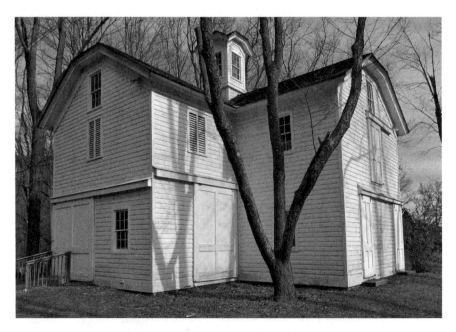

The Samuel T. Smith carriage house. It is also referred to as the White Barn. *From the author's collection.*

24. Tenant House, circa 1860
(Now the Canal Museum)

This tenant house, built in the early 1860s, is now used to house the Canal Society Museum. *From the author's collection.*

This is a one-family timber-framed residence built around 1860. It is now occupied by the Canal Society of New Jersey and is used to house the Canal Society museum.

This may also have been the residence for the village schoolteacher in the Victorian era and, at a different time, the home of Harrison Smith, a boatman on the canal.

25. TENANT HOUSE, CIRCA 1860 (ALSO KNOWN AS THE ADMINISTRATION BUILDING OR THE LIBRARY)

This tenant house, also from the early 1860s, was formerly located in the center of the village but was moved here in the 1940s. *From the author's collection.*

Similar in construction to the canal museum and the Poyuer house, it was moved from the center of the village to this location in the 1940s. It is described in some documents as originally being the laundry for the homestead, though I doubt that, as its original style and design seems to indicate that it was intended as a residence. Also, a Victorian-era photo seems to show a house of this design located between the Peter D. Smith House and the Samuel T. Smith House but set back from the road. If this were the homestead laundry, it would not be in a convenient location. Two additions have been added in later years, after its relocation.

26. Waterloo Estates Cottage and Barn, circa 1930 (Also Known as the Newcomb House or the Hunting Lodge)

The Waterloo Estates Cottage was built around 1930 as a model house for a planned housing division. *From the author's collection.*

This building is a private residence/office and, therefore, should be viewed from a distance.

The foundation brochure identifies this as a hunting lodge built in the 1930s but later used by the foundation as its offices. I seriously doubt that this was ever a real hunting lodge, and it is likely that the name was dreamed up by the foundation in an attempt to give it a more romantic history. It has also been said that it was a Sears Roebuck mail order house, though that seems unlikely.

Most likely, it was a model home built around 1930, when the Waterloo Lakes Estate and Development Company was preparing to offer building lots for sale. The historical architects have said that it was designed by Bernhardt E. Muller, a New York architect who also designed the Waterloo Lakes Estates subdivision.

It has been said that a widow named Mrs. Newcomb lived here and that Percy, through some questionable practice, managed to get the cottage away from her. The DEP purchased it from the foundation in 1978.

You have now reached the eastern end of the village. If you are still up for a bit of a walk, you can continue along Waterloo Valley Road, through the woods and past several ponds until you reach another set of structures.

27. LENAPE INDIAN VILLAGE, CIRCA 1986

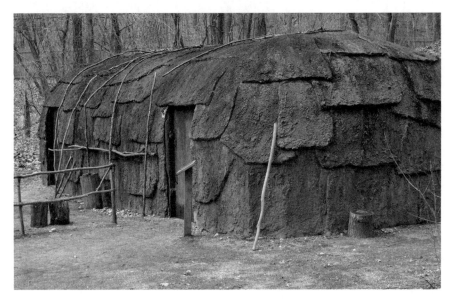

The Lenape Indian Village was built during the living history museum years. It has been one of the most popular attractions for children. *From the author's collection.*

Built as part of the living history museum, this simulated Indian village is a favorite attraction for school tours that visit Waterloo. It is staffed by volunteers in costume who interpret the village for the children.

Though its operation is not connected with the Canal Society's twice-a-month Heritage Days, it is sometimes also open on those days. Even if it is not staffed, it is worth a visit if you don't mind the short walk.

28. Village School, circa 1842
(No Trace Exists Today)

A school was first opened in the village possibly as early as 1842. On Sundays, it was used for Methodist services until the church was built in 1859. The original site is reportedly on the shore of Lake Waterloo and may have been inundated when the ice dam was built around 1890.

A picture postcard from around 1910 shows three different structures that are said to have been used as schoolhouses in Waterloo. One of the images shows the remnants of a stone building, and that would have been the original schoolhouse. The second image on the postcard shows a close up of a one-room building that appears to be of stone and either whitewashed or stuccoed. This same building appears in a photo of the village taken at long range. It was located to the right of the tenant house that became the Canal Museum building but some distance farther north, closer to the base of Allamuchy Mountain.

The third photo shows a modern wooden structure with a chimney on at least one gable end and a bell tower over an entrance foyer. The postcard describes all three buildings as one-room schoolhouses, but it is possible that this later one had two rooms. It was probably built no later than 1889, when the ice dam was built, but it possibly could have been built earlier. It was in use at least until 1913. This later building was probably located at the same place as the previous schoolhouse. It served students from both the Waterloo and the Cranberry Lake area. None of these buildings exist today.

Some of the teachers who worked at the village school, as listed in the census and other sources, are listed here:

- Late 1850s: According to McMickle, John Burrell worked as teacher in the village school before becoming a clerk in the Smith General Store, though no specific date is indicated in his paper.[125] Burrell, a British army veteran, was reported to have arrived from England in 1854 and initially worked as a railroad laborer. By the time of the 1860 census, he is recorded as the clerk in the Smith General Store, so he would have been the teacher sometime between 1854 and 1860.
- 1861 (per the *Sussex Register*): Ms. Crater, who was seriously injured in the accident at the plaster mill.
- 1880 census: Elizabeth Shorter (thirty-seven), who was living with Peter D. Smith's family.

- 1900 census: (first name unreadable, possibly Harrison) McConnell (twenty-six).
- 1910 census: Leah Beardille (thirty-four) and Jennifer Olsted (twenty-two). Jennifer was boarding with the store operator Linn Cassedy. As there were two teachers living in the village in 1910, it is possible that the building in use at that time may have contained two classrooms.

29. RUTAN CABIN, CIRCA 1825

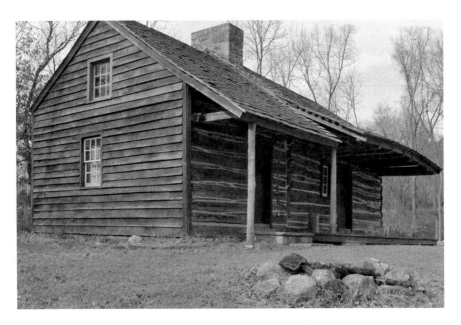

The Rutan Cabin was moved here from a different location to save it from the bulldozer. *From the author's collection.*

In 1990, this cabin was relocated from its original site in Frankford Township to Waterloo to prevent its loss to developers. The structure as it now stands is a combination of two different log buildings with a common loft.

The Modern-Era Buildings

The following buildings were constructed in the 1980s to support the living history museum. They are generally clustered behind and to the left of the historical buildings. Since they do not have historical significance, photographs are not included. They are, however, included on the map.

30. Various Farm Buildings

These include a stable, smokehouse, storage shed and cottage. These are modern-era buildings constructed to blend in with the older buildings.

31. The Meetinghouse
(Also Called the Visitors' Center)

A modern building with meeting rooms, conference space and a commercial kitchen. Currently the offices of the site coordinator are located here. These offices are generally staffed Wednesday through Sunday, from 10:00 a.m. to 4:00 p.m., and group tours or special events can be booked here. In the near future, this office may be moved to one of the historical buildings.

32. Comfort Station

Public restrooms and other support space. These are open on a daily basis for visitors.

33. Pavilion

One of the last buildings constructed in the village, it was a snack shop. Its open-space configuration would make it an ideal presentation room for future conferences.

34. GAZEBO

This is a good meet-up place if your party has split up during the walking tour.

35. FARM BARN

This is a modern-era building erected atop the foundation of a canal-era barn that burned down in the mid-1850s (or mid-1880s, depending on which article you read). It is located behind the homestead. In the early living history museum years, it was called the meetinghouse, but a newer building (31) supplanted it with the same title. It was used as a display for antique horse-drawn coaches during the living history museum era. It overlooks a pond (actually now just a wet spot) that is often referred to as Forge Pond. This should not be confused with the millpond that provided water to power the mills and the original forge.

WHAT IS THE FUTURE OF WATERLOO?

Until mid-2013, there were no state staff members assigned to Waterloo Village on a permanent basis. That has recently changed, and now there are two permanent maintenance workers and a full-time resource interpretive specialist, who functions as the on-site coordinator of activities at Waterloo and has a part-time assistant. Private tours can be arranged through this coordinator. There have also been recent discussions about the state's leasing some of the modern-era facilities to a private company.

The Canal Society of New Jersey, with permission from the state, holds several events at the village during the summer and autumn. The season kicks off on the last Saturday of June with an annual Canal Day, with period music, storytelling, vintage baseball, a pontoon boat ride on the canal and many crafts on display. This event is followed by Heritage Days on the second and last Saturdays from July through October, featuring many of these same activities.

During these events the Canal Society provides knowledgeable volunteers to staff several buildings that are open to the public, including the Smith General Store, the gristmill, the blacksmith shop and the canal museum. Both the gristmill and blacksmith shop are operated on these days.

Other special events sponsored by various groups are held at Waterloo throughout the year. On some of those occasions, these attractions may also be open if the State requests the Canal Society to provide volunteers.

Appendix A

What Do We Call This Village?

O ur village, as usual for the times, was not given an official name at its inception. Many early colonial villages were named by their settlers after their former home villages in England or elsewhere. Others were named based on such things as a road junction, a tavern, store owner's name or any number of such things. Over time, these early unofficial names might change, as was the case for Waterloo.

At various times the village was known as Andover Forge, Old Andover and, eventually, Waterloo. Similarly, the nearby hamlet of New Andover is frequently referred to as Lubber's Run in early documents.

The Reverend L.B. McMickle recognized this problem when he wrote in 1915: "It would be interesting to know many things concerning its [Waterloo's] history…of the names Andover, New Andover, Old Andover, Andover Forge, Andover Furnace, and Andover Forge Pond, and why so called."[126]

Now let's address the various names that our Waterloo Village has had over time. This is one of those times that we are going to get down into the weeds.

ANDOVER FORGE

This is an easy one. Around 1760, an industrial complex was established at what is now Andover, New Jersey. It consisted of an iron ore mine, a smelting furnace, farms and various supporting structures, such as mills, barns, houses,

etc. It also had a forge, located seven miles away, with its own mills, farms, etc. Although separated by some distance from the mine and furnace, the forge was an integral part of the complex, and all three—mine, furnace and forge—should be thought of as a single industrial unit: Andover Iron Works. The small hamlet that grew up around the forge, and its supporting structures (Waterloo Village) first began to be known as Andover Forge, which was probably more the result of common usage rather than any official declaration. It carried this name from 1761, when the forge was built, into the late 1820s.

OLD ANDOVER

Now I will to try and confuse the heck out of you by explaining how Andover Forge became known as Old Andover.

In 1823, John Smith acquired sole ownership of an eighty-six-acre tract near the confluence of Lubber's Run and the Musconetcong River, which included a forge that had previously been operated there by Lemuel De Camp. Shortly after becoming sole owner of the site, John Smith and his three youngest sons took up residence there. He began referring to this place as New Andover, as confirmed by deed transfers of the time.[127] Not long after this area was named New Andover, the by now largely abandoned hamlet of Andover Forge began to be referred to as Old Andover.

Many people say that the change was to avoid confusion between the two settlements. However, this does not seem to be sufficient cause for the Andover Forge name to change. Though they both have Andover in the title, the names Andover Forge and New Andover are sufficiently different to avoid confusion. That is, until John Smith did something else (probably for no other reason than to confuse people two hundred years in the future). When John Smith named his new settlement New Andover, he also renamed De Camp's forge there as Andover Forge.[128]

So within a mile of each other, there was the old village that had been known as Andover Forge for over sixty years and a new village called New Andover. The old village had had a forge called Andover Forge (which had not been active for over thirty years), and the nearby village of New Andover now had one with the same name.

People got confused. Whenever someone mentioned Andover Forge, no one knew which place they were talking about, so it's natural that they would begin referring to our village as Old Andover so as not to confuse it with the

newly named Andover Forge at New Andover. So the caution here is that you should be careful whenever you hear or read the three words *old*, *Andover* and *forge* used together. They could be referring to either the long-abandoned old forge at Andover Forge or the old Andover forge at New Andover—got that?

A final thought on this issue: when John Smith decided to settle in New Andover instead of the place called Andover Forge, which he also partly owned, then New Andover seemed to be the future and the abandoned village of Andover Forge the past.

WATERLOO VILLAGE

Around 1840, the original Andover Forge village, later Old Andover, began to be commonly referred to as Waterloo Village. There are six different stories or explanations (that I know of) that describe how the name Waterloo may have come about, and I will discuss each of them.

First, the Friends of Waterloo Village's 1984 self-guide brochure states that "John Smith, shortly after his 1812 purchase of the 282-acre Forge Farm tract, revived the iron works with the establishment of the Waterloo Foundry which was named in celebration of Wellington's defeat at Waterloo...Gradually the name Waterloo became associated with the Village itself."[129]

On the face of it, this is not true, as our village first began to be referred to as Waterloo around 1840, some twenty-eight years after the land purchase mentioned above. Also, the forge at Waterloo never reopened after it closed in 1795, and the forge at New Andover was never called Waterloo Foundry. Lastly, John Smith became a brigadier general in the Morris militia and had been a member of that unit during the War of 1812 (against the British). It seems unlikely that he would have been predisposed to honor the British by naming his village after their famous victory.

The second reason proposed, in a much more recent document, indicates that the village was named for a 1740 French army officer's hospital in Waterloo, Belgium.[130] This was seventy-five years before the famous battle. This is unlikely, as it is doubtful that the Smiths would even have been aware of such a small, distant and unimportant structure one hundred years in their past. I think we can discount this one entirely.

A third proposed reason for the name is that the name Waterloo was intended to reflect the importance of water and the village's reliance on the water passing through it.[131] This is possible, but if that's the case, then why wouldn't it be

named something like Watertown? While I would not argue against the village being named to reflect the importance of the river, that doesn't really explain the Waterloo name, and I fail to see a strong connection here.

A fourth story, from an unknown source related to me verbally, is that the landowner John Smith, celebrating his honeymoon in Waterloo, New York, an area known for its beautiful canals, began referring to his village as Waterloo when the Morris Canal was being built through it in 1831. Keeping in mind that the first documented use of the name Waterloo for this village was around 1840,[132] let's assume that the underlying story might be valid but that the year that the name started to change was misquoted. So the question now is, could John Smith, around 1840, have started referring to his village as Waterloo as a reminder of his honeymoon location? Let's explore this possibility.

According to the family histories, John Smith married his first wife, Rachael Woolin, in 1793. Rachael died in 1842, and John married his second wife, Caroline, in 1844. Caroline died soon after, and John's third marriage to Catherine Johnson was in 1845. Both of these later marriages were after the name Waterloo was documented, so any potential honeymoons with either of these two wives would not qualify as a source for the name. Let's assume that John and his first wife, Rachael, did have a honeymoon, that the honeymoon was shortly after they married and that it was to Waterloo, New York. This would mean that if the name for his village was derived from his honeymoon, it was from his first honeymoon with Rachel forty-seven years before. I believe this unlikely, though possible, as there are many fond and lasting memories formed during honeymoons.

The next account says that the name Waterloo was assigned to the village by the Delaware, Lackawanna & Western Railroad as a designated stop.[133] But, since that railroad did not yet exist at the time the name Waterloo became associated with the village, we can totally discount this one.

Finally, another account states that "recent research speculates that the Smiths were descended from Flemish Protestants and that Waterloo, Belgium, may have been their ancestral home. Pride in this connection was probably stimulated by Napoleon's defeat at Waterloo, Belgium, in June 1815."[134] This does not seem to have any credence at all, as Ezekiel Smith did not migrate to America from Belgium, but from Britain, and carries a British surname. So any ties to an original homeland in Belgium would have been watered down through several generations.

My conclusion is that there is no strong evidence of how the name Waterloo Village came about, and there probably never will be. Even common sense lets us down on this issue. So let's move on.

Appendix B

The Iron Act of 1750

P rior to the colonization of America, England imported most of its iron ore from Sweden. Restrictions that Sweden placed on the amount that it would export left England hungry for more iron. This shortage impeded growth and especially impacted the materials needed for military purposes, specifically for the Royal Navy. In 1741, the Morris County Council of representatives made a presentation to Governor Lewis Morris:

> *With proper encouragement they could probably in some years wholly supply the necessary commodity to Great Britain and Ireland for which they become annually greatly indebted to Sweden and other nations, but hitherto they had made but small advantage therefrom, having imported but very inconsiderable quantities of either pig metal or bar iron into Great Britain, by reason of the discouragement they be under for the high price of labor and the duties by Act of Parliament on these commodities.*[135]

They argued:

> *Should it please the British Legislature to take off the duties at present payable on Importation, and allow a small bounty thereon as to them in their great wisdom might seem reasonable, the inhabitants of this and other of his Majesty's colonies in North America would be thereby better enabled to discharge the respective balances due by them to their mother*

country...and the annual debt...incurred to Sweden and other foreign countries would be lessened.

This wholly reasonable suggestion was answered by Parliament a few years later when it passed the Iron Act of 1750, which removed the import duties on both pig iron and bar iron. But Parliament also added to the act the following two provisions that negatively impacted the colonies: 1) It forbade new construction in America of any mill for slitting or rolling iron, any plating forge to work with a tilt hammer and any furnace to make steel; 2) Any such mills, forges or furnaces that existed in America before the act passed could continue to operate, but the colonial governors were required to certify and list them. In response to this, a report to the governor of New Jersey listed only three such operations in the state: one slitting mill in Hunterdon County (Allen & Turner's Union Iron Works), one plating forge in Trenton and one steel-producing furnace, also in Trenton, though not in operation at the time of the report.[136]

This act clearly was not what the colonies had asked for. The act would increase exports of bar iron and pig iron to Britain but also restrict colonial manufacturing of wrought-iron finished products. This was a continuation of long-term British policy designed to direct most trade to England, protect the British tradesmen and assure a foreign market for finished iron products produced in England. The act tended to be self-perpetuating, as it had the effect of preventing robust industrial development in the colonies. Manufacture and trade were, forevermore, to be the monopolies of the mother country. In the process, of course, the cost of finished goods to the American consumer—the poor farmer, the frontier housewife, the tradesman, the small business owner—was vastly increased.

Any new furnaces or forges built in America would now only be allowed to process raw iron ore until it reached the intermediate stage known as "pig iron" or "bar iron." That iron would then have to be exported to England for the next stage of iron processing, which was to work the iron into wrought-iron finished goods, or through a much more complex process, the wrought iron could be further worked into steel, which was especially important for the production of military armaments. In addition to protecting the British metalworking trades and increasing iron imports, it also was a boon to Philadelphia and New York merchants and to British ship owners, as the increased flow of iron to Britain and finished goods back to America meant more money in their pockets. In reality, of course, there was strong temptation for the colonial furnace and forge owners to violate this act, no

matter how loyal they were to the Crown in other respects. The territorial governors were responsible for policing adherence to the act, but in many cases, these same governors had a hidden ownership interest in those same industries. The act was repealed in 1757, but by then, the simmering anger of the colonies had already risen to a higher level.

Appendix C

A Critical Review of Snell's History

I t is important to carefully address and critique Snell's 1881 *History of Warren and Sussex Counties* as his descriptions of the Smith family's early association with Waterloo is the most complete. However, his account contains several inaccuracies, and these errors are repeated in later works. Most of these later works repeat his account almost verbatim, without attributing his work as their source.

Snell's account was written at a time when John Smith's grandsons, who had all grown up in the village, were still alive. Snell, or his helpers, would certainly have interviewed them for much of the information in his section on Waterloo. The oldest grandson, Samuel T., was twenty-six when John passed away in 1859, and Peter D. was fifteen. They both are assumed to have been first-person witnesses to several discussions with their grandfather about the good old days. So one would expect Snell's account to be somewhat reliable, even if based on secondhand reports.

Let's look at Snell's description of the Smiths' arrival in Waterloo, found on pages 467 and 468 of his book:

> In 1790, John Smith, who had been a "boss collier" at Andover Iron Works, joined his brother Samuel in leasing the land lying about Waterloo, and engaged their brothers George and Daniel to assist them in farming the tract. There were at that time upon the site of Waterloo six stone and five framed houses that had been earlier occupied by the people engaged at the works, but which were then abandoned. The brothers selected the best of the

dwellings for residences, and, in addition to their farming labors, engaged in the manufacture of flax in the old mill building. Before they had proceeded very far in that enterprise the mill was burned, and the flax business came to an end in that locality. The Smiths had a fifteen years' lease of the property, but at the end of ten years disposed of it to Isiah Wallin and moved to Schooley's Mountain. Wallin farmed the place five years, and in 1805 John Smith purchased it and hired Joseph Wallin to work it.

In 1820, John Smith came from Schooley's Mountain and located on Lubber's Run, a mile above Waterloo, for the purpose of making iron in a bloom-forge…he also built a store and founded a small settlement at the forge, which took the name Old Andover, from the earlier settlement farther down the stream. When the Morris Canal pushed its way to where Waterloo now is, Mr. Smith's sons abandoned the upper location and moved a mile down the stream. There they built a store, grist-mill and tavern…

The business interests of the village have always remained in the hands of the Smith family. Samuel T. Smith, Seymour R. Smith, and P.D. Smith, grandsons of John Smith, who started the forge at Old Andover in 1820 and remained there until his death.

Now let's dissect this account and see what is reliable and what is debatable:

1) Smiths arrive at Waterloo in 1790: According to the genealogy "Smiths of Sussex and Morris Counties: Descendants of Ezekiel Smith," Ezekiel Smith's sons were all born between 1775 and 1790 in New York State. Later census reports confirm the accuracy of the birth dates and birth location for two of his sons, John and Samuel. There are also later census listings for both a George Smith and a Nathan Smith that show birth dates that agree with the genealogy, but their children's ages in those census reports do not match the family histories. Although there is not independent confirmation in all cases, I believe the genealogy is correct. Therefore, since it says all Ezekiel's children were born in New York, the last one in 1790, I accept the 1790 date as the earliest date that the Smiths could have arrived at Waterloo.

2) John Smith was the "boss collier" at the Andover Iron Works: I believe this is not correct, as in 1790, John Smith was only fifteen, hardly of an age to have the maturity and technical knowledge and experience needed to be a boss collier. An alternate theory that lends some level of support to Snell's account can be found in Suzanne Miller's 1981 article in the *Sunday Herald*, in which she states, "Forging operations at Waterloo were carried on

at a greatly reduced scale in the 1790's [*sic*] under Cadawalder Evans. He employed John Smith as boss collier for the forge at that time.''

If her statement is correct, then she is clarifying Snell's reference to the "Andover Iron Works" as actually meaning the Andover Forge site at Waterloo. The forge at Waterloo closed in 1795, when John would have been twenty. Under Ms. Miller's description, John would have been, as a teenager, responsible for the technically challenging task of making charcoal for the forge. That doesn't mean that it wasn't true, but there are no other independent supporting sources for this account. I remain skeptical, especially as, being the eldest son of Ezekiel, John would have been needed to work the family farms. My assessment of this statement is that it is unsupported and unlikely.

3) In 1790, John Smith and his brother Samuel leased land at Waterloo and farmed the land with their brothers: As said above, in 1790, John Smith was fifteen years old, and Samuel was eleven. I doubt that at these ages, they were the leaseholders. Also, John's other brothers at that time were thirteen, five and less than a year. The thought of these five young lads leasing and working a farm does not seem to ring true.

I think the more likely scenario is that John's father, Ezekiel, leased the land and died sometime during this period. There is no information on when or where Ezekiel died, and there is no more mention of him after the family arrived at Waterloo. If he did die some years after the lease was made, then perhaps John, now a bit older, would have taken over the lease. John married at age eighteen, to a woman five years his senior, so he must have been mature beyond his years. My conclusion is that Ezekiel, not John, leased the land.

4) They selected the best of the residences at Waterloo for their dwellings: I think this is unlikely, as during the first five years of the family's lease, the forge and mills at Waterloo were leased to and operated by Cadawalder Evans and his partners. During those five years, it is known that Evans lived in the stone two-family house that would later be called the Waterloo Hotel. The building that later would be called the homestead had already been turned into a barn. That just leaves the Samuel T. Smith House and the other half of Evan's two-family house to accommodate his gristmill and sawmill operators and his ironmaster. So it is unlikely that the Smith family would have occupied any of the stone residences at Waterloo during the first five years of their lease and instead probably occupied wooden

residences closer to their leased farm near Dragon's Brook. Perhaps after Evans gave up his lease in 1795, the Smith family then moved into the buildings. I believe Snell's description of the living arrangement is possible, but I question his timing.

5) At the end of ten years (1800), the Smiths disposed of the lease and moved: I think the 1800 date is a few years too early. In March 1802, John Smith purchased land around Dragon's Brook, and his residence on that transfer is listed as Independence Township, indicating that he had not yet moved from the Waterloo area.[137] Granted, this is not perfect proof, but I think it is strong enough evidence to state that he probably relocated sometime after March 1802.

6) When John Smith moved away he relocated to Schooley's Mountain: There could be some confusion on this issue as there are other accounts that state he moved to Smithtown and others that say Morris County. I think I can clear this up: Smithtown, though not an actual town, was so named because of the many Smith families who eventually lived in the area in the mid- to late nineteenth century. It is at the eastern tip of the ridge called Schooley's Mountain, which is in Morris County. So all three places—Smithtown, Schooley's Mountain and Morris County—are actually one and the same.

The reference in the March 1802 land purchase noted above, in which he is living in Independence Township, can also be confusing, apparently showing that, at that time, he had relocated to Warren County. This apparent anomaly can be explained: In 1782, Hardwick Township, Sussex County, was split into Hardwick and Independence Townships. In 1825, most of Independence Township was transferred to Warren County, with the remainder staying in Sussex County but being renamed Green Township. In 1829, part of Green Township was transferred to Byram Township. So the Waterloo section appears to have migrated (in name only) from Independence Township to Green Township to Byram Township, but always within Sussex County.

7) John Smith never lived in Waterloo: Both Snell and the family histories agree on this point. However, I do not think that they are talking about his younger days, while farming the leased land. I believe what they are saying is that after he relocated from Smithtown to New Andover in late 1823, he stayed there and never moved from there to Waterloo.

However, the 1850 census appears to show John Smith living next door to the hotel in Waterloo. This census does not show any house numbers, but on September 16, the census taker visited a total of twenty-eight families. I cannot place any of the first eighteen families as living in Waterloo, but the nineteenth family recorded was Charles Crane, known to be the proprietor of the Waterloo Hotel. Included in that entry were the hotel's eleven boarders. The next family recorded was John Smith's, so it would appear that John was living next door to the hotel, probably in the homestead. There were eight more entries that day, the last one being Nathan Smith. The next day, the first entry is that of Peter Smith, followed by entries that appear to be families living outside Waterloo.

And to add further strength to the thought that John Smith lived in Waterloo in 1850, the *Sussex Register* reported on April 3, 1847, that the dwelling owned by General Smith in New Andover was destroyed by fire, with a loss of $500. These two documents together, though not proof that John Smith lived at Waterloo, seem pretty strong evidence that he did.

So if John Smith never lived at Waterloo, as the family histories and Snell all say, how do we explain the 1850 census? Let's give it a try.

First of all, an 1860 map of Sussex County clearly shows, near the forge at New Andover, a dwelling listed as that of General John Smith. The location of this dwelling on the map also coincides with the description listed in Peter Smith's 1875 will and also in the deed dated April 1859 that transferred land to the Sussex Mine Railroad.[138] The map also shows six other buildings located close by that are also owned by him, so maybe the building that burned was one that he owned, not his actual residence.

Secondly, regarding the census, it is possible that the census taker, after arriving at the village some time that day, checked in to the hotel, took down the census information there, then moved along to John's house in New Andover and worked his way back to Waterloo, visiting seven more residences and ending his day at Nathan Smith's house. After spending the night at the hotel, he starts the next day by recording information at Peter Smith's dwelling (perhaps Peter was not home the previous evening?) and then leaves the village to continue his census work.

While I don't know if this scenario is a reflection of the truth, it certainly cuts the legs out of the argument that the 1850 census definitely proves that John Smith lived at Waterloo.

Appendix D

Morris Canal and Banking Company

The following is summarized from: "Internal Improvements in New Jersey: Planning the Morris Canal," H. Jerome Cranmer. Listed in the New Jersey Historical Society *69 (January–October 1951)*

When George McCulloch envisioned the "Jersey Ditch" crossing from Philipsburg on the Delaware River to Newark on the Passaic River, he all along considered that this would be a project funded by the State of New Jersey, as transportation facilities in the 1820s and '30s were recognized as essential to America's economic development and, therefore, of supreme interest to government. Virtually all other states were playing a leading role in such improvements, and since economic conditions were not favorable for private funding of such a large project, government funding was thought to be the only recourse.

Besides, private funding for a similar project in New Jersey had been tried before. In 1796, a subscription offering for the Delaware and Raritan Canal had been insufficient to begin that project. It was tried again eight years later with the same results. It was resurrected one more time in 1820, with an authorized stock issue of $800,000, but again failed to take off.

The New Jersey economy, with its major market being the New York area, was in trouble. Transportation of processed iron ore from the Jersey highlands to the markets in New York cost roughly 20 percent of its value. As large as the iron trade was, it was far over shadowed by agriculture. The cost of hauling fruits and vegetables by wagon amounted to up to 25 percent

of its value. Added to this, intense cultivation without fertilizer over the past fifty years had a disastrous effect on the New Jersey soil, reducing fields' yields and the efficiency of their operations. Increasing competition from upstate New York was already beginning to be felt in the New York markets, and this competition would soon grow tremendously when the Erie Canal, which was nearing completion, opened and added produce and goods from the Great Lakes states into the mix. The Champlain Canal likewise was nearing completion and would open in 1823.

Mr. McCulloch was able to gain broad support for his idea; in the summer of 1822, the president of the Morris County Agriculture Society sent a series of letters to the regional newspapers supporting the idea of a canal. Several local papers printed these letters, garnering wide support among their readers.

A petition was presented to the New Jersey legislature in November of that year, requesting funding of a route survey and feasibility study. The results were presented to the assembly in November 1823 and $2,000 was appropriated.[139] The report stated that the effort was "worthy of the highest efforts of the state." The study found that the proposed canal would bring anthracite coal to the iron industry and provide cheap transportation for bringing its products to market. It would also bring limestone and plaster (lime) to the worn-out soil of the region and reduce transportation cost for agricultural produce. Furthermore, it would provide a source of revenue to the state that would make public taxation forever unnecessary. (The report also pointed out that, whereas previously the only effective way to transport the produce from New Jersey orchards to market was by distilling the apples into cider, the canal would remove that limitation, thus improving the morals of the community.)

The forty-ninth general assembly convened on October 27, 1824. The Morris Canal was on the agenda. However, it was not the only canal to be considered by this assembly, as the Delaware and Raritan Canal project, across the middle portion of New Jersey, was being presented (again). These two projects were considered to be rivals, and each had its share of backers. There was also a third block of legislators representing the South Jersey agricultural interests. This third group opposed state funding of either project, especially the Morris Canal, fearing that state funding would result in higher land taxes, resulting in their members' having to pay for a project that offered no benefit to them. The Morris group controlled thirteen votes, the Raritan supporters controlled eleven and the southern group controlled eighteen. Since the state would not finance two competing projects, it would

be an either-or decision on which canal, if any, to finance. Given the split of votes, neither canal project had a chance of passing.

Blocked by political opposition to a state enterprise on one side, and a lack of willing private capital on the other side, the prospects of a Morris Canal seemed dismal. But there was a solution brewing.

For the two months that the assembly had been meeting, it had been besieged by requests and petitions for bank charters. It seemed that everyone who had a business, no matter of what type or size, wanted to open a bank. Most of the applications were rejected in committee, but eleven made it onto the assembly's agenda; five were eventually approved. If investors were so eager to invest in speculative banking enterprises, why not divert that enthusiasm into something that would benefit the state as much as the investors? Why not award the Morris Canal a bulked-up charter that gave it banking privileges, but no state funding? That would enable it to tap into that pool of private funding that otherwise would not have been interested in funding a canal.

The southern faction had little opposition to such a proposal, as long as state funding was not involved in the project. The Raritan group saw this as a potential precedent that it might be able to replicate, so it dropped its opposition. Thus was born the Morris Canal and Banking Company in December 1824. The company was authorized to issue ten thousand shares at $100 per share for canal construction purposes. For each $200,000 spent on construction of the canal, an equal amount of bank stock (after the fact) could be offered for sale, up to $1 million. This gave the canal company the ability to raise up to $2 million, half in canal stock and half in bank stock. The charter also allowed the company additional benefits: it was exempt from all taxes, it had the right to eminent domain, it had the right to necessary materials on adjacent lands, it could establish its own tolls and rates and it was granted a monopoly. There were also restrictions built in: the legislature could, at any time, appoint a commission to fix and regulate tolls; the banking privileges were limited to 31 years; at any time after 99 years (1923), the state could purchase the canal at "fair value"; after 149 years (1973), the canal would become the sole property of the state, with no payment to be made to the company.

Regardless of the merits of the canal, it was the lust for speculation in bank stock that got the Morris Canal on track. When subscription books opened the following May, the initial $1 million in stock was oversubscribed by fourteen times. Mr. McCulloch was certainly thrilled that his brainchild would become a reality. Or was he?

He strongly objected to the amendment to the charter that allowed it to engage in banking business. He later wrote:

> *The precarious position of a canal coupled to a bank, and directed by men of operations exclusively financial, was obvious. The interests of the country and the development of the iron manufacture were merged in a reckless stock speculation. I did all in my power to arrest this perversion, but soon found myself…standing alone, and responsible in public opinion for acts of extravagant folly…I clung to the sinking ship until every hope of safety had vanished, and then vacated my seat by selling, thus saving myself from ruin, if not loss…From the moment the charter, altered without my knowledge, was obtained, the whole affair became a stock-jobbing concern and the canal a mere pretext.*[140]

This bank mania was short-lived. By 1826, many of the newly opened banks had closed their doors, and the speculation in bank stocks was over. Within a year, the Morris Canal and Banking Company held over 58 percent of its own stock that had been forfeited by its original subscribers (5,808 shares forfeited out of 10,000 issued).

In spite of this, the annual report to the directors for the year 1826 was brimming with confidence. But only a few years later, in 1834, a special report to the board portrayed a tone of bitterness, talking about "the clouds that have so long overshadowed its prosperity." The report mentions the embarrassment of underestimating construction costs: the original estimate was $817,000, while the actual cost was $2.1 million The report identified as its biggest critics those who so earnestly tried to subscribe in the initial stock offering but, unsuccessful in that venture, now were bent on the canal's destruction—in other words, painting the detractors as a case of sour grapes. The report mentions the potential of bankruptcy but confidently predicted that the worse was behind the company and the future ever so bright.

The panic of 1837 led to a long lasting depression and the original canal company failed in 1841. It was reorganized in 1844 with a capitalization of $1 million. In 1849, the company's banking rights were withdrawn, leaving it as strictly a canal operation.

The ability to issue its own currency had attracted board members who were interested in the banking aspect of the company more than the transportation aspect. Their decision making, it turned out, was certainly focused on their own pockets rather than the good of the company. On April 1, 1852, after a period of canal upgrades, the *Sussex Register* newspaper

said, "It was now a canal in reality. Heretofore it had been for many years a plaything for the directors, who gave more attention to the banking powers of the company than to its canal department."

Widening and upgrading of the canal continued over the next decade, and by 1860, the canal could accommodate boat cargoes of seventy tons. Though total tonnages transported increased steadily through the 1840s and '50s, income could never keep up with expenses. From the very beginning the canal was a loss maker. The only exception was the Civil War period, during which the volume of canal traffic, buoyed by military needs, and not yet challenged by railroad competition, resulted in a year or two of profits.

The late 1860s saw the expansion of the railroads and brought competition that the canal could not overcome. Within a few more years several major contracts for its prime cargoes had been lost, and the directors saw that they could not continue. They petitioned the legislature to allow them to lease the canal. In 1871, the legislature amended the canal company's charter. In that same year, the entire canal, with all its facilities and structures, was leased to the Lehigh Valley Railroad Company. The railroad company only wanted the terminal points at Jersey City and Philipsburg but was forced to take the property as a whole. It was also required to keep the canal navigable for the period of the lease, which was in perpetuity, though from the date of the lease onward there was little traffic.

The Lehigh Valley Railroad was saddled with operating expenses for which there was no return. In 1903, and again in 1912, studies were done to determine what should be done with the canal, but no action was taken.

Finally, in 1918, the Lehigh Valley and the Morris Canal and Banking Company sued to stop construction of the Wanaque Reservoir, which was needed to increase water supplies to an ever-growing city of Newark. This project would have diverted water from the canal, and the canal company had a legal mandate entitling it to those waters. Of course, neither plaintiff was interested in those waters; the suit was used to gain leverage. The canal company and the Lehigh Railroad won the suit in 1922.

This convinced the legislature that future development in the state could, and would, be impeded by the continued existence of the canal. Finally it acted, and in March 1923, the canal was taken over by the State of New Jersey. Over the next few years, the canal was systematically demolished.

Appendix E

Description of the Forge at Waterloo, Circa 1761~1795

Waterloo was first (but not foremost) a forge village. Without the forge, nothing else would have happened here during colonial times. So let's spend a fair amount of space to explore the forge itself.

WHAT DID THE FORGE LOOK LIKE?

The most reliable descriptions of the forge appear in various published advertisements. In 1770, Allen & Turner placed an advertisement in the *Pennsylvania Gazette*, offering for lease both the Andover Furnace and the Andover Forge (as well as the Union Iron Works). In that advertisement, the Andover Forge is described as having "4 fires [hearths] and two trip hammers...5,000 acres of well-timbered land...Gristmill, Sawmill, Commodious Houses for a Manager and Forgeman...70 tons of pig metal... sufficient coal (charcoal) to work it...and six Negroe slaves to hire out or sell who are good Forgemen."

Another similar advert appeared in the *Pennsylvania Packet* on December 2, 1780, again advertising both the furnace and forge for lease.

In 1782 a lease agreement was executed between Joseph Turner, representing the company, and Archibald Stewart, who would lease both the Andover Furnace complex and the forge complex at Waterloo, for three years.[141] This lease agreement had an attached list of repairs that the

leaseholder was required to accomplish at both locations, and it is from this document that we can establish the size and layout of much of the forge site. The size of the forge has been estimated at fifty by thirty feet.[142] It had a seventy-foot-long headrace and was surrounded by flumes on three sides. Two of these flumes were for the forge itself, while the third provided water to operate the waterwheels in both the gristmill and sawmill.[143]

The four-hearth arrangement would have actually been two separate forges located in the same building, each having two hearths, two water-driven bellows and one water-powered trip hammer. Each of the two forges would have had its own waterwheel. One of the forges would have been a finery forge, processing pig iron produced by the Andover Furnace into bar iron, while the other would have been a chaffery forge, processing iron ore from local mines into bloom iron and then into bar iron. This two-forge layout is a typical arrangement for a pre-colonial forge processing iron using the Walloon process. This forge layout appears to be modeled after similar facilities previously designed and built in England by John Smeaton.[144]

Where Was the Forge Located?

As with almost everything else at Waterloo, there is some disagreement as to where the forge was located.

Snell states on page 467 that "the forge stood upon a spot a few yards northeast of the gristmill of the Smith Brothers, and east of the forge was a grist-mill whose ruins may yet be seen." Snell was writing in 1882, so we need to place ourselves in the village at that time to interpret his statement, which is quite confusing.

First of all, when he refers to the "gristmill of the Smith brothers," this appears to be an editing error. We think that Snell meant to say the store of the Smith brothers. With that correction, Snell's description would place the forge between the Smith General Store and the gristmill. His reference to the gristmill "whose ruins may still be seen" is also very confusing. In 1882, when his book was published, we believe the gristmill was very much alive and well, operating in the old charcoal house. Perhaps he is referring to the ruins of the original mill, which John Smith replaced in 1831. If Snell is talking about the original colonial-era mill, then he is placing the forge somewhere just west of the original gristmill, near where the lock was built. I do not agree with this location.

Suzanne Miller, in her January 4, 1981 article in the *Sunday Herald*, states that "the Village of Waterloo was constructed across the river from the refinery and distant from its noisy, smoky operations." This places the forge on the Morris County side of the river, but there are absolutely no other records or archaeological evidence of any such operation on that side of the river. In my opinion, this description of its location is totally without merit.

Edward Webb, writing in 1872, places the forge "a few yards northeast of the gristmill, and the walls of the old coal house form a part of this forge."[145] The only way that this description makes any sense is if he is also referring to the original gristmill. This would place the forge where the replica sawmill now stands.

Kevin Wright, in his Internet article, states that the Waterloo Foundation for the Arts plan to reconstruct an eighteenth-century forge at its original location had "misidentified the 18th century gristmill [the original mill] as the original forge site."[146] He goes on to say that if they were to erect one in the correct location, it would require "destruction of the nineteenth century grist, saw and plaster mills." Therefore Mr. Wright is identifying the original forge location as where the gristmill and sawmill are currently located, confirming Webb's account.

The historical architects Connolly and Hickey describe the location as "close to the water's edge on the north side of the Musconetcong River...A coal house or charcoal house was located north of the forge site."[147] They go on to say that "the Gristmill (formerly a coal house) and portions of the foundation of the sawmill may have 18th century origins."[148]

If the current replica sawmill (which was built on the same location as the 1830s sawmill) has eighteenth-century foundations, then that would have to be the site of the original forge. Having the forge next door to the charcoal house, where its fuel was stored, certainly makes sense. Also, their wording of "located north of the forge site" can be misinterpreted. This wording makes it sound like the charcoal house is located some distance away, when in fact it was adjacent to the forge, but on the northern side.

My conclusion is that the original forge was located where the replica sawmill now stands and adjacent to the gristmill

HOW WAS THE FORGE POWERED?

There are some questions about the architecture of the hydropower system used to power the forge and mills. The canal dam, built around 1830, downstream from the colonial industrial complex, raised the water level behind it by about ten feet. This submerged part of the original 1760s dam and hydropower infrastructure that supported the forge and mills. Whatever remained of the original hydropower system that wasn't flooded by the new dam was obliterated by the construction of the canal lock, which required reconfiguration of the mill's tailraces. In the absence of archaeological remains, and with minimal written documents, we can only speculate as to how the original hydropower system may have been configured, relying largely on the 1782 repair schedule.

The 1782 lease agreement noted that the dam had suffered an eighty-foot breach. It is assumed that this was a wing dam, as that type of dam was often used in colonial times. A wing dam is one that angled out into the river but did not reach completely across. The dam would probably also have been a tumbling dam, made of dirt fill and armored with stone, which would have allowed water to flow over it during periods of flood, hopefully without carrying it away. The fact that it had suffered the breach described above was more than likely aided by a period of poor maintenance during those troubled years of the mid-1770s and early 1780s when the forge was not being operated.

The lease agreement also indicates that the forge's head gate and posts required replacement, and that the seventy-foot headrace also needed major repairs. I believe that the millpond at today's Waterloo is located at the same site as the original forge pond. Therefore, to determine the approximate location of the colonial-era dam, it should be a minimum of seventy feet upriver of the eastern edge of the current pond.

Water would have been fed to the two forge overshot waterwheels by aboveground wooden flumes, one flume for each waterwheel. The third flume would have powered a single waterwheel driving both the gristmill and sawmill. The tailraces, unlike the headrace, would have been channels dug into the ground.

WHEN DID THE FORGE CLOSE DOWN?

Most accounts state that following the War for Independence, most mines, furnaces and forges, including the forge at Waterloo, closed down.

Their small sizes and remote locations could not compete with cheaper imports of metal from England. Also by then, the accounts state, the land had largely been deforested, and the economy of the new nation was in trouble. Iron ore processing in New Jersey was dead, never to rise again, so they imply.

To that I say poppycock!

Yes, the economy was going through a difficult period, but life did not stop. There was demand for iron products. The American market was now flooded by cheap British imports, thanks to the English employing technically advanced manufacturing processes. This depressed prices that local producers could charge, but still there were plenty of businessmen who thought they could make a profit in the iron trade.

It's also true that much of the forests had been felled, opening the way for large-scale farming, but there were still plenty of trees available, and by the 1820s, commercially mined coal could be transported by wagon from eastern Pennsylvania. By the 1830s, canal boats would replace the wagons, making coal import much more economical and in sufficient volume to operate the New Jersey furnaces and forges.

A 1784 census, conducted three years after the last Revolutionary War battle, and one year after the Treaty of Paris had been signed, showed that, in New Jersey, there were eight blast furnaces and 79 forges operating, though this was significantly less than were operating in the pre-independence days. By 1834, this had increased to twelve furnaces and 108 forges.[149] Shortly after this latest survey, the furnaces in the northern highlands began to close down. That was when the new canal also made it cost efficient to ship bulk iron ore to the new, large, coal fired furnaces being built in Pennsylvania. By 1856, only five furnaces were operating in New Jersey and only two of those were burning charcoal as fuel. Working forges, however, were still plentiful and continued to be so into the 1870s. So in contradiction to most published information, furnaces and forges in New Jersey certainly were operating in the immediate post–Revolutionary War period.

Throughout the nineteenth century, ironworks in the region operated sporadically, depending on the prices of iron and the efficiency of production. These efficiencies were the result of improved metallurgical technology, improved mining techniques and improved transportation, all of which could make local iron production more efficient. But this would mostly benefit the larger mine and furnace complexes.

Published documents state that from 1782 to 1787 the ironworks, including the mine and furnace in Andover and the forge and mills at Waterloo, were

leased to Archibald Stewart. The Waterloo operation, including the mills and forge, was being managed by Charles Stewart. As late as 1787, the furnace was producing pig iron, some of it shipped directly to New York in that form and some sent to the forge at Waterloo for further processing. In 1787, the forge shipped thirty-two tons of bar iron to New York.[150]

Following Mr. Stewart, the forge and mills in Waterloo (but not the mine and furnace complex) were leased to Mr. John Armstrong, who agreed to a three-year lease from 1788 to 1791. One of the terms of the lease with Mr. Armstrong was that if the owners found someone willing to lease the entire Andover Iron Works as one unit, Armstrong would have to surrender his lease in Waterloo.

Dr. Abraham Baily, Humphrey Hill and Cadawalder Evans agreed to lease the entire holdings effective June 1790, and Armstrong was forced to relinquish his lease.[151] Mr. Cadawalder Evans arrived in Waterloo in April 1790 and occupied the mansion house (the future Waterloo Hotel) and kitchen house.

By June 1795, the leaseholders were five years in arrears of the rent due, and the owners were empowered to seize all the goods and holdings of the leaseholders. Those properties were sold at auction in June 1796 but did not amount to much. The agent's assessment at that time was that the Waterloo mills were in pretty good order, but the forge was reported to be in poor condition, with one of the forge chimneys collapsed and the other about to collapse.[152] Bricks were being scavenged from the site by local people. The Forge Farm was also lying fallow.

Boyer mentions that "according to the *Dover History* it [the Andover Forge] was operated by Lemuel De Camp in 1816."[153] I have not been able to locate the source document *Dover History* that he cites. His statement is confusing. I know that the old Andover Forge at Waterloo was not operated later than 1795. I also know that, in 1816, Lemuel De Camp was operating his forge near the confluence of Lubber's Run with the Musconetcong River, just over a mile upstream of Waterloo. This forge site there would later be named New Andover, and the forge itself would later (after 1823) be called Andover Forge. I believe that Boyer is referring to this later site but was mistakenly referring to it by the later name of Andover Forge.

For information on the processing of iron ore, I refer you to two documents: Kevin Wright's *A History of the Andover Iron Works* (The History Press, 2013) and Jack Chard's *Making Iron & Steel: The Historic Processes 1700–1900,* (North Jersey Highlands Historical Society, 1995).

Notes

PREFACE

1. Johnson and Hart, "History of Byram Township," 20.

CHAPTER 1

2. Wright, "Waterloo Village," Part 1.
3. Ibid.

CHAPTER 2

4. Connolly & Hickey Historical Architects, LLC, and Hunter Research Inc. "Waterloo Village Boundary Increase," section 8, page 3.
5. "Forges and Furnaces."
6. Connolly & Hickey Historical Architects, LLC, and Hunter Research Inc. "Waterloo Village Boundary Increase," section 8, page 4.
7. Miller, "Iron Manufacture Was Important Aspect of Southeastern Sussex County's History." This is a newspaper clipping in the Sussex County Library file on Waterloo.
8. Ibid.
9. Boyer, *Early Forges & Furnaces in New Jersey*, 26. The book cites a notice in the *Pennsylvania Gazette* from October 4, 1770.

10. Wright, *History of the Andover Iron Works*.
11. Webb, *Historical Directory of Sussex County*.
12. Boyer, *Early Forges & Furnaces in New Jersey*, 29.
13. Ibid., 235.
14. Ibid., 239.
15. Ibid., 28.
16. Miller, "Iron Manufacture Was Important Aspect of Southeastern Sussex County's History."
17. Waterloo Foundation for the Arts, "A History of Waterloo: A Self-Guided Tour Brochure," 1984.
18. Sussex County Historical Marker.
19. Boyer, *Early Forges & Furnaces in New Jersey*, 239.
20. Extract of a book or magazine article, located in the Waterloo File at the Sussex County Library dated 1971. The author and source of the article are not identified on the photocopy.
21. Allen, *American Crisis*.
22. Papers of the Continental Congress.
23. Ibid.
24. "Waterloo Village Restoration," Waterloo File at the Sussex County Library.
25. Leonard Lundin, *Cockpit of the Revolution: The War for Independence in New Jersey* (Princeton, NJ: Princeton University Press, 1940), 242, quoted in County Archives of New Jersey, Sussex County, 9.
26. Penn Biographies, "Joseph Turner"; "William Allen."
27. Boyer, *Early Forges & Furnaces in New Jersey*, 237.
28. Ibid., 236.
29. Ibid., 234.
30. Connolly & Hickey Historical Architects, LLC, and Hunter Research Inc. "Waterloo Village Boundary Increase," section 8, page 4.
31. Boyer, *Early Forges & Furnaces in New Jersey*, 235.
32. Ibid., 30; *Sussex Register*, July 30, 1847.
33. Wright, *History of the Andover Iron Works*, 83.
34. Snell, *History of Sussex and Warren Counties, New Jersey*, 467.

Chapter 3

35. Ibid.
36. "Smiths of Sussex and Morris Counties of New Jersey." This is one of two family genealogies used in preparation of this document. The two sources differ in some minor areas.

37. Snell, *History of Sussex and Warren Counties, New Jersey*, 468.

38. Sussex County Deed Book, W-2, 101.

39. Snell, *History of Sussex and Warren Counties, New Jersey*, 468; Johnson and Hart, "History of Byram Township," 23.

40. Boyer, *Early Forges & Furnaces in New Jersey*, 32.

41. Sussex County Deed Book, W, 267.

42. Ibid., M-2, 101.

43. *Sussex Register*, September 26, 1817.

44. Sussex County Deed Book, P-2, 243.

45. Ibid., Q-2, 252.

46. Ibid., R-2, 26.

47. Smith and Smith, *Genealogy of the Smith Family of Waterloo*, 6; Sussex County Deed Book W-2, 101.

48. Sussex County Deed Book, R, 33.

49. Ibid., C-6, 243.

50. Aun, "Fine Old Line Across New Jersey"; West Jersey and South Jersey Heritage, "Where Was the West Jersey/East Jersey Line?"

51. Sussex County Deed Book, T-2, 96.

52. Ibid., X-2, 174; X-2, 176.

53. Snell, *History of Sussex and Warren Counties, New Jersey*, 468.

54. Munsell, *History of Morris County, New Jersey*, 38.

CHAPTER 4

55. Colden, "Report to the Directors of the Morris Canal and Banking Company," 13.

56. "Annual Report Upon the Morris Canal for the Year Ending July 1, 1826," 5.

57. Ibid., 6

58. Sussex County Deed Book, C-6, 246.

CHAPTER 5

59. Ibid., G-3, 257.

60. Ibid., P-3, 40; P-3, 116.

61. Ibid., N-3, 444.

62. Snell, *History of Sussex and Warren Counties, New Jersey*, 468.

63. Connolly & Hickey Historical Architects, LLC, and Hunter Research Inc. "Waterloo Village Boundary Increase," section 8, page 9 (referring to Agreement No. 24 between the Morris Canal and Banking Company, Agreements and Leases, Notebook, 1923–1930s, Land along the Canal, Book 3).

64. Friends of Waterloo Village, "Self-Guide Brochure."

65. These were the dimensions of the Morris Canal boats, but many other boats from other canals traveled through the Morris Canal. Thus, boats originating in Pennsylvania loaded with coal could travel to New York without offloading cargo. Similarly, Morris Canal boats loaded with iron ore could move through the Pennsylvania canals.

66. Lee, *Morris Canal*, 4

67. Wright, "Newton and the Iron Horse."

68. Ibid.

69. Sussex County Deed Book, K-4, 107.

70. Ibid., M-4, 38.

71. Ibid., E-5, 196.

72. Wright, "Newton and the Iron Horse."

73. Sussex County Deed Book, P-4, 285.

74. Wright, "Newton and the Iron Horse."

75. Ibid.

76. Connolly & Hickey Historical Architects, LLC, and Hunter Research Inc. "Waterloo Village Boundary Increase," section 8, page 11 (referring to Joseph J. Macasek's *Guide to the Morris Canal in Morris County* [Morristown, NJ; Morris County Heritage Commission, 1996]: 46–47).

77. Sussex County Deed Book, W-5, 226.

CHAPTER 6

78. Waterloo Foundation for the Arts, "A History of Waterloo: A Self-Guided Tour Brochure," 1984.

79. Wright, "Waterloo Village," Part 1.

80. Sussex County Deed Book, L-8, 433.

81. Ibid., T-9, 6.

82. Ibid., N-8, 48.

83. Ibid., K-8, 470.

84. Smith, will.

85. Sussex County Deed Book, R-9, 413.

86. Ibid., H-6, 503.

87. Ibid., P-4, 414.

88. Ibid., S-6, 139; S-6, 40.

89. Ibid., M-7, 164.

90. Snell, *History of Sussex and Warren Counties, New Jersey*, 469.

91. Sussex County Deed Book, A-7, 192, 195, 198, 200, 203, 206, 214; M-7, 61, 63; O-7, 42.

92. Sussex County Deed Book, Book 303, pages 430–31.

93. Ibid., V-9, 509.

94. Ibid., T-9, 11.

95. Ibid., R-12, 278.

96. Ibid., T-9, 9.

97. Ibid., X-10, 371.

98. Ibid., R-12, 278; Sussex County Deed Book, Book 293, page 550.

99. Ibid., T-12, 33.

100. Sussex County Deed Book, M-11, 18.

101. Connolly & Hickey Historical Architects, LLC, and Hunter Research Inc. "Waterloo Village Boundary Increase," section 8, page 23.

102. Federal Writer's Project, *New Jersey*, 464–65.

103. Connolly & Hickey Historical Architects, LLC, and Hunter Research Inc. "Waterloo Village Boundary Increase," section 8, page 18.

104. Ibid.

CHAPTER 7

105. Wright, "Waterloo Village," Part 6.

106. Hennelly, "New Jersey's Waterloo."

107. Wright, "Waterloo Village," Part 1.

CHAPTER 8

108. Smith, "Waterloo Methodist Episcopal Church—150th Anniversary Book."

109. Sussex County Deed Book, Y-4, 355.

110. John Burrell had been a soldier in the British army and came to America in 1854. Initially, he was a laborer on the Sussex Railroad extension, then a teacher in the Village School and then became a clerk in the store.

111. Beck, *Tales and Towns of Northern New Jersey*, 96.

112. Connolly & Hickey Historical Architects, LLC, and Hunter Research Inc. "Waterloo Village Boundary Increase," section 7, page 27.
113. Ibid., 26.
114. Ibid., section 8, page 14.
115. Hazen, "Personal Tribute."
116. Lee, *Waterloo and Byram Township*, 49.
117. Wright, "Waterloo Village," Part 2.
118. Connolly & Hickey Historical Architects, LLC, and Hunter Research Inc. "Waterloo Village Boundary Increase," section 7, page 36.
119. Wright, *History of the Andover Iron Works*, 75.
120. Connolly & Hickey Historical Architects, LLC, and Hunter Research Inc. "Waterloo Village Boundary Increase," section 7, page 26.
121. Sussex County Deed Book, Q-2, page 252.
122. Wright, "Newton and the Iron Horse."
123. Connolly & Hickey Historical Architects, LLC, and Hunter Research Inc. "Waterloo Village Boundary Increase," section 7, page 12.
124. Wright, "Waterloo Village," Part 1.
125. McMickle, *History of the Waterloo Methodist Episcopal Church*, 28.

APPENDIX A

126. Ibid., 7.
127. Sussex County Deed Book, X-2, 174.
128. Smith, will.
129. Friends of Waterloo Village, "Self-Guide Brochure."
130. Hilbert, "The History of Mount Olive." The original document cannot be located for verification of wording or context.
131. Snell, *History of Sussex and Warren Counties, New Jersey*, 467.
132. Connolly & Hickey Historical Architects, LLC, and Hunter Research Inc. "Waterloo Village Boundary Increase," section 8, page 6.
133. Ibid.
134. Miller, "Iron Manufacture Was Important Aspect of Southeastern Sussex County's History."

APPENDIX B

135. Munsell, *History of Morris County, New Jersey*, 41.
136. Ibid.

Appendix C

137. Sussex County Deed Book, W-2, 101.
138. Ibid., E-5, 196.

Appendix D

139. Mann, *Report to the Commissioners*.
140. *Hopatcong Historama*.

Appendix E

141. Chew Family Papers, New Jersey Land Papers, Series 21, Box 768, Folder 29.
142. Wright, "Waterloo Village," Part 6.
143. Chew Family Papers, New Jersey Land Papers, Series 21, Box 768, Folder 29.
144. Connolly & Hickey Historical Architects, LLC, and Hunter Research Inc. "Waterloo Village Boundary Increase," section 8, page 26.
145. Webb, *Historical Directory of Sussex County*.
146. Wright, "Waterloo Village," Part 6.
147. Connolly & Hickey Historical Architects, LLC, and Hunter Research Inc. "Waterloo Village Boundary Increase," section 8, page 3.
148. Ibid., 26.
149. Cruts, *Mining in the State of New Jersey*, 5.
150. Wright, *History of the Andover Iron Works*, 79.
151. Ibid., 81.
152. Ibid., 83.
153. Boyer, *Early Forges & Furnaces in New Jersey*, 31.

Bibiography

Allen, William. *The American Crisis: A Letter, Addressed…to the Earl Gower…on the Present Alarming Disturbances in the Colonies…* London: T. Cadell, 1774. Reprint by ECCO Print Editions, n.d.

Aun, Fred J. "A Fine Old Line Across New Jersey." *Backsights* (January 1995). Viewed on the Virtual Museum of Surveying website. http://www.surveyhistory.org/a_fine_old_line_across_new_jersey1.htm (accessed January 19, 2014).

Boyer, Charles S. *Early Forges & Furnaces in New Jersey.* Philadelphia: University of Pennsylvania Press, 1931.

Chard, Jack. "Making Iron & Steel: The Historic Processes 1700–1900." Pamphlet. North Jersey Highlands Historical Society, 1995.

Charlton, Henry. *Tales and Towns of Northern New Jersey.* New Brunswick, NJ: Rutgers University Press, 1984.

Chew Family Papers, 1659–1986. Chew family of Pennsylvania and Maryland. Historical Society of Pennsylvania, Collection 2050. http://www2.hsp.org/collections/manuscripts/c/Chew2050.xml (accessed October 10, 2013).

———. New Jersey Land Papers, series 21, Box 768, Folder 29. (This is a printed extract summarizing the 1782 Lease Agreement Repair Schedule between Archibald Stewart and Joseph Turner.)

Connolly & Hickey Historical Architects, LLC, and Hunter Research Inc. "Waterloo Village Boundary Increase." Draft report for the Department of the Interior to expand the boundaries of Waterloo's National Register of Historic Places entry. April 25, 2013.

County Archives of New Jersey. Sussex County. "Inventory of the County Archives of New Jersey—Sussex County: Historical Sketch." Sussex County Library.

Cranmer, H. Jerome. "Internal Improvements in New Jersey: Planning the Morris Canal." *Proceedings of the New Jersey Historical Society* 69 (January–October 1951): 324–41.

Cruts, E.K. *Mining in the State of New Jersey*. Flemington, NJ: Democrat Press, 1960.

Federal Writer's Project of the Works Progress Administration for the State of New Jersey. *New Jersey: The American Guide Series*. New York: Viking Press, 1939.

"Forges and Furnaces 1727–1921." Historical Society of Pennsylvania, Collection 212.

Friends of Waterloo Village. "Self-Guide Brochure." 1984.

Gibbs, Whitfield. *One Hundred Years of the Sussex Register and County of Sussex*. Westminster, MD: Heritage Books, 2007.

Goller, Robert. R. *The Morris Canal: Across New Jersey by Water and Rail*. Charleston, SC: Arcadia Publishing, 1999.

Gordon, Robert B. *American Iron*. Baltimore, MD: John Hopkins University Press, 1996.

Hazen, Theodore R. "A Personal Tribute to and Remembrance of Charles Howell." Mr. Howell, an expert millwright, restored the mill at Waterloo in the mid-1970s. http://www.angelfire.com/journal/millrestoration/howell.html.

Hennelly, Robert. "New Jersey's Waterloo." *New Jersey Monthly* (October 1996).

Hilbert, Rita. "History of Mount Olive." http://nynjctbotany.org/njhltofc/mtolivetwn.html (accessed August 28, 2013).

"Historic Morris County." Forty-page booklet. First National Bank of Morristown, 1955.

"History of the Iron Ore Trade." Cleveland Memory Project, Cleveland State University Library, Cleveland, Ohio. http://www.cleveland memory.org/glihc/oretrade.html.

Hopatcong Historama. Fiftieth-anniversary publication of the Lake Hopatcong Yacht Club. Newark, NJ: Style Printing Co, 1955.

Johnson, Carl, and Elspeth Hart. "History of Byram Township." *New Jersey Herald*, 1964.

Lee, Cindy. *Waterloo and Byram Township*. Charleston, SC: Arcadia Publishing, 1997.

Lee, James. *The Morris Canal*. Easton, PA: Delaware Press, 1994.

Macasek, Joseph J. "Guide to the Morris Canal in Morris County." Morristown, NJ: Morris County Heritage Commission, 1996.

Mann, Jacob. "Report to the Commissioners Appointed by the Legislature of the State of New Jersey for the Purpose of Exploring the Route of a Canal to Unite the River Delaware, near Easton, with the Passaic, near Newark, with Accompanying Documents 1823." *Proceedings of the New Jersey Historical Society* 69 (January–October 1951): 330.

McMickle, Reverend L.B. *History of the Waterloo Methodist Episcopal Church, Waterloo NJ, 1859–1909.* Milford, PA: William H. Nicholls, printer, 1915.

"Military Records 1812." New Jersey Historical Society, Manuscript Group 947. http://www.jerseyhistory.org (accessed August 29, 2013).

Miller, Suzanne. "Iron Manufacture Was Important Aspect of Southeastern Sussex County's History." *Sunday Herald,* January 4, 1981.

Morris County Deeds: Located in the Office of the Morris County Clerk, Morristown, New Jersey.

Munsell, W.W. *History of Morris County, New Jersey.* New York: W.W. Munsell & Co., 1882.

New Jersey Historical Society web page. Archives, Documents, Maps & Photographs, Call No. 947. www.newjerseyhistory.org.

Papers of the Continental Congress. Letters from the Board of War and Ordnance, 1780–81. Vol. 1: 67–69. Viewed at www.fold3.com/image/223103 (accessed February 19, 2014).

Penn Biographies: Penn University Archives & Records Center. "Benjamin Chew." http://www.archives.upenn.edu/people/bioa.html (accessed October 9, 2013).

———. "Joseph Turner." http://www.archives.upenn.edu/people/bioa.html (accessed October 2, 2013).

———. "William Allen." http://www.archives.upenn.edu/people/bioa.html (accessed October 2, 2013).

Smith, D. Alden, and Robert H. Smith. *Genealogy of the Smith Family of Waterloo, New Jersey.* Waterloo, NJ: Waterloo Foundation for the Arts, 1994.

Smith, Peter. Will, dated 1875. Index 8526. Proceedings #6, page 129. Sussex County Surrogate's Office, Newton, New Jersey.

Smith, Robert H. "Smiths of Sussex and Morris Counties of New Jersey: Descendants of Ezekiel Smith." Unpublished manuscript on file at the Morristown Library, Morristown, New Jersey, n.d.

———. "Waterloo United Methodist Church—150th Anniversary." Unpublished anniversary booklet dated August 9, 2009, covering the history of the church.

Snell, James P. *History of Sussex and Warren Counties, New Jersey.* (Philadelphia: Everts and Peck, 1881): 467–71.

Sussex County Deeds: Located in the Sussex County Hall of Records, Newton, New Jersey

Sussex County Historical Marker, Andover, New Jersey, Route 206 South.

Waterloo File at the Sussex County Library. Contains various newspaper clippings and other items pertaining to Waterloo Village. Most of the items are undated and their source and author are not identified.

Waterloo Foundation for the Arts. Self-guided tour brochures from 1984, 1997 and various others undated.

Webb, Edward A. *Historical Directory of Sussex County*. 1872. Reprint, Bowie, MD: Heritage Books Inc., 1992.

West Jersey and South Jersey Heritage. "Where Was the West Jersey/East Jersey Line?" Site managed by Robert Barnett Beck. www.westjersey.org/wj_line.htm (accessed January 19, 2014).

Wilson, Herbert M. "The Morris Canal and Its Inclined Planes." Catskill Archives. http://www.catskillarchive.com/rrextra/abnjmc.Html (accessed February 8, 2014).

Wright, Kevin W. *A History of the Andover Iron Works: Come Penny, Go Pound*. Charleston, SC: The History Press, 2013.

———. "Newton and the Iron Horse: A History of the Sussex Railroad." 2000. http://newtonnj.net/Pages/railroad.html (accessed February 3, 2014).

———. "Waterloo Village." 2011–12. Six-part Internet series published online at http://riverdell.patch.com (accessed August 13, 2013).

MORRIS CANAL REPORTS:

"Annual Report Upon the Morris Canal for the Year Ending July 1, 1826." New York: William Davis Jr., printer, 1826. Morristown Library, Morristown, New Jersey.

Colden, President Cadwallader D. "Report to the Directors of the Morris Canal and Banking Company." May 1, 1827. New York: William Davis Jr., printer, 1827. Morristown Library, Morristown, New Jersey.

"Report of the President and Directors of the Morris Canal & Banking Company to the Stockholders, January, 1835." New York: James Van Norden, printer, 1835. Morristown Library, Morristown, New Jersey.

Roeder, Adolph. "Special Report of the New Jersey State Civic Federation, Number 11: A History of the Morris Canal." Orange, NJ, 1910. Morristown Library, Morristown, New Jersey.

Index